CANON EOS 70D

THE EXPANDED GUIDE

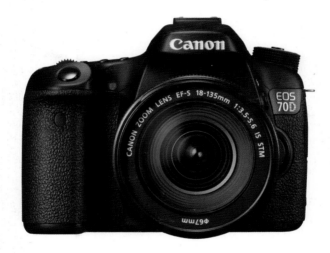

D1198475

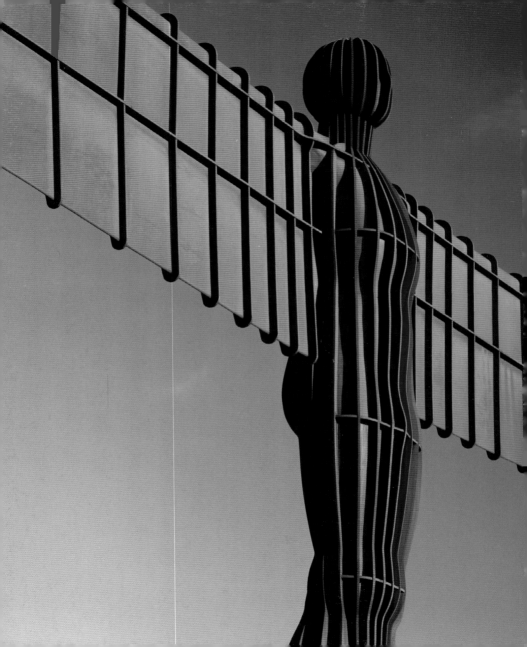

CANON EOS 70D

THE EXPANDED GUIDE

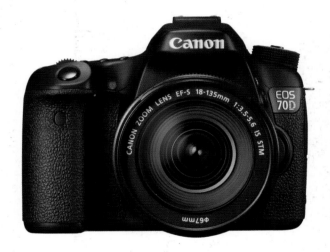

David Taylor

AMMONITE
PRESS

First published 2014 by
Ammonite Press
an imprint of AE Publications Ltd
166 High Street, Lewes, East Sussex, BN7 1XU, UK

Text © AE Publications Ltd, 2014
Images © David Taylor, 2014 (unless otherwise specified)
Copyright © in the Work AE Publications Ltd, 2014

ISBN 978-1-78145-069-7

Editor: Chris Gatcum
Series Editor: Richard Wiles
Design: Belkys Smock

Typefaces: Giacomo
Color reproduction by GMC Reprographics
Printed in China

« PAGE 2
Warm early morning light on
the Angel of the North,
Gateshead, Tyne & Wear,
United Kingdom.

» CONTENTS

1 OVERVIEW

The EOS 70D is the latest in a line of digital cameras that stretches back to the 10D released in 2003. It also belongs to the EOS family of cameras that began with the EOS 650, a film camera launched in 1987.

The EOS 70D was announced on July 2nd 2013. It appears similar to its predecessor, the EOS 60D of 2010, but this is not necessarily a bad thing—Canon produces well thought out cameras with excellent ergonomics. If you're used to using Canon cameras, the EOS 70D will prove easy to become familiar with.

The major changes between the EOS 60D and the EOS 70D are internal, and start with the EOS 70D's newly developed 20.2 megapixel (MP) sensor. This may seem a small increase in resolution from the

18.1MP sensor of the EOS 60D, but the number of pixels isn't the only way a sensor should be judged. By using a revised DIGIC image processor (DIGIC 5+) the EOS 70D's sensor is able to extract more detail at higher ISO settings than the EOS 60D.

However, the real party piece of the EOS 70D's sensor is its Dual Pixel CMOS autofocus (AF) system. Canon has added phase-detection AF sensors onto the image sensor so that each pixel is able to gather light to create an image as well as determine focus distance. This means that AF is fast and smooth when using Live View and, perhaps more importantly, when shooting movies. Slow or non-existent AF during movie shooting has been a bugbear with previous Canon DSLRs, but the EOS 70D is arguably the first Canon video-enabled camera with AF that is as good as a top-flight camcorder. If you're interested in a camera with the capability of shooting high-quality stills as well as video, then the EOS 70D may well be the model for you.

SENSOR ⌄
The EOS 70D's revolutionary 20.2MP sensor allows smooth and fast AF during Live View and movie shooting.

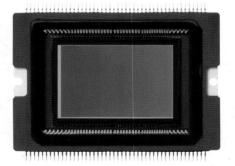

CREATIVE »
The EOS 70D is well-featured, giving you the all the tools you need to create your own personal interpretation of a scene.

» MAIN FEATURES

Body

Dimensions (W x H x D): 5.5 x 4.1 x 3.1 in./139 x 104 x 78.5mm.
Weight: 23.8 oz./675g without battery.
Lens mount: Compatible with EF and EF-S lenses.
Operating environment: 32–104°F. (0–40°C) at 85% humidity maximum.

Sensor and processor

Sensor: 0.86 x 0.58 inch (22.3 x 14.9 mm) CMOS.
Aspect ratio: 3:2.
Effective resolution: Approx. 20.2 megapixels.
Dust deletion: Integrated cleaning system.
Image processor: DIGIC 5+.

Still image file types and sizes

JPEG resolution (pixels): 5472 x 3648 (L), 3648 x 2432 (M), 2736 x 1824 (S1), 1920 x 1280 (S2), or 720 x 480 (S3).
JPEG compression: Fine or Normal quality (except S2 or S3).
Raw resolution (pixels): 5472 x 3648, 4104 x 2736 (M), or 2736 x 1824 (S).
Raw format: .CR2.
Raw bit depth:14-bit color.
Simultaneous Raw + JPEG: Yes.

Shutter

Type: Electronically controlled, focal-plane shutter.
Shutter speeds: 1/8000 sec.–30 seconds, plus Bulb.

Continuous shooting: High speed at 7 fps; Low speed/silent at 3 fps.
Maximum burst rate: 40 shots JPEG; 15 shots Raw.
Self timer: 2- or 10-second delay.

LCD monitor

Type: TFT color.
Resolution: Approx. 1.04 million pixels.
Size: 3.0 in./7.7cm diagonal.
Brightness levels: 7 user-selectable levels.
Live View: Yes.
Grid overlays: 2.

Viewfinder

Type: Eye-level pentamirror.
Coverage: Approx. 98%.
Eye point: 22mm.
Diopter adjustment: -3–+1m-1.

Focusing (Viewfinder)

Type: Phase difference detection.
Modes: One-Shot, AI Servo AF, AI Focus AF, Manual.
AF points: 19 cross-type AF points.
AF point selection: Individual or automatic selection.
AF assist: Yes.

Focusing (Live View)

Type: Dual Pixel CMOS AF/Contrast-detection AF.
Modes: Face detection+tracking, Flexizone-Multi, FlexiZone-Single (all contrast detection AF).

Quick mode (phase-difference detection AF).
Manual focus (MF).
Live View magnification: 1x, 5x, or 10x magnification.

Movies

Resolution: 1920 x 1080 pixels (Full HD) at 30p/25p/24p.
1280 x 720 pixels (HD) at 60p/50p.
640 x 480 pixels at 30p/25p.
Format: .MOV format (H.264 compression for image data and Linear PCM for audio).

Exposure

Metering system: 63-zone iFCL metering system.
ISO range: 100–12,800, plus H (ISO 25,600 equivalent).
Metering patterns: Evaluative, Center-weighted average, Partial (approx. 7.7% of viewfinder at center), and Spot (approx. 3% of viewfinder at center).
Exposure compensation: ±5 stops in ⅓- or ½-stop increments.
Automatic exposure bracketing: ±3 stops in ⅓- or ½-stop increments.

Flash

Integral flash: GN 39.4ft (12m) at ISO 100.
Hotshoe: Yes (compatible with EX Speedlite flashes).
Sync speed: 1/250 sec.
Flash exposure compensation: ±3 stops in ⅓- or ½-stop increments.

Flash modes: 1st curtain sync, 2nd curtain sync, high-speed sync (with compatible Speedlite).

Memory card

Type: Secure Digital (SD, SDHC, and SDXC).

Software

ImageBrowser EX, Digital Photo Professional, PhotoStitch, EOS Utility, Picture Style Editor.

1 » FULL FEATURES & CAMERA LAYOUT

FRONT OF CAMERA

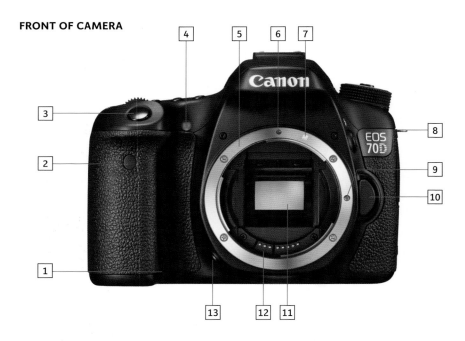

1 DC coupler cord hold		**8** Left strap mount	
2 Remote control sensor		**9** Lens lock pin	
3 Shutter-release button		**10** Lens-release button	
4 Red-eye reduction / Self-timer lamp		**11** Reflex mirror	
5 Lens mount		**12** Lens electrical contacts	
6 EF lens mount index		**13** Depth of field preview button	
7 EF-S lens mount index			

BACK OF CAMERA

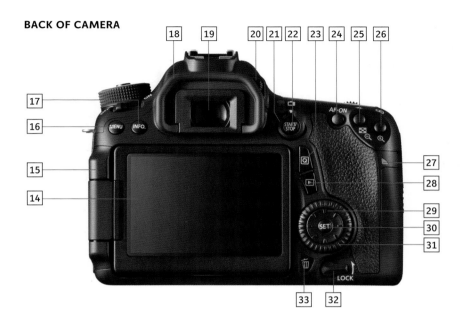

14	LCD monitor	25	✳ AE/FE Lock / ⬛ Image index /
15	LCD monitor hinge		🔍 Reduce button
16	MENU button	26	⊡ AF-Point selection /
17	INFO. button		🔍 Magnify button
18	Eyecup	27	Access lamp
19	Viewfinder eyepiece	28	▶ Playback button
20	Diopter adjustment	29	Multi controller
21	Live View / Movie shooting switch	30	(SET) Setting button
22	Start / Stop button	31	◯ Quick control dial
23	Q Quick control button	32	Multi function lock switch
24	AF Start button	33	🗑 Delete button

TOP OF CAMERA

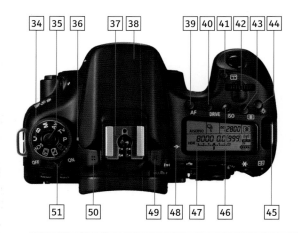

LEFT SIDE

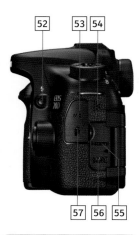

34	Mode dial	44	Top LCD illumination button	52	Flash release button
35	Mode dial lock button	45	Right strap mount	53	External microphone terminal
36	Mode dial index mark	46	ISO speed setting button	54	Speaker
37	Hot shoe	47	Top LCD	55	HDMI out terminal
38	Built-in flash	48	Focal plane mark	56	Audio/Video out / USB terminal
39	AF mode button	49	Right stereo microphone	57	Remote release terminal
40	Drive mode button	50	Left stereo microphone		
41	AF area selection button	51	On/Off switch		
42	Main dial				
43	Metering selection button				

BOTTOM OF CAMERA

RIGHT SIDE

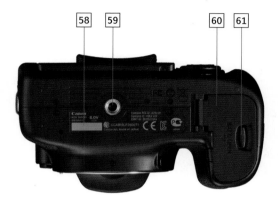

|58| Information panel

|59| Tripod socket

|60| Battery cover

|61| Battery cover lock release

|62| Memory card cover

1 » PLAYBACK SCREEN

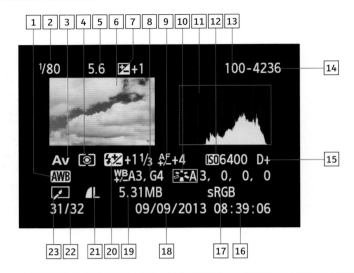

1 White balance setting	**13** Folder number
2 Shutter speed	**14** File number
3 Shooting mode	**15** Highlight tone priority
4 Metering mode	**16** Time of image capture
5 Aperture	**17** Color space
6 Image thumbnail	**18** Date of image capture
7 Exposure compensation	**19** File size on memory card
8 White balance adjustments	**20** Flash exposure compensation
9 Lens AF microadjustment	**21** Image recording quality
10 Picture Style settings	**22** Image number / Number of images on card
11 Histogram	
12 ISO	**23** Creative Filter

» LIVE VIEW

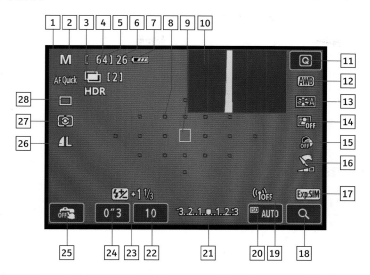

1	AF setting (AF Quick mode shown)	15	Creative Filters (off)
2	Shooting mode	16	Creative Filters (on)
3	HDR active	17	Exposure simulation active
4	Multiple exposures active	18	Magnify view
5	Possible shots	19	Wi-Fi status
6	Maximum burst images	20	ISO speed
7	Battery status	21	Standard exposure index / AEB range
8	Focus point	22	Aperture
9	Active focus point	23	Flash exposure compensation
10	Histogram	24	Shutter speed
11	Quick Control	25	Toggle touch shutter on/off
12	White balance setting	26	Image quality
13	Picture Style	27	Metering mode
14	Auto Lighting Optimizer	28	Drive mode

1 » VIEWFINDER

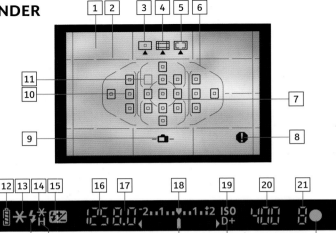

1 Focusing screen	(buSY) / Built-in flash recycling (buSY) / Multi function lock warning (L) / Card full warning (FuLL) / Card error & No card warning (Card) / Error code (Err)
2 Optional grid	
3 Single AF-point indicator	
4 Zone AF indicator	
5 19-point automatic selection AF indicator	**17** Aperture
	18 Standard exposure index
6 Zone AF points	**19** ISO Indicator
7 Spot metering circle	**20** Selected ISO speed
8 Warning indicator	**21** Maximum burst indicator
9 Electronic level	**22** Focus confirmation indicator
10 Inactive focus point	**23** Highlight tone priority
11 Active focus point	**24** Exposure level mark (also used to display: Exposure level indicator / Exposure compensation amount / AEB range / Red-eye reduction lamp-on indicator
12 Battery check	
13 AE Lock / AEB in progress	
14 Flash FE lock / FEB in progress	
15 Flash exposure compensation	
16 Shutter speed / FE lock (FEL) / Busy	**25** High speed flash indicator
	26 Flash ready indicator

» QUICK CONTROL SCREEN

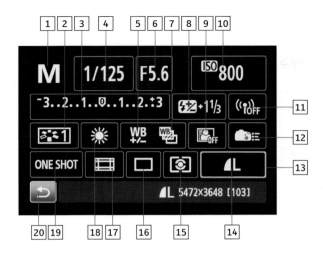

1 Shooting mode	**11** Wi-Fi status
2 Picture Style	**12** Custom controls
3 Exposure level indicator / AEB range / Exposure compensation	**13** Currently selected Quick control indicator
4 Shutter speed	**14** Image quality setting
5 White balance compensation	**15** Metering mode
6 Aperture	**16** Drive mode
7 White balance bracketing	**17** AF area selection mode
8 Flash exposure compensation	**18** White balance setting
9 Auto Lighting Optimizer	**19** Focus mode
10 ISO speed setting	**20** Exit Quick control touch button

2 FUNCTIONS

In many ways the EOS 70D is a "Frankencamera," taking features from many of Canon's current cameras. However, with a new AF system it also has a (so far) unique trick of its own.

All cameras, regardless of make, have certain common features. Often, the biggest difference is in the naming convention used for a particular feature— Canon use Av and Tv for Aperture Priority and Shutter Priority respectively, instead of the more commonly used A and S.

If this is your first interchangeable lens camera or you've just switched from another camera system it can be slightly confusing until you've learned the new "language," but the following two chapters should help you cut through that confusion. However, if you're reasonably familiar with Canon DSLRs you may want to skip the first half of this chapter and go straight to the more detailed explanations of functions after that.

Whatever your level of experience you'll find the EOS 70D is a well-specified camera. It can be used as a "point-and-shoot" camera or you can take full control for greater creative fulfilment. Whichever way you choose to shoot, experimenting with your camera will pay dividends: familiarity will help you make creative decisions quickly and avoid missing photographic opportunities.

CHOICE ≫
The ability to swivel the LCD makes it easier to compose shots above and below eye-level.

BUILDING BLOCKS ≫
Understanding how your camera works is the first stage in using it creatively.

2 » CAMERA PREPARATION

› Attaching the strap

It's a heart-stopping moment when a camera falls to the floor. One way to minimize the risk of this happening is to fit the supplied strap, which allows you to either wear your EOS 70D around your neck or keep it secure by wrapping the strap around your wrist.

To attach the strap to your EOS 70D pull one end of the strap out of the attached buckle and plastic loop and then feed it through either the right or left strap mount on the side of the camera. Feed the end back through the plastic loop and then under the length of strap still in the buckle. Pull the end of the strap so that is fitted snugly in the buckle. For safety, allow at least 2 inches (5cm) of strap to extend beyond the buckle. Repeat the process on the opposite side of the camera.

› Using the viewfinder

All recent Canon digital cameras allow you to compose a shot using the rear LCD screen switched to Live View, but the advantage of a DSLR like the EOS 70D is that you also have the option of using the optical viewfinder. In many ways this is the better choice, as it helps to conserve the camera's battery power and it is also easier to hold a camera steady when it's against

your face, rather than when it is held at arm's length.

A disadvantage of the EOS 70D's viewfinder is that you only see 98% of the scene, so the camera will capture more of the scene than expected. Fortunately, this 2% difference isn't too significant. To get round this problem you could either crop the image in postproduction or compensate before exposure by fractionally zooming in with the lens (or taking a small step forward if using a prime lens).

VIEWFINDER ⌃
Adjusting the EOS 70D's diopter wheel.

The focus (or diopter) of the viewfinder can be adjusted to compensate for individual variations in eyesight. The adjustment range is -3 to +1 m-1. To alter the diopter, look through the viewfinder and move the diopter adjustment wheel up or down until the display at the

bottom of the viewfinder appears crisp. Adjusting the diopter will not affect the focus of the camera.

› Fitting and removing a lens

FITTING ⌃
Attaching an EF-S lens.

The joy of using a DSLR like the EOS 70D is that it's possible to change the lens to suit your needs for each individual shot. To fit a lens, first switch off the camera and then hold it so the front is facing toward you. Remove the body cap (or lens if one is already fitted) by pressing the lens-release button fully and turning the cap to the left until it comes free easily.

Remove the rear protection cap from your lens. If you're fitting an E-FS lens, align the white index mark on the lens barrel with the one on the camera lens mount. If you're fitting an EF lens, align the red mark on the lens with the red

mark on the camera lens mount. Then, holding the solid part of the lens, gently push it into the lens mount until it will go no further and turn the lens to the right until it clicks into place. To remove a lens, reverse the procedure above. If you're not fitting another lens immediately, replace the body cap on the EOS 70D and fit the rear cap onto the lens you've just removed. *See chapter 4* for more information about lenses.

Tip

No matter how careful you are, dust will always find its way inside the camera. The EOS 70D has a dust removal facility, but it's still better to try to minimize the time that the interior of the camera is open to the elements. If you are in a dusty environment and you need to change the lens, try to shelter the camera with your body as much as possible.

2 » POWERING YOUR EOS 70D

› Battery charging

The EOS 70D is supplied with an LP-E6 battery that must be fully charged before first use. Remove the cover from the battery and slide it in and then down into the supplied LC-E6 or LC-E6E charger so that the word "Canon" is in the same orientation on both the charger and battery.

Connect the LC-E6E charger to the AC power cord and insert the plug into a wall socket, or plug the LC-E6 charger directly into a wall socket after flipping out the power terminals. The charge lamp will blink orange once per second, and as the battery is charged the rate of blinking will increase: at three blinks per second that battery will be approximately 75% charged, and when charging is complete the charge lamp will glow green. Once the battery is charged, unplug the charger from the wall socket and remove the battery by pulling it up and out from the charger.

A normal charge for a depleted battery will take approximately 150 minutes. The amount of charge left in a battery is shown on the top LCD (see table below). When fully charged the battery should be able to power your EOS 70D for approximately 920 shots at room temperature when using the viewfinder to compose your images, or 210 shots when using Live View. This is reduced to approximately 850 and 200 shots respectively as temperatures drop close to freezing.

Notes:
The battery charger can be used abroad (100–240v AC 50/60hz) with a suitable plug adapter and does not require a voltage transformer.

The battery use figures above are based on CIPA standards. CIPA is the Camera & Imaging Products Association, a Japanese group of camera equipment manufacturers of which Canon is a member.

Canon has been remarkably consistent in its use of the LP-E6 battery. It's the same battery pack that powers the EOS 60D, 7D, 5D Mk III, and 6D.

Battery charge indicator

▰▰▰	100–70% charged
▰▰	69–50% charged
▰	49–20% charged
	19–10% charged
	9–1% charged
	Battery depleted

› Inserting and removing the battery

To insert the battery, switch the camera off and turn it upside-down. Push the battery cover release lever toward the center of the camera. The cover door should then open easily. With the battery contact terminals facing down and to the center of the EOS 70D, push the battery into the compartment with the side of the battery pressing against the white lock lever as you do so. Once the battery has clicked into place close the battery cover. To remove the battery, push the lock lever away from the battery and gently pull it out.

› Battery life

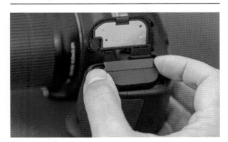

POWERED-UP ✕
Inserting the LP-E6 battery.

The LP-E6 battery supplied with the EOS 70D is a rechargeable lithium ion unit. Lithium ion, or li-ion, batteries are remarkably small and lightweight for their power capacity. However, the EOS 70D's battery will inevitably deplete when used, and also slowly discharge when it is removed from the camera.

The more efficiently you use your EOS 70D, the longer the battery will last. Using the rear LCD to constantly check your images (known as "chimping") is particularly power draining so try to keep the use of the LCD to a minimum. Using Live View compounds the matter, as it requires the sensor to be permanently active as well as the LCD, which puts a further strain on the battery. Keeping Image Stabilization (IS) switched on (if a lens has this feature) will also cause the battery to deplete more quickly.

Ambient temperature has a big effect on the efficiency of a battery. Cold conditions will cause your battery to deplete more quickly than usual. Therefore it's worth carrying a fully charged spare battery with you on days when the temperature is close to freezing.

> ### Note:
> By default, the EOS 70D will power down after **1 min.** if no controls are pressed during that time. You can alter the timing of **Auto power off** or switch it off on the 🔧 menu. Lightly pressing down on the shutter-release button will reactivate the camera when it has powered down.

TURNING THE WHEEL ⌃
The ◯ Quick control dial is used extensively to alter settings on the EOS 70D.

It takes time to get to know a camera well. Ultimately this means using your EOS 70D as often as is practicable, as getting to know the layout of the controls could be the difference between capturing a shot and missing it. Fortunately, Canon has made the EOS 70D ergonomically similar to other models in the EOS range, if you've used another Canon camera you'll quickly get to grips with this one.

Throughout this book I'll be referring to the buttons and controls by using shortcut symbols. To use the various menus and functions (assuming you're not using the touchscreen) you'll mostly use the Main dial behind the shutter-release button, the ◯ Quick control dial on the rear of the camera that surrounds the multi controller. If you need to use the multi controller you'll see either a specific direction arrow (◀ for left, ▲ for up, ▼ for

down, and ▶ for right) or ❊ if you have a choice of which direction to press. The Setting button (SET) at the center of the multi controller is used to confirm a function or menu choice. Other buttons on the camera will be referred to by their name or relevant symbol. When you come across words in bold type these signify options that are visible on a menu screen.

In shooting mode you can switch between several different shooting information screens on the LCD by repeatedly pressing **INFO.**. One of the more useful of these is the virtual spirit level, which is an excellent aid to keeping your camera straight. Pressing **INFO.** in playback mode will cycle through a series of screens showing varying degrees of information about the currently displayed image.

> **Note:**
> *See page 86* for instructions on how to use the EOS 70D's menu system.

› Switching the camera on

The power switch is found below the Mode dial. Switched to OFF, the EOS 70D is entirely inactive. When the camera is switched ON, the Access lamp will flicker briefly, automatic sensor cleaning will be activated, and the top LCD will display the current shooting settings.

› The LCD monitor

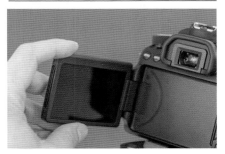

OPENING UP ⌃
Revealing the EOS 70D's LCD.

The viewfinder conveys some information about the configuration of the EOS 70D. However, the same information—and more—can be found on the LCD. This information includes the currently selected shooting settings, a Live View display that displays a live image directly from the camera's sensor (optional when shooting still images or automatically selected when shooting movies), a comprehensive menu system, and the playback function to review images.

The LCD of the EOS 70D is also touch-sensitive so you can select camera functions, without pressing buttons or turning dials. How you control your camera is very much a personal preference, though.

The LCD is hinged and can be rotated so that it faces into the camera. This is useful to avoid the LCD becoming scratched when you're not using your camera. To view the LCD, first pull it out from the camera 180°, and then rotate it forward, toward the front of the camera, by a further 180°. Push the screen back into the camera so that it fits snugly with the screen facing outwards. The LCD can of course be used at any angle, which is particularly useful if you want to use your EOS 70D close to the ground or above head height.

› Using the touchscreen

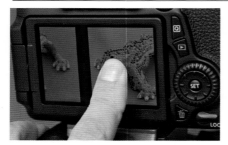

TOUCHED ⌃
The touchscreen allows you to scroll quickly
through your images in playback.

You can set the various functions on your
EOS 70D one of two ways: by pressing
buttons and turning dials, or by using the
LCD touchscreen. Which you choose is
entirely up to you.

There are three ways that you can
interact with the LCD. The first method is
to simply touch an onscreen option to
select it; this is useful when using the menu
system or **Q** screen. You can also select

OK or **Cancel** to confirm an alteration to a
function by touching the relevant option
on the LCD. Touching can also be used
during Live View, either to select a focus
point or to fire the shutter when **Touch
Shutter** is set to **Enable**. Whenever arrows
are displayed on screen you can touch
these to make alterations to settings in
much the same way as using the multi
controller.

The second way to interact with the
LCD is to slide your finger across the
screen. This is used to adjust functions that
use sliders, such as exposure compensation.
When viewing images in playback you can
use a left-to-right sliding motion to quickly
skip through images on the memory card.

The third way to interact with the LCD is
to use two fingers and either bring them
together or pull them apart. This action
can be used to zoom out or zoom in
respectively when viewing images.

Using the touchscreen	
Advantages	Options can often be altered more quickly than using the physical controls. Moving the focus points during movie shooting is smoother with touch focus than turning the lens' focus ring manually.
Disadvantages	You can't use the touchscreen wearing normal gloves. The LCD can become very smeary.

» DATE AND TIME

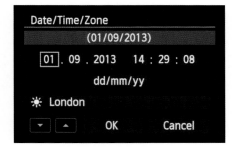

When you first switch on your EOS 70D you'll be prompted to set the correct date and time. If you're itching to begin shooting you could be tempted to skip this step, but it's important to set the correct date and time, as every shot you make has this data embedded into the image's metadata. Metadata is non-image data that can be used to store information such as the exposure settings used for an image and copyright information.

You can use metadata to find or to sort images, making the job of finding a particular photograph far easier, but without the correct time and date set on the camera, the metadata will be inaccurate. Metadata can be read and displayed by image-editing software once an image has been copied to a PC.

Setting the date and time for the first time

1) Turn on your EOS 70D.

2) Use ◀ / ▶ to highlight the date or time value you want to alter and then press (SET).

3) Press ▲ / ▼ to change the time or date value and then (SET) to set that value.

4) Highlight the date format box and alter the date format if required.

5) Choose ☀OFF and set daylight saving if this applies to your region. When ☀ is displayed the time is advanced by one hour.

6) Highlight the time zone box and set the correct time zone. If you travel between time zones you can use this option to quickly set the correct time for your current location without needing to adjust the time using the procedure at step 2.

7) Highlight **OK** and press (SET) to save your new settings, or highlight **Cancel** and press (SET) to exit without saving.

> *Note:*
> If you don't complete the sequence above you will be prompted to do so every time you turn the camera on until you do.

2 » MEMORY CARDS

› Inserting and removing a memory card

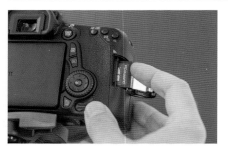

STORAGE ⌃
Inserting a memory card.

Before you begin to use your EOS 70D you'll need to install a memory card to store images and movies. The EOS 70D uses Secure Digital (SD) memory cards. The SD standard has evolved and the latest and variant is known as SDXC, which is available in sizes up to 256GB (theoretically SDXC cards can be made with a 2 Terabyte capacity, though this has not happened at the time of writing). The EOS 70D is compatible with the UHS-1 version of this type.

The EOS 70D is also compatible with Eye-Fi technology. This is a proprietary SD memory card that has a built-in Wi-Fi transmitter, allowing you to copy files from your camera to a computer wirelessly. The EOS 70D has a comprehensive menu screen allowing you to set up a card quickly and easily. *See chapter 8* for more details.

Fitting and removing a memory card
1) Make sure that your EOS 70D is switched off, and then open the memory card cover on the right side of the camera.

2) With the memory card contacts facing into and toward the front of your EOS 70D, push the card into the slot until it locks with a click. Close the memory card cover.

3) To remove the memory card, push it into the slot slightly until you hear a click. The card should now come free. Pull it out gently and close the memory card cover.

> *Notes:*
> If your memory card has a write-protect tab, slide the tab to the unlocked position. If the card is locked, **Card's write protect switch is set to lock** will appear on the LCD and you will not be able to take photos. Locking the card will ensure that images stored there will not be erased accidentally.
>
> If there is no memory card in the camera it is still possible to shoot photos by setting **Release shutter without card** to **Enable** on the �‍▢ menu. However, even though you can fire the shutter, your photos will not be saved. *See chapter 8* for a use for this function.

› Memory card speed

The greater the capacity of a memory card, the more images you'll be able to fit onto the card, but another important factor is a memory card's read/write speed. This refers to how fast data can be written to and from the card: faster cards tend to be more expensive than slower ones. If you shoot a lot of video (or are just impatient when copying images to your computer) the fastest card you can afford is highly recommended, but if your style of photography isn't so speed dependent (if you shoot a lot of landscapes, for example) you may find that compromising on speed in order to buy a larger capacity memory card is a better option.

The speed of a memory card is often given as a Class Rating: the higher the Class Rating, the faster the card. A memory card's speed is also sometimes shown as a figure followed by an "x." This figure refers to the speed of the card in comparison to the read/write speed of a standard CD-Rom drive. Canon recommends a Class 6 (or 40x) memory card or higher for shooting video.

UHS-1 stands for Ultra High Speed and is a new class rating for SDHC and SDXC memory cards. UHS-1 memory cards have a data transfer rate of 104 Mb/s, which is far faster than the minimum required for shooting video.

Warning!

When the access lamp on the back of your EOS 70D is flashing it means the camera is either reading, writing, or erasing image data on the memory card. Do not open the memory card cover or remove the card or the battery when the lamp is flashing. Doing this may cause data on the card to be corrupted, and potentially damage your camera.

Speed	Read/Write speed (Mb/s)	Class Rating
13×	2.0	2
26×	4.0	4
40×	6.0	6
66×	10.0	10

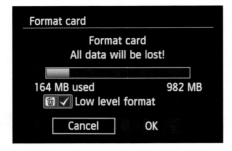

Most SD memory cards are sold pre-formatted. However, it's good practice to format a memory card when first used in your EOS 70D. This is particularly important if the card has been used in another camera previously, as files saved by another camera may not be visible to the EOS 70D meaning there is less space on a memory card than you realize.

Formatting a memory card
1) Press **MENU** and navigate to ❤. Highlight **Format card** and press ⑤ET to select the option.

2) Highlight **OK** and press ⑤ET to begin formatting the card. If you've changed your mind, select **Cancel** and press ⑤ET to return to ❤ without formatting.

3) As the card formats, **Busy...Please wait** will be displayed on screen. Once complete the camera returns to ❤ automatically.

Note:
On the Format screen is a **Low Level Format** option. When a memory card is formatted, usually only the list of contents is erased. The original files are still on the memory card, although as the list of contents has been removed the camera can't "see" them. As you create more images, these leftover files are gradually overwritten. If you accidentally format a memory card it is often possible to recover your files with file-recovery software, provided you don't use the card before then.

However, when **Low Level Format** is selected, everything on the card is erased, not just the list of contents. This takes more time than a standard format, but it is worth doing every so often, particularly if you shoot video. To use low level formatting press 🗑 when you first enter the **Format card** screen. A ✔ will be displayed next to **Low Level Format** to show that you've chosen this option.

» TOP LCD PANEL

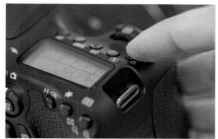

SEEING THE LIGHT ⌃
To illuminate the top LCD press the Exp.SIM button. The LCD stays lit for approximately five seconds.

There are a number of ways that you can view the current camera settings of your EOS 70D: via the viewfinder display, on the rear LCD, or on the top LCD. Although the top LCD doesn't have the visual appeal of the rear LCD it's actually a very useful addition to the EOS 70D. Its most useful aspect is that it's far more power-efficient than the rear LCD, so using the top screen is a good way of conserving battery power.

There are five function buttons in front of the top LCD: AF mode, Drive mode, ISO, metering mode, and LCD panel illumination button. To change the settings using the top LCD (with the exception of the illumination button), press the required button and turn ⚙ or ◌. You do not need to keep your finger on the button as you turn either control—the setting can still be altered for five to six seconds after you take your finger off the button.

2 » QUICK CONTROL MENU

The EOS 70D's menu system (described in chapter 3) is very comprehensive—perhaps even too comprehensive if you want to make rapid changes to the camera's functions. Fortunately, the EOS 70D has a useful shortcut in the form of its Quick Control menu, which is called up by pressing the Q button.

The options shown will vary depending on whether you are in a Basic or Creative Zone shooting mode, or whether you are viewing images and movies in playback.

There are two ways to use the Quick Control menu. You can press ✳ to highlight the required option and then (SET) to view a detailed option screen where the required changes can be made, or with the option highlighted on the main Quick Control menu screen, turn 🔆 to make the desired changes. You can also press options on the LCD rather than using the physical controls.

Quick Control shooting options	Comments
Shutter speed	**Tv/M** modes only
Aperture	**Av/M** modes only
ISO	Not Basic Zone modes
Exposure compensation / Bracketing	Not **M** or Basic Zone modes
Flash exposure compensation	Not Basic Zone modes
Picture Style	Not Basic Zone modes
White Balance	Not Basic Zone modes except 🏃, 🏔, 🌷, and 🏊
White Balance shift	Not Basic Zone modes
Auto Lighting Optimizer	Not Basic Zone modes Disabled when Highlight tone priority is activated
Built-in flash settings	Not Basic Zone modes, except basic control options in 🏃, 🏔, 🌷, and 🏊
AF mode	Not Basic Zone modes MF only when lens is set to manual
Drive mode	–
Metering mode	Not Basic Zone modes
Image quality	Not Basic Zone modes
Background blur control	Creative Auto only

» ELECTRONIC LEVEL

If you're shooting at social events there's no real need to worry whether your camera is perfectly level. Indeed, shooting at odd angles or from unusual viewpoints is a very creative way of working. However, some subjects require a more rigorous approach. Landscape and architectural photography, for example, often involve setting up a camera on a tripod and keeping it perfectly horizontal or vertical.

One landscape subject that definitely requires this level of attention is water. An image of a body of water that slopes looks distinctly odd. Lakes and oceans should be horizontal and not appear to be running out of the side of the image.

A slightly different problem, known as "converging verticals," occurs when shooting geometric subjects, in particular buildings. This is a visual effect where buildings appear to be falling either forward or, more commonly, backward in a photographic image. It is caused when the camera is not parallel to a building.

Fortunately your EOS 70D can help you avoid both of these problems if you use the built-in electronic level that can be displayed both on the rear LCD and in the viewfinder. In Shooting mode press **INFO.** until the electronic level appears on the LCD. The long bar across the screen outside the central circle shows the horizontal angle of the camera: when it is red, the EOS 70D is not horizontal; when it is green, the camera is perfectly horizontal.

The smaller white bar at the center of the circle shows the vertical angle. Tip the camera upward and the vertical angle bar drops lower; tip the camera down and the vertical angle bar rises. When the vertical angle is correct the bar will be centered in the circle and the line on either side will turn green.

Notes:
To display the electronic level set **Electronic Level** to ✓ on the ✚**INFO. button display options** screen.

There are two viewfinder levels. One is set using **Viewfinder level** on ◘, while the other uses the AF points and can be switched on by setting the depth of field button function on the **C.Fn III-4 Custom Controls screen.**

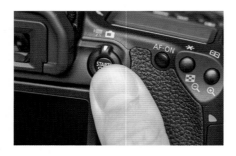

By switching on Live View you can use the rear LCD screen to compose your shots. In this mode the mirror inside the camera is flipped up (blocking the viewfinder), the shutter is opened, and a live feed from the sensor is sent to the LCD. Live View is arguably better than the viewfinder as you can see the effect of functions such as Picture Styles. You can also get a reasonable simulation of the final exposure when **Exp. SIM** is colored white on the LCD (if the image on the LCD is displayed at a different brightness to the final exposure **Exp. SIM** will blink, or if final exposure cannot be simulated—when using flash, for instance—**Exp. SIM** will be grayed out).

To activate Live View press START/STOP. The mirror inside the camera will rise and the Live View image will be displayed on the LCD. Pressing **Q** displays the Quick Control options. These are overlaid on the Live View image. You can also choose how much, or how little, shooting information

is shown on screen by pressing **INFO.**. One particularly useful piece of information is the live histogram showing the tonal range of the image, although in general it's a good idea to show as little shooting information as possible when you're composing your shots, so that no important detail is missed. You can then display shooting information to refine the image's settings.

One problem with Live View is that it's more difficult to hold a camera steady at arm's length. Using Live View will also deplete your camera's batteries more quickly than use of the viewfinder.

> **Notes:**
> You can magnify the Live View image by 5x or 10x: press ⊕ to magnify the Live View image 5x, again to magnify 10x, and a third time to restore the display to normal. Magnifying the Live View image is particularly useful for checking critical focus in the scene. Use ✸ or touch the arrows on the LCD to pan around the magnified image if desired.

» THE SHUTTER-RELEASE BUTTON

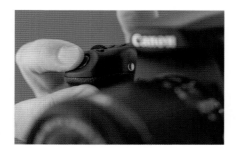

Inside your EOS 70D is a light-tight, metal curtain that covers the sensor. This metal curtain is the shutter. When you press down fully on the shutter-release button the shutter rises and, for a set period of time, the sensor is exposed to light. Once the set period is up, the shutter closes, covering the sensor once more. The set period of time is the shutter speed you or the camera has chosen for the exposure.

The EOS 70D's shutter-release button has two separate stages. If you press the shutter-release button lightly down halfway the AF and camera metering are activated (canceling playback mode automatically if you were looking at previously shot images).

When the drive mode is set a Single shooting mode, the shutter will only fire once, so if you want to shoot another image the shutter-release button must be released fully and then pressed down once more. Set to a Continuous shooting

mode the EOS 70D will continue firing at the maximum possible frame rate until either the memory card or the image buffer is full, or you release the shutter-release button.

Tip

The shutter-release button is reasonably sensitive so you don't need to force it down or jab sharply. Pressing the button down smoothly will help keep your camera more stable when handholding the camera too.

2 » DRIVE MODE

The EOS 70D has five frame advance (or "drive") modes, two self-timer settings, plus exposure and white balance bracketing. The shooting mode you use will determine which drive modes are available.

The fastest drive mode is ⛶H High speed continuous, which allows you to shoot at a maximum rate of 7fps (frames per second). However, this is the maximum frame rate, and depending on the write speed of your memory card and the ambient lighting conditions, the actual shooting speed could well be less than this. Both Low Speed Continuous and Silent Continuous shooting allow a shooting speed of 3fps.

The two Silent shooting modes (□S Silent single and ⛶S Silent continuous) are both far quieter than the equivalent "standard" shooting modes. If you regularly shoot weddings—when near-silence is preferable—the Silent shooting modes are ideal.

The EOS 70D has a built-in frame buffer in which images are stored temporarily until they have been written to the memory card. If you shoot continuously, the frame buffer will gradually fill until it is "full." At this point the camera can no longer continue shooting until the buffer is at least partially cleared. This is most likely to happen when you're shooting Raw+JPEG, as the camera needs to process the maximum amounts of data possible. When the frame buffer is full, the maximum burst indicator in the viewfinder will show 0, and buSY will flash up.

Drive Mode	Action	Symbol
Single shooting	One shot per press of the shutter-release button	□
High speed continuous	Shutter fires at 7fps (max.)	⛶H
Low speed continuous	Shutter fires at 3fps (max.)	⛶
Silent single	One shot per press of the shutter-release button	□S
Silent continuous	Shutter fires at 3fps (max.)	⛶S
Self-timer: 10 seconds	Shutter fires after a 10-second delay	🎙⟲
	Can be used with a remote control	
Self-timer: 2 seconds	Shutter fires after a 2-second delay	🎙⟲2
	Can be used with a remote control	

» FOCUSING

You have several choices in how a lens is focused. Manual focus (MF) is arguably the "retro" method, and although it may seem an odd choice it still has its place. Automatic focus (AF) systems aren't perfect and there are situations when it can fail: when ambient light levels are low or when there is insufficient contrast in a scene, for example. In these situations the lens may start to "hunt" and fail to lock the focus: focusing manually avoids this. MF is also useful when using techniques such as hyperfocal distance (*see chapter 4*). All Canon EOS lenses have an AF/MF switch on the lens barrel so you can quickly switch between AF and MF.

The EOS 70D uses two different AF technologies. When you use the viewfinder, the camera employs "phase detection" AF (the AF sensors are housed in the base of the camera and use light redirected from the reflex mirror to focus the lens). This method of focusing is very fast and accurate, so it's ideal for action photography.

When you switch to Live View, the EOS 70D uses "Dual Pixel CMOS AF." This is also a phase detection system, but it uses AF sensors that are incorporated onto the EOS 70D's sensor itself. It's still not quite as fast as the viewfinder AF system, but it's very close. Users who will benefit most from this technology are those who use their cameras to shoot movies. With an STM lens fitted, the EOS 70D's AF can track movement quickly and silently as a movie is recorded.

Using MF (viewfinder)

With the lens set to MF, hold the shutter-release button down halfway and rotate the focusing ring on the lens to focus. When the subject is in focus, the green ● confirmation light is displayed in the viewfinder, the relevant AF points flash red, and the camera beeps.

Warning!

Ring-type USM lenses can be adjusted manually even when the focus switch is set to AF. Don't turn the focusing ring on a non-USM lens when the focus switch is set to AF as this may damage the AF motor in the lens.

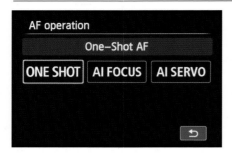

The EOS 70D has three AF modes to choose from when you use the viewfinder. To choose the AF mode, set the lens to AF and press the AF button or press Q to select the AF mode from the Quick Control screen.

One-Shot AF

One-Shot AF is suited to shooting static subjects only. After you've pressed down halfway on the shutter-release button, focus and exposure will be locked and confirmed by ● lighting green in the viewfinder. If you keep the shutter-release button partially depressed, it's possible to recompose your photo without the focus or exposure altering. If focus cannot be confirmed ● will blink and you will not be able to fire the shutter. Pressing the shutter-release button down fully exposes the image.

AI Servo AF

AI Servo AF is designed for keeping moving subjects in focus. AI Servo AF is arguably most effective when using 19-point automatic selection. The manually selected point is used to begin focusing initially and then, by holding the shutter-release button down halfway, focusing will automatically switch to one of the other points as movement is tracked (providing your subject remains within the area delineated by the 19 AF points). Neither focus nor exposure is set until you press the shutter-release button down fully and ● does not light.

AI Focus AF

This mode is a cross between One-Shot AF and AI Servo AF. AI Focus AF starts in One-Shot AF mode, but as long as you keep the shutter-release button pressed down halfway it will switch to AI Servo AF if the subject begins to move. When focus has switched to AI Servo AF the beeper will continuously sound very softly as focus is tracked.

> *Notes:*
> The AF mode is selected automatically when the camera is set to a Basic Zone mode.
>
> If **Beep** is set to **Enable** (on the 📷 menu) the camera will also beep to confirm focus in One-Shot AF mode.

› AF points

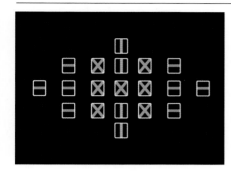

AF POINTS

When using a lens with a maximum aperture smaller than f/5.6, the outer eight AF points only detect horizontal lines, while the central top and bottom four AF points only detect vertical lines.

Notes:
AF point selection is only available when using a Creative Zone mode.

You don't need to set the lens to its maximum aperture to focus—the lens is kept open at its widest setting until you make an exposure.

When you look through the viewfinder you'll see a flat diamond shape made up of 19 squares. These squares are focus points. When the camera focuses, at least one of these points is used to determine the

camera-to-subject distance and focus the lens accordingly. All of the AF points are cross-type, which means that they can detect both vertical and horizontal lines. However, the focus points aren't all identically specified. The most effective focus point is the one at the center, and if you use a lens with a maximum aperture of f/1.0–f/2.8 vertical line detection increases in accuracy. When a lens with a maximum aperture smaller than f/5.6 is used, the outer AF points lose their ability to detect both horizontal and vertical lines simultaneously (see the diagram above). Focusing accuracy also reduces in low light. If you fit a slow lens (or add a teleconverter) you may find the AF struggles with focus points other than the center, in which case switch to the central AF point to focus, lock the exposure, and reframe your shot if necessary.

› AF area selection

When you're using the viewfinder your EOS 70D can focus using one or more of the 19 AF points. The AF points can be selected individually, as areas referred to as zones, or automatically. To switch between the three ways of selecting the focus point press the ⊡⊡ button repeatedly, until the desired selection method is highlighted in the viewfinder. To adjust the settings of the selected method press ⊞ and follow the instructions below.

⊡ Single AF-point

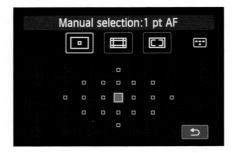

Only one focus point is available ▭ , which can be moved manually around the AF Frame area using ❉. This is ideal for off-center subjects or when you need to focus on one particular element in the scene. A good example is when shooting portraits and you want to focus on your subject's eye—the focus point could be moved precisely to the eye to ensure it is pin-sharp.

⊞ Zone AF

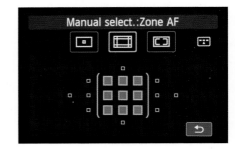

In this mode the AF area is divided into nine zones. Any or all of the AF points in a selected zone will be used automatically for focusing, typically focusing on the closest object to the camera covered by the selected zone. ⊞ is most useful for shooting action images, particularly when you're confident that your subject will enter the selected zone and will also be the closest element in the image.

▭ 19-point automatic selection AF

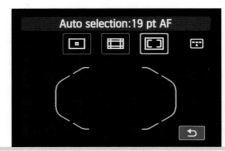

Set to this mode any or all of the AF points will be used for focusing. Focus is set to the nearest point in the image that provides enough detail for focusing. When One-Shot AF is used, the AF point(s) that achieve focus will light. When AI Servo AF is selected, the first manually selected AF point will be used to begin focusing. Focusing will then switch automatically to the other points as the movement is tracked.

› Live View AF

There are four AF modes available when Live View is used. They are set when your EOS 70D is in Live View using the Live View 📷 menu or 🇶. Other than AF Quick Quick Mode, Live View AF will be slower than focusing when using the viewfinder. The AF system may take a few seconds to focus, unless Continuous AF is set to Enable.

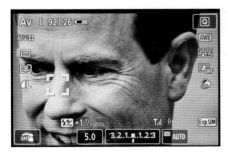

ʊ᚜ + Tracking is the default setting for Live View AF. As the name suggests it's designed for shooting portraits. Your

subjects don't even have to stay still, because their face will be tracked if they move.

When activated, the camera will automatically detect a face and draw a white focus frame ⌐ ⌐ around it. If there are a number of faces in the shot the focus frame will change to ⟨ ⟩. Move this frame to the target face by pressing ◄ / ► or tap on the face you want to focus on. Press the shutter-release button down halfway to focus. Once focus has been achieved the target box will turn green as confirmation. Press the shutter-release button down fully to take the shot. If focus cannot be achieved, the focus frame will turn orange, and focus will be set to the center of the screen.

FlexiZone AF()

This mode divides the image up into 31 AF points that are automatically selected by the EOS 70D, or nine large AF zones that can be selected manually. When selected,

FlexiZone AF () will initially be set to automatic selection.

The automatically selected AF point (or points) will be shown as green boxes when focus is achieved after pressing down on the shutter-release button. To switch to zone selection press (SET) or 🗑. Zone selection allows you to choose which area of the image is focused: you can jump between the nine zones by pressing ✳ or touching the LCD in the required area.

FlexiZone AF □

This AF mode is the simplest of the four. The AF point (shown as a white box) will initially be set at the center of the screen. To move the AF point around press ✳ (or press (SET) to quickly re-center the AF point). Press down halfway on the shutter-release button to focus. The AF point will turn green when focus is achieved. If focus cannot be confirmed the AF point will turn orange, in which case you should move the AF point and try again.

Quick Mode

This mode uses the EOS 70D's phase-detection AF sensors to achieve focus. To do this, Live View is temporarily turned off. When **Quick Mode** is selected, press 🔲 to select the AF area selection mode. When the AF area selection mode is set to 🔲 or ▦ press ✳ or touch the LCD to choose the single AF point or AF zone respectively (when ▭ is selected the AF point is chosen automatically). Press down on the shutter-release button halfway to focus. The Live View image will briefly disappear while the camera focuses. When focus has been achieved, the Live View image reappears and the focus point(s) that achieved focus will turn green. Press the shutter-release button down fully to take the shot. If focus cannot be achieved the focus point will turn orange and blink.

The smaller the camera-to-subject distance, the more restricted depth of field becomes, particularly when using wide apertures, so focusing needs to be very precise. Live View is particularly useful when shooting macro images, as the focus point can be moved over a greater area of the image and you can zoom into the image to check that the focus is accurate.

Settings
> Aperture priority **Av** mode
> ISO 800
> 1/250 sec. at f/5
> Evaluative metering
> 100mm lens

2 » EXPOSURE

› Metering modes

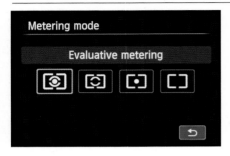

There are four exposure metering modes that can be selected on the EOS 70D, either from the **Q** screen or by pressing the metering mode button.

Evaluative metering ⊙

Evaluative is the default metering method, which works by splitting the image into 63 zones. Each zone is metered separately and the exposure is calculated by combining these results, taking into account where the focus point is. This system is very accurate and can generally cope even with unusual lighting situations.

Center-weighted average metering ⊡

As with Evaluative metering, 63 zones are used to read the exposure, but the exposure is then biased heavily toward the center of the image frame. If you are shooting subjects that are always in the

center of your image, filling the frame, this mode will prove very accurate, but center-weighted metering has largely been superseded by Evaluative metering.

Partial metering ⊙

Rather than assess the entire image, partial metering evaluates the exposure from a 7.7% area at the center of the image frame. You would use this mode if you wanted to measure a wider area of the image than Spot metering (see below).

Spot metering ⊡

A more precise variant of Partial metering. Spot metering reads the exposure from 3% of the center of the image frame, allowing you to take an accurate reading from a very small area of the scene.

Notes:
The metering mode is set to ⊙ in the Basic Zone modes.

The exposure can be overridden using exposure compensation (see next page), unless you are using **M**, **B**, or a Basic Zone mode.

Exposure is not set until the shutter-release button is fully depressed when using ⊙, ⊡, and ⊡ metering.

› Exposure compensation

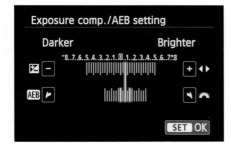

Exposure comp./AEB setting

Darker Brighter

Exposure compensation allows you to
override the camera's suggested exposure
in **P**,**Tv**, and **Av** modes in ½- or ⅓- stop
increments, up to ±5 stops. This means you
can adjust for any exposure errors that the
camera may make or change the exposure
for creative effect.

There are several ways to set exposure
compensation. The easiest is to turn ◌
after pressing halfway down on the
shutter-release button to activate the
camera's metering. The change is reflected
in the viewfinder, on the top LCD screen,
and on the LCD (if active).

Exposure compensation can also be set
by pressing Q and selecting **Exposure
comp./AEB setting**. Once the exposure
compensation screen is displayed, turn ◌
to the left to apply negative compensation
(making the final image darker) or to the
right to apply positive compensation
(making the final image lighter). Press (SET)
to confirm the new setting.

› Automatic exposure bracketing

Bracketing is the term used to describe the
shooting of two or more images at
different settings (most often exposure,
although the EOS 70D allows you to
bracket the white balance as well). The first
shot is usually the "correct" setting
(according to the camera) and the other
shots are variations on the settings used to
make the initial image.

With automatic exposure bracketing
(AEB), the bracketed shots are darker and
lighter versions of the first image.
Bracketing is a good safety net if you're not
sure whether the settings you've chosen
are correct. It is also useful if you intend to
create HDR images later in postproduction.

On the EOS 70D, the bracketing
sequence can cover a range of up to ±3
stops lower or higher than the first image.
AEB is set on the exposure compensation
screen by turning ⌁. Turning to the
right will increase the difference in the
exposure of the bracketed sequence;
turning to the left will decrease it. As with
exposure compensation, press (SET) to
confirm the new setting.

There are often occasions when the exposure needs to set and then the shot recomposed. A good example of such an occasion is when an off-center subject is spot-lit against a dark background. The dark background will potentially cause overexposure if included in the metering, and if you pressed down halfway on the shutter-release button this would lock focus as well (which may be undesirable).

One solution is to switch to ⊡ metering and point the camera so that your subject is within the spot-metering circle. The meter reading can then be locked using ✳ AE lock and the shot recomposed.

Activating AE lock

1) Press the shutter-release button down halfway to activate the exposure meter in the camera (changing the metering mode if necessary).

2) Press ✳. ✳ will light in the viewfinder, or if you are using Live View, it will be displayed on the LCD to show that AE lock has been activated.

3) Recompose and press the shutter-release button down fully to take the shot.

4) AE lock is canceled automatically after you've taken the shot. If you want to keep the exposure locked, hold down ✳ as you shoot.

Metering mode	AF point selection method Automatic	Manual
⊚	Exposure is determined and locked at the AF point that achieved focus	Exposure is determined and locked at the selected AF point
⊙ / ☐ / ⊡	Exposure is determined and locked by the center AF point	

› Histograms

One of the most useful exposure tools is the histogram, which can be displayed on screen when using Live View or next to an image in playback. A histogram is a graph showing the distribution of tones in an image, and once you've learned how to "read" the graph it's a very accurate way of assessing whether an image is correctly exposed or not. It's certainly more precise than judging exposure by just looking at an image on the LCD, and by interpreting a histogram correctly you'll know whether you need to make adjustments to exposure and reshoot.

The left half of a histogram shows the range of tones in an image that are darker than mid-gray, with black at the extreme left edge. The right half of the histogram shows the tones in an image that are lighter than mid-gray with white at the extreme right edge. The vertical axis of the histogram shows the number of pixels in an image of a particular tone. If a histogram is skewed to the left, this may be an indication that the image is underexposed; if skewed to the right, it may be overexposed. If a histogram is squashed against either the left or right edge it has been "clipped," which means there are pure black or pure white pixels in the image that contain no usable image data.

HISTOGRAMS ⌄
With practice, it's possible to look at an image's histogram and know which area of the histogram relates to which area of the image.

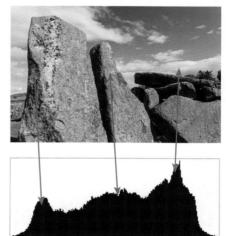

Tip

If you're shooting Raw, it's a good idea to use as neutral a Picture Style as possible and switch off functions such as Highlight tone priority. This is because the histogram in both Live View and playback is based on an image with these functions applied, so it may not accurately show you the range of tones you would have in the final Raw file.

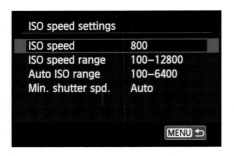

ISO speed settings

ISO speed	800
ISO speed range	100–12800
Auto ISO range	100–6400
Min. shutter spd.	Auto

MENU ⮌

The shutter speed and aperture control how much light reaches the sensor. However, through careful use of the ISO setting, you can determine how much light is required to make an image. The higher the ISO value you set, the less light is needed—think of it as turning up the volume on the sensor. Unfortunately there is a price to pay for increasing the ISO: image noise. Image noise is seen as a reduction in fine detail and an increase in "grittiness" in the image: the higher the ISO, the "grittier" the image becomes.

The optimal ISO setting for a digital camera is usually the lowest setting available, which is ISO 100 on the EOS 70D. However, the ability to alter the ISO is one of the most useful aspects of a digital camera. If you're handholding the camera in low light, for example, you may not be able to keep the camera steady if the shutter speed is too slow. Increasing the ISO will allow you to use a faster shutter speed, and in this instance an increase in

Using a low ISO setting	
Advantages	Image noise is virtually non-existent: image quality is optimal Dynamic range is at its highest: when shooting a scene with bright highlights and dark shadows, you'll have a greater chance of capturing the full tonal range. There's more scope for postproduction alteration of the image
Disadvantages	You may need to use a slower shutter speed or wider aperture than is desirable. Camera shake can mar an image if a camera is handheld while using a slow shutter speed
Using a high ISO setting	
Advantages	In low light, you can use faster shutter speed or smaller aperture
Disadvantages	Image noise increases the higher the ISO: image quality drops
	There's less scope for altering the image in postproduction without image quality dropping farther

image noise would be preferable to losing shots because of camera shake. A certain level of noise can be removed relatively easily later (albeit with some loss of fine image detail), whereas camera shake cannot currently be cured in postproduction.

Noise is most visible on screen when an image is viewed at 100% magnification. However, when you reduce the resolution of an image, noise becomes less visible, so using a higher ISO setting is less of an issue if you know that the image will be reduced in size later.

The EOS 70D offers you the choice of either selecting a specific ISO value or letting the camera choose an ISO automatically depending on the lighting conditions (**ISO Auto** is most useful when handholding your camera). There are several ways to set the ISO: you can press the ISO button and turn ◯ to change the ISO using the top LCD (or the rear LCD in Live View), or you can set the ISO on the Ｑ screen. There are also a number of options that enable you to fine-tune the ISO by choosing ◘/**ISO speed settings**.

The standard ISO range on the EOS 70D is ISO 100–12,800, which can be adjusted in 1-stop increments (ISO 100–6400 is set automatically in the Basic Zone modes). You can expand the ISO range by using "H," which is equivalent to ISO 25,600. This option

is not recommended for everyday shooting, though, as image quality is extremely low.

Setting ISO via the menu system

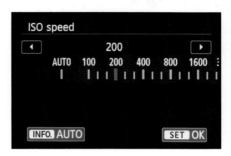

1) Press **MENU** and select **ISO speed settings** on ◘ menu.

2) Select **ISO speed**. Turn ◯ to move the red selection bar to the required ISO speed or press **INFO.** to quickly set ISO Auto. Press ⑯ to return to the main ISO speed settings menu.

Tips

Don't use Auto ISO when using ND (neutral density) filters.

Image noise is more easily seen in areas of even tone (such as sky). If using a high ISO setting avoid including large areas of even tone.

2

Constraining the selectable ISO speed range

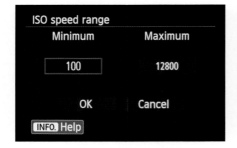

1) To constrain the available ISO range, first select **ISO speed settings** from the 📷 menu.

2) Select **ISO speed range**. The **Minimum** value will be shown surrounded by a red box. Press (SET) and turn ⊙ to choose the lowest ISO value you want to be able to select, and then press (SET) again.

3) Turn ⊙ to move the red box to the figure under **Maximum**. Press (SET) and turn ⊙ to choose the highest ISO value you want to be able to select. Press (SET).

4) Select **OK** to save the settings or **Cancel** to return to the main **ISO speed settings** menu without saving.

Constraining the Auto ISO range

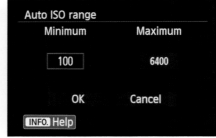

1) To set the range of values the EOS 70D can use in ISO Auto, select **Auto ISO range** on the **ISO speed settings** screen.

2) Set the minimum and maximum values the EOS 70D will use when ISO Auto is set using the same procedure as above.

3) Select **OK** to save the settings or **Cancel** to return to the main **ISO speed settings** menu without saving.

Setting the minimum shutter speed when using ISO Auto

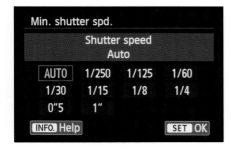

1) To set the lowest shutter speed that you want to maintain for as long as possible (ISO is adjusted to maintain this shutter speed), select **Min. shutter speed** on the **ISO speed settings** screen.

2) Turn ⊙ to highlight the required shutter speed and then press ⊛.

» IMAGE PLAYBACK

By default, your EOS 70D will automatically display the image you've just shot once you've released the shutter-release button. The length of time the image is initially displayed for can be changed using the **Image review** settings accessed via the ◘ menu.

To view other still images or movies after shooting, press ▶. The last still image or movie viewed will be displayed on the LCD (a movie can be distinguished by a **SET** 🎞 icon at the top left of the LCD). You can skip backward or forward through your still images and movies by pressing ◄ / ► or by swiping left or right with your finger across the LCD (you can also turn 🔄 to skip through images using the method set up on **Image jump** w/🔄 on the ▶ menu).

Pressing **INFO.** repeatedly toggles between four different ways of viewing still images and movies. The default is a simple display showing only the still image or the first frame of the movie. The second option shows the still image or movie with a restricted amount of shooting information; the third screen shows detailed information with a brightness histogram; and the final screen removes some of the shooting information to display both a brightness and RGB histogram.

› Playback Quick Control

If you press **Q** during playback, you can set the following functions: **O⊓** Protect images, **⊙** Rotate, ★ Rating, **◐** Creative filters, **⊡** Resize (Jpeg only), **⁰N** Highlight alert, **⁰⁰N** AF point display, **⚑** Jump method, or **(«ṇ»)** Wi-Fi. Options in gray are not available when viewing movies.

› Magnifying images

You can magnify still images in playback up to 10x. This is useful for checking critical focus of a particular area of an image.

Magnify images

1) Navigate to the image you want to view.

2) To zoom into an image, either press **⊕**, or place the tips of two fingers close together on the screen and gently pull them apart. Use **⋇** or move a finger around the LCD to scroll around the zoomed display. A white box within a small gray box appears at the bottom right corner of the LCD to show your position in the image.

3) To zoom back out, press **▦** / **⊖**, bring your two fingers together again, or tap **↰**.

Image index

Up to nine images can be shown on screen at any one time to help you quickly scan through the images on your memory card.

1) In single-image playback mode, press **⊖** or place the tips of two fingers spaced apart on the screen and then gently pull them together.

2) The selected image will be highlighted with an orange frame. Use **⋇** or tap on the relevant thumbnail on the LCD to select another image.

3) When the image you wish to view is highlighted, press **(SET)** to revert to single-image display.

» ERASING IMAGES

After an image has been shot it can be erased immediately by pressing 🗑 and selecting Erase. The same method of erasure can be used when reviewing pictures shot previously, unless the image is protected.

Selecting a range of images for deletion

1) Press **MENU** and navigate to ▶. **Select Erase images**.

2) Choose **Select and erase images**.

3) Press ◀ / ▶ to navigate through the images on the memory card.

4) When the image you want to erase is displayed, press (SET) to toggle the erase marker. ✔ will be displayed in a box at the top left corner of the LCD to show that the image has been marked for erasure. The number of images marked for erasure is shown to the right of the ✔ icon.

5) Repeat steps 3–4 to mark additional images for erasure if necessary.

6) Press 🗑 to erase all the marked images. Select **OK** to erase the selected images, or select **Cancel** to return to step 3.

Other deletion options
1) Press **MENU** and navigate to the ▶ tab. Select **Erase images**.

2) Select **All images in folder**. Press ▲ / ▼ to choose the folder you wish to erase images from and press (SET). Select **OK** to continue, or select **Cancel** to return to the select folder screen.

3) To erase all the images on the card, except those that are protected, select **All images on card** at step 1. Select **OK** to continue or **Cancel** to return to the main **Erase images** menu.

Accidentally deleting an image from your camera's memory card is easily done. Fortunately, you can "protect" images to avoid this happening. Once an image has been protected, the only way to erase it is either to remove its protection or to format the memory card (formatting removes both protected and unprotected images alike).

Selecting a range of images for protection

1) Press **MENU** and navigate to the ▶ menu. Select **Protect images** followed by **Select images**.

2) Press ◀ / ▶ to skip through the images on the card. When the image you want to protect is displayed, press ⑤ to toggle the protection marker ⊶. This marker will be displayed at the top of the LCD to show that the image has been protected.

3) Repeat step 2 to protect other images.

4) When you're done, press **MENU** to return to the main **Protect images** menu.

Other protection options

1) Select **Protect images** on the ▶ menu.

2) Select **All images in folder**. Press ▲ / ▼ to choose the folder you wish to protect and then press ⑤. Highlight **OK** and press ⑤ to continue, or highlight **Cancel** and press ⑤ to go back to the select folder screen. Press **MENU** to return to the main **Protect images** screen.

3) To protect all the images on the memory card, select **All images on card**. Highlight **OK** and press ⑤ to continue, or highlight **Cancel** and press ⑤ to return to the main **Protect images** menu.

4) To remove protection, follow steps 2–3, but select either **Unprotect all images in folder** or **Unprotect all images on card**.

» THE MODE DIAL

The mode dial on top of the EOS 70D has 10 settings, each represented by an icon. To choose a setting press down on the mode dial lock button and then turn the dial until the icon of the relevant setting is aligned with the white index mark (the mode dial turns freely in either direction).

Canon has grouped the settings into two categories: Basic Zone and Creative Zone. The Basic Zone options are the more automated shooting modes, which are designed to let you "point and shoot," albeit with more or less control depending on the mode. Special Scene **SCN** allows you to choose one of seven sub-modes designed for specific shooting situations, such as portraiture or landscapes.

As the name suggests, you have more control over the camera when using the Creative Zone modes. This does mean that using your EOS 70D requires more thought (it's possible to make more errors using a Creative Zone mode), but these options

make the photographic process more rewarding.

Creative Zone	
Program AE	**P**
Shutter priority	**Tv**
Aperture priority	**Av**
Manual	**M**
Bulb	**B**
Custom shooting	**C**
Basic Zone	
Scene Intelligent Auto	A⁺
Flash Off	⚡
Creative Auto	CA
Special Scene	**SCN**

> **Notes:**
> **Tv** stands for "Time value," which is another way of describing shutter speed. Av stands for "Aperture value."
>
> The position of the mode dial affects the available options when shooting both still images and movies.

2 › Scene Intelligent Auto \boxed{A}^+

\boxed{A}^+ is the EOS 70D's "point-and-shoot" mode. Virtually all shooting functions are set and cannot be altered. The only function you can alter is drive mode. This leaves you free to compose images without worrying about technical details. The downside is that most of the creative decisions are taken out of your hands. However, if you just want to shoot and have a better than average chance of success, \boxed{A}^+ is ideal. If you use \boxed{A}^+ in Live View, the EOS 70D will analyze the scene and

Subject	People		Non-people or landscape subjects		
Background	Normal	Moving	Normal	Moving	Close-up
Bright					
Bright & backlit					
Image includes blue sky					
Blue sky & backlit					
Sunsets	—			—	
Spotlights					
Dark					
Dark with tripod		—		—	

display an icon on screen. See the grid below for a description of the range of scenes.

[Q] **options:** Drive mode

› Flash Off

This shooting mode is essentially the same as $[\mathbf{A}]^+$, but with one important difference: neither the built-in flash, nor an external flash (if fitted) will fire. You'd typically use this mode for scenes in which flash would not be creatively appropriate, such as candid street photography or when you want to retain the atmosphere of an image, particularly one shot under artificial lighting at dusk or at night.

Flash Off mode increases the ISO automatically to try to maintain a shutter speed fast enough to avoid camera shake. You can help by switching on the Image Stabilization in your lens (if available). Using a wide-angle lens will also reduce the risk of camera shake compared to a telephoto lens. If the shutter speed is low enough that

camera shake is a possibility, the shutter speed display in the viewfinder will flash.

[Q] **options:** Drive mode

› Creative Auto

Creative Auto is similar to $[\mathbf{A}]^+$, but you gain control over four shooting options, altered by pressing the [Q] button. The first is **Ambience-based shots**. There is a range of presets, and these can be refined in intensity.

The second control allows you to change the depth of field via **Background blur**. When set to ▨, depth of field will be minimized and the background area will be softer, while ▨ maximizes depth of field, making the image sharper overall.

Drive mode can also be changed, using the range of options described previously, and there is more control over the flash: **Auto Flash**, **Flash on**, and **Flash off** are available.

[Q] **options**: Ambience-based shots, Background blur, Drive mode, Flash

2

Ambience-based shots options

Setting	Options	Comments
STD Standard	None	The standard image setting for the chosen shooting mode.
V Vivid	Low; Standard; Strong	Increases the saturation of the colors in an image. Note that the effect can appear cartoon-like if shooting a scene that is already highly saturated.
S Soft	Low; Standard; Strong	Reduces contrast to produce a softer effect.
W Warm	Low; Standard; Strong	Adds red to an image to increase warmth.
I Intense	Low; Standard; Strong	Contrast is increased to add drama to an image.
C Cool	Low; Standard; Strong	Adds blue to an image to cool it down.
B Brighter	Low; Medium; High	Brightens an image for a "high-key" effect. Lightens shadows, but can lead to burnt-out highlights in high-contrast lighting.
D Darker	Low; Medium; High	Darkens an image for a "low-key" effect. Darkens highlights, but can lead to dense, black shadows in high-contrast lighting.
M Monochrome	Blue; B/W; Sepia	Removes the color from your images, turning them to black and white (or with an optional Blue or Sepia tone).

Light/scene-based shots options

Setting	Result	Comment
[STD] Default	Image stays relatively true to the light source.	The default setting. Good for general-purpose photography.
☀ Daylight	Image colors are correctly balanced for shooting during the middle of the day under sunlight.	Images will appear too warm when shooting indoors under artificial lighting.
🏠 Shade	Image colors are rendered true when shooting in open shade.	Shade light is very blue. 🏠 adds red to the image to correct for this tendency.
☁ Cloudy	Image colors are rendered true when shooting under cloudy conditions.	As with shade, overcast light has a tendency to blueness, though not as dramatically.
💡 Tungsten	Corrects image color when shooting under household lighting.	Tungsten lighting is biased toward red. 💡 adds blue to compensate for this. This option is not available when shooting using 🏔.
🔆 Fluorescent	Corrects image color when shooting under white fluorescent lighting.	White fluorescent is warmer than daylight, but not as warm as tungsten lighting, so less blue is added to compensate. This option is not available when shooting using 🏔.
🌅 Sunset	Keeps the warmth of sunlight at sunrise and sunset.	Direct sunlight at either end of the day is very warm in color.

SCN is actually seven modes in one, with each sub-mode designed for a specific shooting situation. To switch between them, press **Q** and select the mode icon at the top left of the LCD.

Portrait 📷

Portrait
For portrait shots. Backgrounds are blurred,subjects stand out. Smoothes skin tone and hair.

As the name suggests, 📷 Portrait is designed to help you create pleasing shots of people's faces. To achieve this, the EOS 70D biases the aperture setting so that depth of field is minimized. This means that backgrounds will be relatively soft and less distracting: the longer the focal length of the lens, the greater the effect. Using a telephoto lens also has the happy result of creating a more natural perspective for your subject too (*see chapter 4*). However, when the depth of field is minimized, focusing needs to be accurate, so ensure that your subject's face is within the AF focusing area when using the viewfinder.

Q **options**: Ambience-based shots, Light/scene-based shots, Drive mode, Flash

Landscape 🏔

Landscape
For landscape shots. Wide DOF (foreground–background in focus), sharp images.

🏔 Landscape mode on the EOS 70D is designed to enhance your landscape shots by boosting the saturation of green/blue and increasing the sharpness.

Landscape is a big genre that embraces many different styles. The "classic" approach involves using a wide-angle lens to capture the scale of a landscape, but there's nothing wrong with experimenting with telephoto lenses to capture a more intimate landscape.

The true landscape photography aficionado will be out either early in the morning or later in the afternoon, as the warm, low light at these times of day helps to produce attractive landscape images. However, there are some subjects that benefit from the softer light found on

overcast days, such as woodland, for example, when the soft light reduces the contrast range, making it easier to record detail in both the shadows and the highlights.

Q options: Ambience-based shots, Light/scene-based shots, Drive mode

Close-up ✿

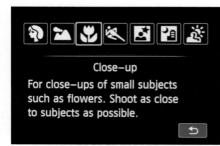

Using ✿ can be confusing if you're used to using a compact camera with a close-up mode that allows you to get within inches of your subject. When switched to ✿ Close-up, the EOS 70D is optimized to shoot close-up images (the aperture and shutter speed are set to minimize depth of field and reduce the risk of camera shake), but unless you have a macro lens attached to your camera you will not actually be able to shoot really close-up images (*see chapter 7*).

The 18–55mm kit lens commonly sold with the EOS 70D doesn't have a macro facility, but with a minimum focusing distance of 25cm it will allow you to capture reasonably close-up images.

Q options: Ambience-based shots, Light/scene-based shots, Drive mode, Flash

Sports ✦

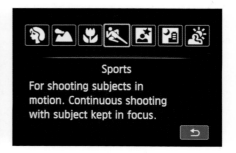

Sports mode gives priority to fast shutter speeds at the expense of aperture (minimizing depth of field). The ISO is also increased, up to a maximum of ISO 6400, making your action images potentially "noisy."

Capturing fast action successfully isn't just about shooting wildly and hoping that at least one frame works. The most successful sports photographers understand their subject and can anticipate when the action will occur—

they will be ready to shoot at that point. This discipline was often honed by shooting on film, when exposing multiple rolls of film would incur unnecessary expense. It's worth training yourself to think in a similar way. Although digital images are essentially "free," it takes time to work through hundreds of almost identical images. Time is precious, so wouldn't you rather be out shooting other events than staring at a computer screen?

Q options: Ambience-based shots, Light/scene-based shots, Drive mode

Night portrait

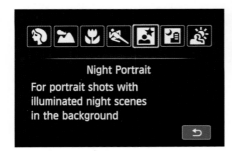

Night portrait is essentially Slow Sync flash shooting automated (*see chapter 5*). The flash will fire automatically to illuminate your subject, but the shutter will stay open to expose the background. Because the shutter speed will be longer at night, mounting your camera on a tripod (or other support) is highly recommended.

If the shutter speed drops below ¼ sec., ask your subject to keep as still as possible during the exposure. If they move, they will be recorded as a ghostly double image: a sharp image lit by flash, and a more blurred image lit by the ambient light.

Q options: Ambience-based shots, Drive mode

Handheld night scene

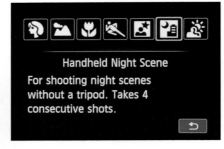

As mentioned, a tripod is usually a necessity at night. However, is a particularly cunning shooting mode that allows you to shoot reasonably successfully without a tripod. It's not perfect, but when used carefully it allows you to capture images that would otherwise have been impossible.

During shooting, the ISO is temporarily increased to reduce the shutter speed. The camera then shoots four images in rapid succession before merging them to reduce the appearance of noise.

A drawback to this mode is that you still need to keep as still as possible while you take the four shots to avoid any alignment issues. There is also a slight lag while the images are blended, so you can't shoot very quickly.

Q options: Ambience-based shots, Drive mode, Flash

HDR Backlight control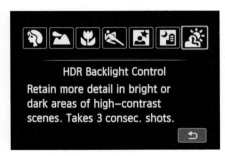

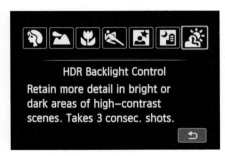

The dynamic range of a camera is its ability to record usable detail in both the shadows and the highlights, so the greater the dynamic range of a camera, the better able it is to cope with high-contrast scenes.

The greatest challenge to a camera is when shooting backlit scenes, because they are very high-contrast. Usually, the choice is to either expose for the background (so the subject is in silhouette), or to expose for the subject (so the background is overexposed). However, HDR (or High Dynamic Range) is a technique

that can be used to artificially increase the dynamic range of the camera to cope with situations such as this.

The technique involves shooting a number of frames at different exposure settings and then blending the results. Normally, this is achieved in postproduction using HDR software, but the EOS 70D can create HDR blends in-camera. As with Handheld night scene, several shots are taken (in this case three) with the exposure altered between them so there is one light, one dark, and one in between. The exposures are then processed to create a single blended image containing the best parts of each shot, which is saved to the memory card.

As with Handheld night scene, you need to keep as still as possible while taking the three shots to avoid misaligning any of them, and the processing slows shooting down.

Q options: Drive mode

The longer the lens, the harder it is to achieve front-to-back sharpness. To shoot this image, I focused on the front of the train, since this was the area I wanted sharpest. The fact that the depth of field wasn't sufficient to render the farthest part of the train sharp is acceptable in this instance.

Settings
> Aperture priority **Av** mode
> ISO 200
> 1/200 sec. at f/11
> Evaluative metering
> 100mm lens

» CREATIVE ZONE MODES

If you want to take full control of your EOS 70D, then you'll need to use one of the Creative Zone modes. It's important that you understand some of the basic concepts of photography, such as how the aperture and shutter speed will affect an image. Some of these concepts are described on the following pages, along with how to use the Creative Zone modes to take control of your photography.

SETTINGS AVAILABLE IN THE CREATIVE ZONE MODES

Focus settings
One-Shot AF; AI Servo AF; AI Focus AF; AF point selection; AF-assist beam; Manual Focus
Live View only:
ʊ+Tracking; FlexiZone - Multi; FlexiZone - Single; Quick mode

Image settings
Quality: JPEG (◢L ; ◣L ; ◣ ; ◢M ; ◣M ; ◢S1 ; ◣S1 ; S2 ; S3); Raw (RAW ; M RAW ; S RAW); Raw+JPEG
Other: Aspect ratio (in Live View); Lens aberration correction

Exposure settings
Metering: Evaluative; Center-weighted average; Partial; Spot
Settings: Program shift (**P** only); Exposure compensation (not **M** or **B**); AEB; AE Lock (not **B**); DOF preview

Tone settings
White balance (AWB; Preset; Custom; Correction/Bracketing); Auto Lighting Optimizer; Highlight tone priority; Color space (sRGB; Adobe RGB); Picture Style

Drive mode
Single; High speed continuous; Low speed continuous; Silent single; Silent continuous; Self-timer (2 or 10 seconds)

ISO settings
ISO Auto; ISO speed (manual selection ISO 100–12,800; expandable to H); ISO speed range; Auto ISO range; Min. shutter speed; High ISO speed NR; Long exposure NR

Flash settings
Built in flash: Manual firing; Flash off; Red-eye reduction; FE lock; Flash exposure compensation; Wireless control
External flash: Function settings; Custom function settings

Other settings
Multiple exposure; HDR; Mirror lockup; Dust delete data

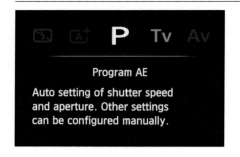

Program AE
**Auto setting of shutter speed
and aperture. Other settings
can be configured manually.**

At first glance, **P** is very similar to \boxed{A}^+, in that both are essentially "point-and-shoot" modes in which the camera sets the exposure automatically. However, **P** is far more useful than that. Unlike \boxed{A}^+, you can override the exposure decisions made by your EOS 70D by applying exposure compensation, changing the ISO, or

setting Program Shift. You are also free to use a full range of creative options, such as Picture Style. Think of Program AE as a halfway point between \boxed{A}^+ and the semi-automatic **Tv** and **Av** modes described on the following pages.

Although Program AE sets both the shutter speed and aperture, you don't have to settle for the chosen combination of values. You can shift the combination so that you have a wider aperture/faster shutter speed or a smaller aperture/longer shutter speed than the original settings selected by the camera. To set Program Shift, turn once you've pressed the shutter-release button down halfway to activate the camera's exposure meter.

Using P

Advantages	Shutter speed and aperture are set automatically. The EOS 70D will bias the shutter speed to avoid camera shake if possible. No loss of control over functions such as white balance.
Disadvantages	You have no control over the exposure settings initially chosen by the camera. Program Shift settings are lost after a few seconds of inactivity.

Using P mode

1) Turn the mode dial to **P**.

2) If you are shooting using the viewfinder, press lightly halfway down on the shutter-release button to focus. Once focus has been achieved, the active focus point(s) will flash red, the camera will beep, and the focus confirmation light ● will be displayed. If **30"** is displayed and is blinking in the viewfinder or on the LCD, this indicates underexposure. You will need to increase the ISO or add extra illumination to the scene (potentially by flash). If **8000** is displayed and is blinking in the viewfinder or on the LCD, this indicates

overexposure. You will need to decrease the ISO or reduce the amount of light reaching the sensor.

3) Turn to change the shutter speed and aperture combination if required, and then press lightly halfway down on the shutter-release button again. When focus has been achieved, press down fully on the shutter-release button to take your shot.

EVENTS »
P is ideal when shooting event photography: the exposure is set automatically so you can concentrate on reacting to the photographic opportunities as they happen.

P Tv Av M

Shutter priority AE

Adjust shutter speed to make moving subjects look still or capture motion blurring

Tv and **Av** (*see page 70*) are both semi-automatic exposure modes: you set one aspect of the exposure and the camera sets the other automatically. In the case of **Tv**, you decide on the shutter speed and the camera sets a suitable aperture.

If there is no movement in the scene, then the shutter speed you choose is relatively unimportant—it could be 1/4000 sec. or it could be 30 seconds, but visually there would be little difference. However, as soon as you want to record movement, the shutter speed is critical, as it will affect how that movement is recorded in the final image.

If you want to freeze movement, you'll need to use a fast shutter speed: the faster the movement, the faster the shutter speed will need to be. You also have to take into account the distance between you and your moving subject, since the closer the subject is to the camera, the faster the shutter speed will need to be. A subject moving across the image frame will also need a faster shutter speed than one moving toward or away from the camera.

Slowing the shutter speed down will make your moving subject appear more blurred and soft. This is not necessarily a bad thing, since a certain amount of softness will help to convey a sense of movement more effectively than pin-sharp detail. With a sufficiently long shutter speed a moving subject may even disappear entirely from the image—this can be an effective way to "remove" people from a scene. The slower the shutter speed, the more necessary a tripod or other support will become.

Using Tv	
Advantages	Control over shutter speed and how movement is recorded. Ambient light exposure control when using flash.
Disadvantages	No control over depth of field. Camera shake can be a problem if too low a shutter speed is used.

Using Tv mode

1) Turn the mode dial to **Tv**.

2) Turn to the right to set a faster shutter speed or to the left to set a slower shutter speed. As you change the shutter speed, the EOS 70D will change the aperture to maintain the same level of exposure overall. However, if the maximum aperture figure blinks in the viewfinder or in Live View, your image will be underexposed. You'll need to use a longer shutter speed (or increase the ISO). If the minimum aperture figure blinks, the image will be overexposed, and you'll need to use a faster shutter speed (or decrease the ISO).

3) If using the viewfinder to frame your shots, press halfway down on the shutter-release button to focus. Once focus has been achieved, the active focus point(s) will flash red, the camera will beep, and the focus confirmation light ● will be displayed. When focus has been achieved, press down fully on the shutter-release button to take the shot.

WATERFALL　　　　　　　　　　**»**
Flowing water will be recorded in different ways depending on the shutter speed you use. This image was shot using a shutter speed of 10 seconds. As a result, the water has been recorded as a smooth flow.

Note:
If you're using flash, you can't set a shutter speed faster than 1/250, unless you're using an external flash set to use high-speed sync (*see chapter 5*).

P Tv **Av** M B

Aperture priority AE

Adjust aperture to blur backgnd
(subjects stand out) or keep
foreground and backgnd in focus

Inside every EF and EF-S lens is an aperture that can be varied in size to allow more or less light into the camera. The aperture also controls the amount of acceptable sharpness in an image: as the aperture is made smaller a zone of sharpness extends either side of the focus point. This zone of sharpness is known as "depth of field." Depth of field always extends further back from the focus point than it does in front.

The extent of the achievable depth of field is influenced by three factors. The first is the available aperture range on a lens; the second is the focal length of the lens;

and the third factor is the camera-to-subject distance.

Depth of field increases as the aperture gets smaller, so the depth of field at f/4 is less than it is at f/16, for example. The depth of field is also greater at any given aperture when using a shorter focal length lens than a longer focal length, so using an 18mm focal length at f/8 will give a larger depth of field than a 55mm focal length at f/8. Finally, the shorter the camera-to-subject distance, the less achievable depth of field there'll be, even at minimum aperture. This is a particular problem when shooting macro images.

When you look through the viewfinder (or when viewing a Live View image), you see the scene at maximum aperture/minimum depth of field. However, if you press and hold in the EOS 70D's depth of field preview button, the aperture is temporarily closed to the selected shooting aperture. If you've selected a small aperture, the viewfinder will go dark, but you should be able to see a difference

Using Av	
Advantages	More control over depth of field.
	Setting the effective flash distance is easier than other modes.
Disadvantages	No control over shutter speed.
	Focus needs to be accurate when using large apertures.

in overall sharpness. In some respects Live View is a better option if this is your intention, since the brightness of the screen remains constant, making it easier to see the increase in depth of field.

Using Av mode

1) Turn the mode dial to **Av**.

2) Turn to the right to decrease the size of the aperture or to the left to increase it. As with Program mode, if the shutter speed shows 30" and this figure blinks in the viewfinder or in Live View, your image will be underexposed, so you will need to use a larger aperture (or increase the ISO). Conversely, if the shutter speed shows 8000 and this figure blinks, the image will be overexposed; use a smaller aperture or decrease the ISO.

3) If you're composing your shots using the viewfinder, press lightly halfway down on the shutter-release button to focus. Once focus has been achieved, the active focus point(s) will flash red, the camera will beep, and the focus confirmation light ● will be displayed. When focus has been achieved, press down fully on the shutter-release button to take the shot.

DEPTH ⹁

Landscape photography often involves using small apertures to get a big depth of field and achieve full front-to-back sharpness.

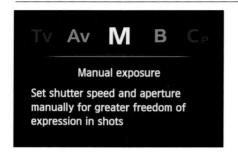

Tv Av **M** B C_P

Manual exposure

Set shutter speed and aperture manually for greater freedom of expression in shots

Manual **M** exposure mode puts you fully in control of how your images are exposed. You adjust both the shutter speed and the aperture, so if you get it wrong, you've no one to blame but yourself.

However, this is also one of the joys of **M**. Because you're in complete control you can deliberately ignore your camera's exposure meter and use an exposure that captures the image precisely as you visualize it. Choosing how an image is exposed is as much a part of the creativity of photography as composition—there is

no need to feel every shot has to be technically "correct" all the time.

Related to **M** is Bulb **B**. As with **M**, you set the required aperture, but the difference here is that the shutter will stay open for as long as the shutter-release button is held down. This could get tiring after a while so it's far easier to use a remote release with a locking mechanism to hold the shutter open. **B** mode is generally used when an exposure of over 30 seconds is required (when shooting in low light or if a dense, light-absorbing filter is fitted to the lens, for example). During the exposure, the elapsed time is displayed on the LCD.

Note:
Manual mode is best used with a definite ISO value rather than using Auto ISO.

Using M	
Advantages	Complete freedom to set the required exposure. Exposure will not change, which is useful when consistent exposure is required (such as when shooting a sequence for panoramic stitching).
Disadvantages	Exposure will not change. You'll need to be aware of this when moving between locations with different light levels. Filters that reduce light will not be compensated for automatically.

The drawback to extremely long exposures is battery depletion. Ironically, it's a good idea to switch off 📷/Long exp. noise reduction to conserve battery power, and then deal with any noise in postproduction.

Using M mode
1) Turn the mode dial to **M**. Set the required shutter speed by turning ⛭ and set the aperture by turning ◌. The correct exposure is set when the exposure level mark is centered in the exposure level indicator in the viewfinder or LCDs. When the exposure is more than 3 stops from the correct exposure ◄ will be shown at the left of the exposure level indicator (indicating underexposure), or ► will be shown at the right (indicating overexposure).

2) Press halfway down on the shutter-release button to focus. Once focus has been achieved, the active focus point(s) will flash red, the camera will beep and the focus confirmation light ● will be displayed (looking through the viewfinder using One-Shot AF) or focus lock will be confirmed by the focus box turning green and the camera beeping (when using Live View).

3) When focus has been achieved press down fully on the shutter-release button to take your shot.

Using B mode
1) Turn the mode dial to **B** and set the required aperture by turning ⛭.

2) Press lightly halfway down on the shutter-release button to focus. As with Manual mode, the active focus point(s) will flash red, the camera will beep, and the focus confirmation light ● will be displayed or the focus lock will be confirmed by the focus box turning green and the camera beeping.

3) When focus has been achieved, press down fully on the shutter-release button to take the shot. Hold the shutter-release button down until the required exposure is achieved. The accumulated length of the exposure—in seconds—will be shown on the top LCD during the exposure.

camera shake, I prioritized shutter speed over aperture. This meant that my focusing had to be precise, since depth of field was less than desirable (not helped by the use of a 300mm focal length). Even though I've focused on the bird closest to the camera, the rock face at bottom left is slightly (and acceptably) soft.

Settings
> Aperture Priority **Av** mode
> ISO 100
> 1/800 sec. at f/5.6
> Evaluative metering
> 70–300mm lens at 300mm

» MAKING MOVIES

Every Canon DSLR release since the EOS 5D MkII has been able to shoot movies, and the EOS 70D is no exception. As with some of Canon's recent Rebel/XXXD cameras, the EOS 70D can continuously auto focus during movie recording, and this can be further refined by the use of Canon's small, but growing, range of STM lenses.

› Memory cards

Creating a movie means capturing a continuous stream of digital data. Fortunately, the EOS 70D compresses this data, otherwise it couldn't be written to a memory card fast enough and the card would be filled quickly.

Movies are compressed by comparing individual frames within the movie. If there is little or no difference between two or more successive frames, the camera doesn't need to save the data for each frame over and over again—only the

changes, if any, need to be recorded, so the more static a shot, the more easily it can be compressed.

However, the opposite is also true: the greater the difference between frames, the more data needs to be captured, and the lower the compression rate. This means that a movie with lots of movement will take up far more room on a memory card than a static one. To cover all eventualities, Canon recommends the use of a Class 6 memory card (capable of recording 6 MB/s).

› H.264

Movies shot with the EOS 70D are recorded in the .MOV format using the H.264 video-encoding standard. This is used in a wide variety of applications from Blu-Ray players to YouTube. The .MOV format is also supported by movie-editing software such as Adobe Premiere Elements and Final Cut Express.

Warning!

Do not touch the microphones next to the hotshoe while you are recording, since this will create extraneous noise.

› Shooting a movie

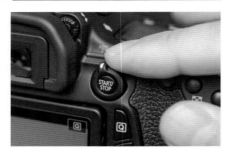

1) Turn the Live View/Movie shooting switch to 🎥. Your EOS 70D will switch automatically to Live View—movies cannot be composed by looking through the viewfinder.

2) Press the shutter-release button halfway to focus. Adjust the focal length of your lens too, if necessary.

3) Press START/STOP to begin recording a movie. A red ● mark will be displayed in the top right of the LCD to show that recording has started.

4) Press START/STOP once more to stop recording.

› The mode dial and movies

The amount of control you have over the exposure of your movies will depend on the position of the mode dial. When the

mode dial is set to one of the Basic Zone modes, the EOS 70D will detect the type of scene being shot and adjust the exposure settings accordingly including ISO.

In **P**, **Tv**, and **Av** modes, the exposure—including ISO—will be adjusted automatically as well, although you can lock and unlock exposure by pressing ✱ and then 🔲 respectively. Turning ○ allows you to apply exposure compensation.

Pressing the shutter-release button down halfway displays the current exposure settings, while pressing it down fully takes a still image using those settings (temporarily pausing movie recording).

When you set the mode dial to **M**, you have the greatest control over the exposure of your movies, as you can alter the ISO setting, aperture, and shutter speed. Note, however, that the lowest shutter speed available is 1/30 sec.

Notes:

When the mode dial is set to Ⓐ, scene icons will be displayed on the LCD. *See page 56.*

The longest movie clip size is 4GB. If a clip exceeds that length during recording, a new clip is started automatically.

Movies can't be shot if Wi-Fi is enabled.

» MOVIE PLAYBACK AND EDITING

You can view and make simple trimming edits to your movies on the EOS 70D. For greater control over the editing process (such as slicing up footage and rearranging the order of those slices), you would need to use movie-editing software on your computer. Editing software used to be expensive and hard to find, but there is now a much greater range of relatively inexpensive tools that are readily available and easy to use. Good examples of this type of software include Adobe Premiere Elements and iMovie.

Playing a movie

1) Press ▶. Navigate to the movie you wish to view—movie files are distinguished from still-images by the display of **SET** 🎬 at the top left corner of the LCD (**SET** 🎬 for Video Snapshot movies).

2) When you've found the movie you want to view, press (SET) to display the movie playback panel.

3) The play symbol, ▶, is highlighted by default when you first view the playback panel. Press (SET) to play the movie or tap ▶ on the LCD.

4) When the movie finishes, you will be returned to the first frame of the movie.

> **Notes:**
> When you are viewing an index display, movies will be denoted by a perforated left edge to the thumbnail.
>
> During movie playback, press (SET) to pause the movie and turn 🎛 to increase or decrease the volume.

Movie playback panel options

▶ Movie playback.
▶ Slow motion—press ◀/▶ to decrease/increase speed.
◀◀ Jump back to the first frame of the movie.
◀❙❙ Move back one frame every time (SET) is pressed; hold down (SET) to skip backward.
❙❙▶ Move forward one frame every time (SET) is pressed; hold down (SET) to skip forward.
▶▶❙ Jump forward to the last frame of the movie.
♫ Plays movie accompanied by music copied to the memory card using EOS Utility software.
✂ Edit movie.

> ## The EOS 70D Editing Suite

The EOS 70D has a built-in editing facility so your movies can be trimmed at either end if you feel that they're too long. It's not a precise way of trimming a movie, though, and you'll achieve better results using movie-editing software.

Editing movies

1) Follow step 1 in Playing a movie on the previous page.

2) Select ✂ on the playback control panel.

3) To cut the beginning of the movie, highlight ▨ and press (SET). To cut the end, highlight ▨ and press (SET). Press ◀/▶ to move the trimming point backward and forward a frame respectively. The light gray time bar at the top of the LCD shows you how much of the movie will be left once it has been edited. Press (SET) when you have set the edit point.

4) Highlight ▶ and press (SET) to view the edited movie.

5) If you're happy with the edited movie, highlight to save the movie to the memory card. Highlight **New File** if you want to create a new movie file with the edit applied, **Overwrite** if you want to save over the original movie, or **Cancel** to return to the editing screen. Press (SET) and follow the instructions on screen.

6) At any point in the editing process, pressing **MENU** or touching ⤺ on the LCD will take you back to the movie playback control panel. Highlight **OK** and press (SET) to exit without saving your changes, or **Cancel** to return to the editing screen.

› **Quick Control**

The movie Quick Control screen is controlled the same way as the Quick Control screen in Live View when shooting still images. Press Q to alter any or all of the following before recording your movie: AF method, Drive mode (still-images only),

Movie recording size, Digital zoom, White balance, Picture Style, Auto Lighting Optimizer, and Video snapshot.

› **Live View**

Movies are only shot using Live View (so you can't use the viewfinder for composing shots) and pressing **INFO.** toggles between screens with different levels of shooting information. The picture displayed before and during recording reflects the following functions that you or the camera have set automatically: Auto Lighting Optimizer, Picture Style, white balance, Peripheral illumination correction, exposure, and depth of field.

› **Shooting stills**

Pressing the shutter-release button during movie record will temporarily pause the recording to shoot a still image. The pause is approximately 1 second in duration.

Notes:
Movies are edited in 1-second increments, so your in-camera edit may be less precise than anticipated.

If there is not enough room on the memory card to save a new movie, **New File** will not be selectable.

› Exposure

The shutter speed you choose has an impact on the look of your movie. A movie is shot at a certain frame rate, and the EOS 70D lets you choose between 25/30, 50/60, and 24 frames per second, depending on how ♀/**Video System** is set. However, the shutter speed that you use doesn't necessarily have to match the frame rate of the movie. You could, for example, use a shutter speed of 1/200 sec. If the movie frame rate is 60fps, this means that one frame lasting just 1/200 second will be recorded every 1/60 of a second. However, using such a fast shutter speed will produce staccato movie footage that will be

BLUR ⌄
Slow shutter speeds to induce blur often produce more natural looking footage.

effective when shooting short action sequences, but uncomfortable to watch for longer periods of time.

Although it sounds counterintuitive, a slight amount of blurring between frames actually produces movie footage that is more comfortable to watch. The general rule when selecting a shutter speed is to use one that's twice the chosen frame rate, so a shutter speed of 1/50 sec. is ideal when shooting at 25fps, and 1/60 sec. is a good choice when shooting at 30fps. Shooting at the lowest possible shutter speed of 1/30 sec. can result in smeary footage, particularly if there is a lot of movement in the scene being filmed.

One of the benefits of using a camera like the EOS 70D to record video is the wide range of lenses available with large maximum apertures. This means being able to shoot in low light and to easily restrict the depth of field of the footage, isolating your subject from the background.

This is a technique often seen in commercial movies, but shooting in this way means that accurate focusing is a must. Professional moviemakers use tape measures to ensure accurate focus, and while there's no need to be quite so obsessive, it's still important to be as careful as possible when setting up a shot.

Tips

Use an ND filter to lower the shutter speed in bright conditions.

Movie footage is saved using the currently selected Picture Style. Use a low-contrast, neutral Picture Style if you intend to process the colors in postproduction—it's easier to add contrast and saturation than it is to remove them.

Using a kinetic shooting style in which the image moves randomly around is a good way to induce nausea in your movie's audience. If you want the camera to move, do it slowly and smoothly, and if you do move the camera rapidly, try to limit the length of time this footage is used for. Fast zooming can also be very off-putting to a viewer, so if you want to zoom, do it slowly and don't zoom over an extreme focal length range.

Tripods are almost a necessity when shooting movies, since random jiggles from a handheld camera are extremely distracting. Although cameras are often handheld when professionals shoot movies, they are generally stabilized using mechanical rigs produced by companies such as Steadicam. Because of the growing popularity of shooting movies with DSLRs, it's now possible to buy relatively inexpensive miniature Steadicam rigs.

If you use a tripod, you'll find that tripod heads designed for photography aren't necessarily that effective for video. A dedicated video head will allow you to make smoother movements as you pan your camera.

FOCUS «
Accurate focusing is a must when shooting close-up. Using a tripod will help prevent the focus from drifting due to movement of the camera.

› Story

Composition is just as important when shooting movies as it is with still images, so your choice of lens is important. Wide-angle lenses are good for establishing shots, enabling you to show context for your movie, but longer focal lengths are better for close-ups. This is particularly true when filming people, as a longer lens will help you capture their facial expressions more easily. However, the problem with longer lenses is depth of field—if you've got a particularly excitable subject they may move in and out of focus while you're recording. If that happens, either use a smaller aperture or try to persuade your subject not to move around as much.

STORY ⌄

Knowing what story you want to tell and how to tell it should be worked out before you begin to shoot your movie.

A good movie should have a structure that holds a viewer's interest: a linear structure where the narrative has a definite beginning, progresses to the middle, and then reaches a conclusion is the easiest structure to work with. However, whatever structure you decide to use, it's vitally important to work it out before you begin shooting. Professional moviemakers use storyboards as an aid to establishing structure and it's a method of working that is well worth copying. You don't even need to be able to draw—stick figures and lollipop trees will serve. As you're telling a story, you will need to establish a premise and a resolution. The real skill of movie making is making the journey between these two points interesting for the viewer.

3 MENUS

If you want complete control over your EOS 70D, you'll need to delve into the menu system. Despite the system's apparent complexity, it is logically laid out, so it's easy to find the required functions quickly.

The various menus let you set a large number of the shooting, movie, and playback functions of your camera. The menus are divided into color-coded sections, each with its own symbol: Shooting ⭘ (including Live View Shooting ⬛ and Movie 🎦), Playback ▶, Set-up ♈, Custom Functions 🔧, and My Menu ★. Each section is then subdivided into a number of separate menu screens—the number of small squares at the right of the section icon shows you which particular subsection you are viewing.

The number of menu screens available is dependent on the mode you are using, Fewer menu screens are shown when the mode dial is set to a Basic Zone mode—it's only when you select a Creative Zone mode that you have full access to the various options.

One of the keys to using a camera well is understanding what it is doing as you use it. It's therefore a good idea to work your way through the menu options, making sure you understand what they do and that they're set correctly for your needs.

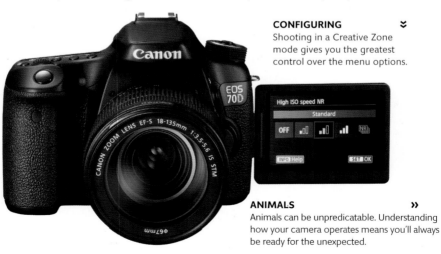

CONFIGURING ⌄
Shooting in a Creative Zone mode gives you the greatest control over the menu options.

ANIMALS »
Animals can be unpredicatable. Understanding how your camera operates means you'll always be ready for the unexpected.

Changing the menu options

1) Press **MENU**.

2) Press ◀ / ▶ or turn ᠊᠋᠊ to move left or right between the different menu sections and their various subsections. As you jump between the various menu screens, the relevant icon on a tab at the top of the LCD will be highlighted.

3) When you reach the required menu screen, press ▲ / ▼ to move up or down the options listed. Press (SET) when the function you want to change is highlighted.

4) Highlight one of the options for your chosen function by pressing either ▲ / ▼ for simple menu options or ⊹⊱ when there is a series of options arrayed around the screen. Press (SET) once more to make your choice. If you press **MENU** before making your choice, you will jump back up a level

to the previous menu screen without altering the option.

5) Press **MENU** or lightly down on the shutter-release button to return directly to shooting mode.

> *Notes:*
> Some options will require you to confirm your choice before proceeding. This is done by either selecting **OK** to continue or **CANCEL** to reject the choice. Highlight the required option and press (SET).
>
> You can also use the touch screen to select options from steps 2 to 5.
>
> Menu settings shown in gray in the following menu summary are not available in the Basic Zone modes.

» MENU SUMMARY

SHOOTING 1 📷 (Red)	OPTIONS
Image quality	JPEG: ◢L Large Fine; ◢L Large Normal; ◢M Medium Fine; ◢M Medium Normal; ◢S1 Small 1 Fine; ◢S1 Small 1 Normal; S2 Small 2; S3 Small 3; Raw: RAW ¹; 🔲 ¹; S RAW ¹
VF grid display ²	Enable; Disable
Viewfinder level ²	Hide; Show
Beep	Enable; Touch to 🔇; Disable
Release shutter without card	Enable; Disable
Image review	Off; 2 sec.; 4 sec.; 8 sec.; Hold

SHOOTING 2 📷 (RED)	OPTIONS
Lens aberration correction	Peripheral illumination and Chromatic aberration (Enable [with compatible lenses]; Disable)
Flash control	Flash firing (Enable; Disable); E-TTL II metering (Evaluative; Average); Flash sync. speed in Av mode (Auto; 1/200–1/60sec. auto; 1/200 sec. fixed); Built-in flash settings; External Flash C.Fn settings; Clear settings
Red-eye reduction	Enable; Disable
Mirror lockup	Enable; Disable

¹ Not available in 🖼 or 🎆 modes
² Not available during movie shooting

3

SHOOTING 3 📷 (RED)	OPTIONS
Expo. comp. / AEB	Exposure compensation (±5 stops in ⅓-stop increments); AEB (±3 stops)
ISO speed settings	ISO speed; ISO speed range; Auto ISO range; Minimum shutter speed
Auto Lighting Optimizer	Disable; Low; Standard; High
White balance	Set white balance preset
Custom white balance	Manual setting of white balance
WB Shift / BKT	White balance correction; White balance bracketing
Color space	sRGB; Adobe RGB

SHOOTING 4 📷 (RED)	OPTIONS
Picture Style	[A] Auto; [S] Standard; [P] Portrait; [L] Landscape; [N] Neutral; [F] Faithful; [M] Monochrome; User Def. 1; User Def. 2; User Def. 3
Long exposure noise reduction	Enable; Auto; Disable
High ISO speed noise reduction	High; Standard; Low; Disable; Multi shot noise reduction
Highlight tone priority	Enable; Disable
Dust Delete Data	Image capture for automatic dust removal in Digital Photo Professional
Multiple exposure	Multiple exposure (Enable; Disable); Multi-expose ctrl (Additive; Average); No. of exposures (2–9); Continue Mult-exp (1 shot only; Continuously)

HDR Mode	Adjust dyn range (Disable HDR; Auto; ±1EV; ±2EV; ±3EV); Continuous HDR (1 shot only; Every shot); Auto Image Align (Enable; Disable)
LIVE VIEW 1 📷 (RED)	**OPTIONS**
Live View shooting	Enable; Disable
AF method Quick mode	☷+Tracking; FlexiZone-Multi; FlexiZone-Single;
Continuous AF	Enable; Disable
Touch Shutter	Enable; Disable
Grid display	Off; 3x3 ╫; 6x4 ╫╫; 3x3+diag ╳
Aspect ratio	3:2; 4:3; 16:9; 1:1
Exposure simulation	Enable; During 🌣; Disable
LIVE VIEW 2 📷 (RED)	**OPTIONS**
Silent LV shooting	Mode 1; Mode 2; Disable
Metering timer	4 sec.; 16 sec.; 30 sec.; 1 min.; 10 min.; 30 min.
PLAYBACK 1 ▶ (BLUE)	**OPTIONS**
Protect images	Select images; All images in folder; Unprotect all images in folder; All images on card; Unprotect all images on card
Rotate	Rotate images by 90–270° clockwise
Erase images	Select and erase images; All images in folder; All images on card

Print order	Selection of images for printing
Photobook Set-up	Select images; All images in folder; Clear all images in folder; All images on card; Clear all on card
Creative Filters	Grainy B/W; Soft focus; Fish-eye effect; Art bold effect; Water painting effect; Toy camera effect; Miniature effect
RAW image processing	Convert and process Raw files to Jpeg

PLAYBACK 2 ▶ (BLUE)	**OPTIONS**
Resize	Reduce the resolution of compatible images
Rating	Rate images (Off; 1–5 ★)
Slide show	Select images for automatic slide show
Image jump w/	Jump by 1; 10; 100 images; Display by Date; Folder; Movies; Stills; Rating

PLAYBACK 3 ▶ (BLUE)	**OPTIONS**
Highlight alert	Enable; Disable
AF point display	Enable; Disable
Playback grid	Off; 3x3 ┼┼; 6x4 ┼┼┼; 3x3+diag ✳
Histogram display	Brightness; RGB
Movie play count	Rec time; Time code
Ctrl over HDMI	Enable; Disable

SET UP 1 ☼ (YELLOW)	OPTIONS
Select folder	Create and select a folder
File number	Continuous; Auto reset; Manual reset
Auto rotate	On📷🖥; On🖥; Off
Format	Format memory card
Eye-Fi settings	Settings for Eye-Fi card use (only visible when an Eye-Fi card is used)

SET UP 2 ☼ (YELLOW)	OPTIONS
Auto power off	1 min.; 2 min.; 4 min.; 8 min.; 15 min.; 30 min.; Disable
LCD brightness	Seven levels of brightness
LCD off/on button[1]	Remains on; Shutter-release button
Date/Time/Zone	Sets date and time; Current time zone; Daylight saving time
Language	English; German; French; Dutch; Danish; Portuguese; Finnish; Italian; Ukrainian; Norwegian; Swedish; Spanish; Greek; Russian; Polish; Czech; Hungarian; Romanian; Turkish; Arabic; Thai; Simplified Chinese; Chinese (traditional); Korean; Japanese
GPS device settings	Settings available when GPS unit GP-E2 is fitted

[1] Not available during movie shooting

SET UP 3 ☼ (YELLOW)	OPTIONS
Video system	PAL; NTSC
Feature guide	Enable; Disable

Touch control	Enable; Disable
INFO. Button display options	Displays camera settings; electronic level; shooting functions
Wi-Fi	Enable; Disable
Wi-Fi function	Transfer images between cameras; Connect to smartphone; Remote control (EOS utility); Print from Wi-Fi printer; Upload to Web service; View images on DNLA devices

SET UP 4 ♥ (YELLOW)	OPTIONS
Sensor cleaning	Auto cleaning (Enable; Disable); Clean now; Clean manually
Battery info.	Register battery; Remaining capacity; Shutter count; Recharge performance; Battery registration; Battery history
Certification logo display	Displays the logos of the camera's certifications
Custom shooting mode	Register settings; Clear settings; Auto update set. (Disable; Enable)
Clear all camera settings	Resets camera to default settings
Copyright information	Display copyright info.; Enter author's name; Enter copyright details; Delete copyright information
Firmware ver.	Currently installed camera firmware version number; Install new camera firmware

CUSTOM FNS 📷 (ORANGE)	OPTIONS
I Exposure	
1 Exposure level increments	⅓-stop; ½-stop
2 ISO speed setting increments	⅓-stop; 1-stop
3 Bracketing auto cancel	On; Off
4 Bracketing sequence	0 - +; - 0 +; + 0 -
5 Number of bracketed shots	3; 2; 5; 7
6 Safety shift	Disable; Shutter speed/Aperture; ISO speed
II Autofocus	
1 Tracking sensitivity	Locked on; Responsive
2 Accel./decel. tracking	0; 2
3 AI Servo 1st image priority	Release; Focus
4 AI Servo 2nd image priority	Speed; Focus
5 AF-assist beam firing	Enable; Disable; Enable external flash only; IR AF assist beam only
6 Lens drive when AF impossible	Continue focus search; Stop focus search
7 Select AF area selec. Mode	Single-point AF (Manual selection; Manual select.; Zone AF; Auto selection; 19 pt AF
8 AF area selection method	⊞ AF area selection button; ⊞ Main dial

9 Orientation linked AF point	Same for both vertic./horiz.; Select different AF points
10 Manual AF pt. Select. pattern	Stops at area edges; Continuous
11 AF point display during focus	Selected (constant); All (constant); Selected (pre-AF, focused); Selected (focused); Disable display
12 VF display illumination	Auto; Enable; Disable
13 AF Microadjustment	Disable; All by same amount; Adjust by lens

III Operation/Others

1 Dial direction during **Tv/Av**	Normal; Reverse Direction
2 Multi function lock	🔧 ; ⭕ ; ✳
3 Warnings ❗ in viewfinder	When monochrome ⬛M set; When WB is corrected; When ISO expansion is used; When spot meter. is set
4 Custom Controls	Customize control button operation

MY MENU ⭐ (GREEN)	OPTIONS
My Menu settings	Choose your most commonly used menu options for easy accessibility

MOVIE 1 🎥 (RED)	OPTIONS
AF method	😊+Tracking; FlexiZone–Multi; FlexiZone–Single
Movie Servo AF	Enable; Disable
Silent LV shoot.	Mode 1; Mode 2; Disable
Metering timer	4 sec.; 16 sec.; 30 sec.; 1 min.; 10 min.; 30 min.

MOVIE 2 🎥 (RED)	OPTIONS
Grid display	Off; 3x3 ⊞; 6x4 ⊞⊞; 3x3+diag ※
Movie rec. size	1920x1080 25/30fps[1] ALL-I; 1920x1080 25/30fps1 IPB; 1920x1080 24fps ALL-I; 1920x1080 24fps IPB; 1280x720 50/60fps1 ALL-I; 1280x720 50/60fps1 IPB; 640x480 25/30fps1 IPB
Digital zoom	Disable; Approx. 3–10x zoom
Sound recording[2]	Sound recording (Auto; Manual; Disable); Recording level; Wind filter/Attenuator (Enable; Disable)
Time code	Count up (Rec run; Free run); Start time setting (Manual input setting; Reset; Set to camera time); Move rec count (Rec time; Time code); Movie play count (Rec time; Time code)
Video snapshot	Video snapshot (Enable; Disable); Album settings (Create new album; Add to existing album)

[1] Frame rate depends of whether Video system is set to PAL or NTSC
[2] Can only be set to On or Off in Basic Zone modes.

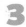

› Image quality

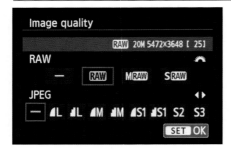

You have two basic choices when it comes to saving your images: you can save them as Raw files or JPEG files. Both image formats have strengths and weaknesses, so which you choose will depend on your style of shooting and attitude to postproduction.

JPEG is the option to choose if you want to minimize the amount of time spent in postproduction. When your EOS 70D saves a JPEG to the memory card, it applies various image settings (such as white balance and Picture Style) to the image. These settings are "baked" into the image, making them difficult to undo later (this is particularly true if you shoot using a setting such as the Monochrome Picture Style). However, this does mean that your JPEG images are ready for immediate use as soon as they've been saved.

JPEG files can be used by different types of software, such as image editors to word processors. JPEGs are also one of the standard file formats used on web pages and by social media sites such as Flickr and Facebook. Another advantage of JPEG is that images use less space on a memory card than an equivalent Raw file. The downside is that JPEGs are compressed using a system that simplifies fine detail. Although this sounds undesirable, in practice it's often hard to spot where the loss has occurred unless you look closely at an image at 100%, sometimes even 200%, magnification.

A Raw file is a "packet" that contains all the image information captured by the sensor at the moment of exposure. Although the Raw file initially uses the current image settings, these aren't fixed, so the settings can be changed in postproduction without any loss of quality. This makes Raw ideal if you want to experiment with the look of your images.

Raw files require suitable conversion software and your EOS 70D is supplied with Digital Photo Professional, which is a very comprehensive and useful tool. However, other options include processing the Raw file in-camera or using third-party products such as Adobe Lightroom or Phase One's Capture One. Once you've processed your

Raw file, you would then export the image to a more useful file format such as JPEG (the only option in-camera) or TIFF.

The EOS 70D can be set to shoot Raw, JPEG, and Raw+JPEG simultaneously. JPEGs can be shot at two different quality settings: Fine and Normal, with Fine giving better quality, but larger file sizes. You can also choose to shoot using one of five different pixel resolutions: Large, Medium, Small 1, Small 2, and Small 3. Raw can also be shot at different resolutions: **RAW**, **M RAW** and **S RAW**. The lower the pixel resolution

you use, the more limited your printing options will be later on.

If you have a sufficiently large memory card, then shooting Raw+JPEG **◢L** will give you the best of both worlds—a JPEG ready for immediate use straight out of the camera, and a Raw file that can be processed later.

Note:
Image quality can also be set via the Quick Control screen when the mode dial is set to a Creative Zone mode.

Quality		Resolution (pixels)	Number of shots [1]	Printable size: cm [2]	Printable size: in [3]
JPEG	◢L	5472 x 3648	2000	55 x 37	22 x 14.5
	◢L		3940		
	◢M	3648 x 2432	3680	37 x 24.5	14.5 x 9.7
	◢M		6820		
	◢S1	2736 x 1824	5580	27.6 x 18.4	11 x 7.2
	◢S1		10400		
	S2	1920 x 1280	9980	19.3 x 13	7.7 x 5.1
	S3	720 x 480	38760	7.2 x 4.8	2.9 x 1.9
Raw	RAW	5472 x 3648	520	55 x 37	22 x 14.5
	M RAW	4104 x 2736	740	41.4 x 27.6	16.4 x 11
	S RAW	2736 x 1824	940	27.6 x 18.4	11 x 7.2

[1] With a 16GB memory card installed. [2] Approximate size when printed at 99 pixels per cm.
[3] Approximate size when printed at 250 pixels per inch.

› VF grid display

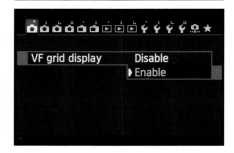

Sandwiched between the EOS 70D's mirror box and the viewfinder pentaprism is a transmissive LCD panel. This displays information such as the selected AF point. You can also choose to display a grid across the viewfinder by setting **VF grid display** to **Enable**. As with the selectable Live View grid, this is useful as an aid to aligning elements when composing shots. If you find the grid too distracting set **VF grid display** to **Disable**.

› Viewfinder level

Another benefit of the EOS 70D's customizable viewfinder is that you can choose to show a level in the viewfinder by setting **Viewfinder level** to **Show**. When you can see ‑◻‑ in the viewfinder, the camera is level left or right. If you see ‑◻ or ◻‑ , the camera is tilted 1° left or right respectively. If ◻ or ◻ is displayed, the camera is tilted 2° or more, left or right respectively. The viewfinder level is particularly useful when handholding your camera—when shooting on a tripod, the Live View level is more comprehensive, since it also shows whether your camera is tilting forward or backward.

› Beep

A good proportion of the options on the Shooting menus will be set according to personal preference. **Beep** is one of those options that will either be very useful to you or be one of the first options you turn off. When set to **Enable**, the EOS 70D will beep to confirm focus lock, beep

whenever you touch the LCD to change an option, and beep when the self-timer is activated; set to **Disable**, your photography will be blissfully silent. As a compromise, you can also set **Touch to** , which mutes the noise made when touching the LCD only.

› Release shutter without card

When **Release shutter without card** is set to **Enable**, you can fire the shutter when there is no memory card installed in your EOS 70D. The image shot will be displayed briefly on the LCD, but it will not be saved and so will be lost. When set to **Disable**, a warning will be displayed on the LCD if you attempt to shoot without a memory card in the camera, and the shutter will not fire.

You'd be forgiven for thinking that **Release shutter without card** is a slightly eccentric option—after all, what use is a photograph that isn't saved? However, you can connect your EOS 70D to a computer and use a technique known as "tethered shooting." When shooting tethered, the images are automatically transferred to the computer and can be saved to its hard drive. *See chapter 8* for more details.

› Image review

After you've taken a shot, it will be displayed on the LCD for a set period of time. The default is **2 sec.**, but this can be altered to **Off, 4 sec.**, or **8 sec.** When set to **Hold**, the image will remain on screen until you press any of the controls or until the camera automatically powers down. The LCD is one of the biggest drains on the battery of the EOS 70D, so use a setting that is as energy efficient as possible, but that is still useful to you.

› Lens aberration correction

Lens aberration correction
EF-S18-55mm f/3.5-5.6 IS STM

Correction data available

| Peripheral illumin. | ▶Enable |
| | Disable |

There's always an element of compromise in the design of a lens. Some lenses are better than others, of course, but even the very best lens won't be absolutely perfect. Fortunately, the particular flaws of a specific lens design can be quantified and either removed or reduced using **Lens aberration correction**. The flaws that can be tackled using this option are vignetting and chromatic aberration (*see chapter 4* for a description of other potential lens problems).

Lens aberration correction requires the profile for a particular lens to be installed on your EOS 70D, with profiles for 27 Canon lenses already programmed. You can add or delete a lens by using the EOS Utility software when your EOS 70D is connected to your computer via the USB cable. Unfortunately, only Canon lenses are supported and it's unlikely that third-party lenses, such as those from Tamron, Tokina, and Sigma will ever be added to EOS Utility.

Peripheral illumin.
Vignetting is the darkening of the corners of an image compared to the center. Most lenses will display a certain amount of vignetting at maximum aperture (and wide-angle lenses are more prone to the effects of vignetting than telephotos), but this is usually reduced as the aperture is stopped down.

If vignetting is a problem with a particular lens, set **Peripheral illumin.** to **Enable**. However, vignetting is not necessarily a bad thing. Some darkening of the corners will help to focus attention on the center of an image, which is ideal if this is where your subject is placed.

A downside to using **Peripheral illumin.** is the potential for an increase in noise in the corners of your images. For this reason, the amount of correction applied is reduced, the higher the ISO value you use.

> **Note:**
> These functions are only applied when you shoot JPEG. If you shoot Raw, defect reduction must wait until postproduction. Both Peripheral illumin. and Chromatic aberration correction can be applied to Raw files using DPP.

Lenses supported by default

EF-S 10–22mm f/3.5–4.5 USM

EF-S 15–85mm f/3.5–5.6 IS USM

EF 16–35mm f/2.8 L II USM

EF 17–40mm f/4 L USM

EF-S 17–55mm f/2.8 IS USM

EF-S 18–55mm f/3.5–5.6 IS STM

EF-S 18–135mm f/3.5–5.6 IS

EF-S 18–135mm f/3.5–5.6 IS STM

EF-S 18–200mm f/3.5–5.6 IS

EF 20mm f/2.8 USM

EF 24mm f/2.8 IS USM

EF 24–70mm f/2.8 L USM

EF 24–70mm f/4 L IS USM

EF 24–105mm f/4 L IS USM

EF 28–135 f/3.5–5.6 IS USM

EF 28mm f/1.8 USM

EF 28mm f/2.8 IS USM

EF 35mm f/2

EF 35mm f/2 IS USM

EF 40mm f/2.8 STM

EF 50mm f/1.4 USM

EF 50mm f/1.8 II

EF-S 55–250mm f/4–5.6 IS II

EF 70–200mm f/4 L IS USM

EF 70–200mm f/4 L USM

EF 70–300mm f/4–5.6 IS USM

EF 70–300mm f/4–5.6 L IS USM

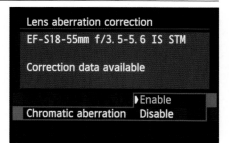

Chromatic aberration

Chromatic aberration (or achromatism) is caused when the optics in a lens aren't able to focus the various wavelengths of colored light to exactly the same point. This is seen as colored fringing along the boundaries of light and dark areas of an image.

There are two types of chromatic aberration: axial and transverse. Axial chromatic aberration is visible across the entirety of an image when a lens is used at maximum aperture. The more the lens aperture is stopped down (made smaller), the more the effects of axial chromatic aberration are reduced. Axial chromatic aberration usually disappears entirely when the aperture is set a few stops smaller than maximum.

Transverse chromatic aberration is seen only at the edges of an image and is not reduced by stopping the aperture down.

When set to Enable, Chromatic aberration corrects for the effects of transverse aberration. Axial chromatic aberration is harder to correct for, although some software, such as the latest versions of Adobe Lightroom, offer tools that can mitigate its effects.

› Red-eye reduction/Flash Control

See chapter 5 for more detail.

› Mirror lockup

There are many causes of camera shake, and rather ironically, one of these is the camera itself: vibrations from the reflex mirror as it is swung upward when an exposure is made can introduce slight shake. When **Mirror lockup** is set to **Enable/▽**, pressing the shutter-release button once will lock the mirror into the up position without making an exposure. It's only when the shutter-release button is pressed for a second time that the shot will be taken, and as the mirror is already raised there is less risk of camera shake. After the exposure has been made the mirror returns to the down position as normal.

The big drawback to using mirror lockup is that the view through the viewfinder will be blocked, so it is only really suitable when you're using a tripod and there's no chance that your composition will change accidentally. The most effective way to use mirror lockup is in conjunction with a remote release or by setting the drive mode to self-timer. Set mirror lockup to **Disable/OFF** to return to normal shooting.

› Expo. comp./AEB

Exposure compensation allows you to override the suggested exposure of an image, as well as shoot a bracketed sequence of images. *See page 45* for details.

ISO speed settings
These settings allow you to set the ISO speed, the ISO and Auto ISO range, and the minimum shutter speed for Auto ISO. *See page 48* for details.

› Auto Lighting Optimizer

Contrast can be a big problem when you are trying to capture a scene. Sometimes the highlights are too bright in an image; sometimes the shadows are too dark. If you shoot Raw, this can often be rectified in postproduction, but choose JPEG and your options are more limited.

Auto Lighting Optimizer is Canon's

solution to this problem. Switched to any mode other than 🖼OFF **Off**, Auto Lighting Optimizer will analyze your images as you shoot and, if necessary, the shadows will be lightened and the highlights reined in. This theoretically leads to a more balanced looking image. You can control the effect by choosing 🖼 **Low**, 🖼 **Standard**, or 🖼 **Strong** (with 🖼 applying the most correction to your images).

Auto Lighting Optimizer isn't perfect. Lightening the shadows can make them appear gritty through the introduction of noise (particularly when using 🖼 **Strong**) and if the scene you're shooting is relatively low in contrast, Auto Lighting Optimizer can make it appear flatter still. It can also undo slight changes to exposure you make with exposure compensation, so with Auto Lighting Optimizer activated you may find you need to dial in a higher exposure compensation value than you would normally. It's also not recommended if you want your subject to be in silhouette when backlit.

> ### Notes:
> Auto Lighting Optimizer cannot be used at the same time as Highlight tone priority.
>
> Press **INFO.** when setting Auto Lighting Optimizer to allow its use when shooting in **M** mode (when **Disable** is unchecked).

Most light sources have a color bias—usually either a red bias (resulting in the light being "warm") or blue (or "cool" light). Our eyes adjust so that we don't realize that the light is not neutral in color; it is only when the color bias is extreme (such as the warmth of candlelight) that we really notice the difference. This

variation in the color bias of light is known as a variation in the "color temperature," measured using the Kelvin Scale (K).

A camera will faithfully record the color bias of light if you don't intervene, producing images that may look too warm (when tungsten lighting is used) or too cool (the ambient light of open shade). White balance is the technique of adjusting for this color bias so that whites in an image appear perfectly white. Your EOS 70D lets you set the white balance for a particular light source either by using one of the presets built into the camera or by specifying a Kelvin value. For the greatest accuracy, you can also create a custom white balance for a particular light source.

White balance settings

AWB	White balance is set automatically
☀	Daylight/5200K: sunny conditions
⌂	Shade/7000K: shady conditions
☁	Cloudy/6000K: overcast light
☀	Tungsten/3200K: domestic lighting
☷	White fluorescent lighting/4000K
⚡	Flash/5500K
◩	Custom white balance
K	Specific Kelvin value

› Custom white balance

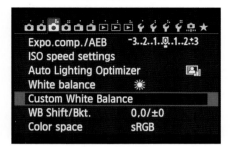

Using Auto WB is generally a good way to achieve reasonably accurate colors. However, there are certain shooting situations that can confuse Auto WB, such as when there is one predominant color in a scene. This can fool Auto WB into trying to compensate for that color. If you're shooting using a red background, for example, the preponderance of red can cause Auto WB to try to cool the image down too much. In this situation the best solution is to use an appropriate preset or, better still, create a custom WB. However, be aware that a custom WB is specific to one particular scene, so as soon as you shoot using different lighting, the custom WB will need to be updated.

To set a custom white balance, you must first take a photo of a neutral white surface that is lit by the same light as the scene that you're shooting. Ideally, the white surface should fill the viewfinder for greatest accuracy. Next, switch your lens to

MF (it doesn't matter whether the white surface is in focus or not) and adjust the exposure so that the white surface is almost (but not quite) clipping the right edge of the histogram (this generally means applying 1 to 2 stops of positive exposure compensation).

Setting the custom white balance
1) Select **Custom White Balance**.

2) The image you've just shot should be displayed (turn 🕶 if it isn't, or if you want to use a different image to create the custom WB). Press (SET).

3) Highlight **OK** and press (SET) again to create the custom WB or highlight **Cancel** to return to step 2.

4) Once you've created your custom white balance, select the 🔯 custom white balance preset.

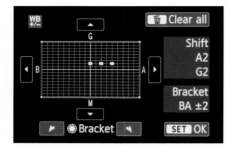

The various WB presets are a good starting point, but if you find that they aren't quite accurate for a particular scene (and you don't want to create a custom WB), you can modify them by selecting **WB Shift/ BKT**. This option allows you to add in more green (G), magenta (M), blue (B), or amber (A) to the WB preset. You can also bracket WB, so that three shots are taken using slightly different color settings.

Setting WB shift
1) Select **WB Shift/BKT**.

2) Use � to move the square WB adjustment point around the grid. Moving the point to the right increases the amber bias (making the image warmer), while moving it to the left adds more blue (making it cooler). Moving the point up and down adds more green and magenta respectively. These latter two adjustments are most useful when shooting under

fluorescent lighting, which often has an odd green/magenta color bias.

3) To set WB bracketing, turn ◌. Turning ◌ to the left sets the G/M bracketing. Turning to the right sets the B/A bracketing. If you choose to bracket the white balance, the next three shots that you take will use the preset WB, then the preset with a blue bias, and then with an amber bias, or the preset WB followed by a magenta bias and then a green bias. The cycle repeats until WB bracketing is canceled.

4) Press (SET) to set the WB adjustment and return to the main ◙ menu screen or press 🗑 to clear the WB adjustments and return to step 2.

> **Note:**
> The number of bracketed shots can be altered by adjusting Custom Fn. I 5.

› Color space

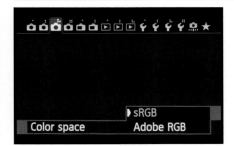

A color space is a mathematical model that allows colors to be represented using numbers. An RGB color space uses a mixture of red, green, and blue to define colors (a fully saturated red and blue combined would give you magenta, for example). All color spaces commonly in use today are a subset of an international standard known as the CIE standard. The CIE standard is a huge color space that encompasses all conceivable colors, including some that can't be perceived by human vision.

Adobe RGB and **sRGB** are far smaller color spaces that aren't quite so wide in scope. Your EOS 70D allows you to record your images using one of these two color spaces. The **sRGB** color space is approximately 35% of the size of the CIE standard, while Adobe RGB is approximately 50%, so **Adobe RGB** encompasses a larger and richer range of colors than **sRGB** (but still far less than the CIE standard).

You'd think that more is better and that Adobe RGB is the option to choose, and generally that's correct. However, there are devices, such as printers, that use even smaller color spaces. Internet browsers also prefer images to be **sRGB**, so if you plan to print or use your images online without adjustment, **sRGB** is a better option. Which you choose is particularly important if you use JPEG: Raw files can be tagged with a different color space when they are imported for postproduction, but a JPEG cannot.

> **Notes:**
> The first character of file names of images captured using Adobe RGB is an underscore: _.
>
> sRGB is used automatically when the mode dial is set to a Basic Zone mode.

› Picture Style

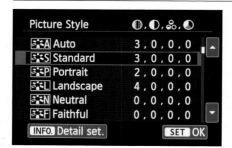

A photograph isn't an objective recording of reality: you make certain choices before shooting that determine the look of the final image (even if these choices can be altered later when shooting Raw). Picture Style allows you to refine how your images will look either by using one of a number of presets or by defining your own personal Picture Style.

If you've chosen to shoot using [A⁺], the [⚞⚟A] Picture Style is automatically selected. In other Basic Zone modes, the most relevant Picture Style is used and cannot be altered. It's only in the Creative Zone modes that you have full control over the Picture Style applied to your images.

Setting Picture Style
1) Select **Picture Style** on the 📷 menu.

2) Highlight the required Picture Style by pressing ▲ / ▼. Press (SET) to return to the main 📷 menu.

Presets	Description
[⚞⚟A] Automatic	Picture Style is automatically modified depending on the shooting situation.
[⚞⚟S] Standard	Suitable for general photography.
[⚞⚟P] Portrait	Sharpness is set lower than Standard.
[⚞⚟L] Landscape	Greens and blues are more saturated.
[⚞⚟N] Neutral	Natural colors with lower saturation.
[⚞⚟F] Faithful	Lower saturation still.
[⚞⚟M] Monochrome	Converts images to black and white.
[⚞⚟1] User Defined 1–3	-

⟨⁂S⟩ Standard

⟨⁂P⟩ Portrait

⟨⁂L⟩ Landscape

⟨⁂N⟩ Neutral

⟨⁂F⟩ Faithful

⟨⁂M⟩ Monochrome (Green filter)

Detail settings

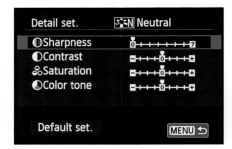

You don't have to be content with the default settings used to create a Picture Style. Each can be modified by the adjustment of one or more of four detail settings: ◖ **Sharpness**, ◖ **Contrast**, ♣ **Saturation**, and ◖ **Color tone** (Monochrome is the exception; see below).

To adjust these settings, highlight the Picture Style you wish to alter and then press **INFO.** Highlight the desired detail setting and press ⓢ. Press ◀ to decrease the effect of the setting or ▶ to increase it, then press ⓢ when you're happy with your adjustments. Adjust the other settings as required by repeating the procedure.

Press **MENU** to return to the main Picture Style screen when you're finished. To clear the settings, highlight **Default set.** at the bottom of the screen and press ⓢ.

Monochrome

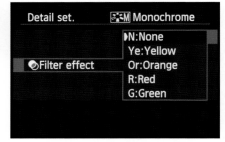

When you modify the **Monochrome** Picture Style, the ♣ **Saturation** and ◖ **Color** parameters are replaced by ◗ **Filter effect** and ⊘ **Toning effect**. Filter effect mimics the use of colored filters when shooting with black and white film, while Toning effect adds a color wash to your monochrome images. Choose between **N: None**, **S: Sepia**, **B: Blue**, **P: Purple**, and **G: Green**.

Presets	Description
◖ Sharpness	0 (no sharpening applied) to 7 (maximum sharpening)
◖ Contrast	- Low contrast / + High contrast
♣ Saturation	- Low color saturation / + High color saturation
◖ Color tone	- Skin tones more red / + Skin tones more yellow

Filter effect	Description
N: None	No filter effect applies
Ye: Yellow	Blues are darkened, greens and yellows lightened
Or: Orange	Blues darkened further, yellows and reds lightened
R: Red	Blues very dark, reds and oranges lightened
G: Green	Purples darkened, greens lightened

User Defined Picture Style

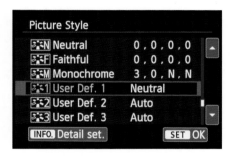

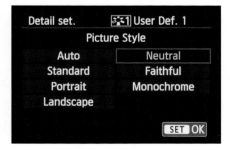

This option allows you to modify up to three of the Picture Style presets and save the changes as **User Def. 1**, **2**, and **3**. Highlight **User Def. 1, 2,** or **3** and press **INFO.** to create your custom **Picture Style**. Highlight Picture Style at the top of the LCD and press ⊛. Use ✤ to highlight the Picture Style you wish to modify and press ⊛ once more. Highlight and alter the four parameters below Picture Style as described previously. Press **MENU** to return to the main Picture Style menu once you're finished.

There are a few good reasons to define your own Picture Style. The first is that it allows you to personalize your images further. Using the original presets is all very well, but it's not particularly creative. It is also a good idea if you are shooting JPEGs and intend to modify your images in postproduction. It is generally easier to add contrast and saturation than it is to remove it, so a subdued Picture Style that is low in contrast and saturation is beneficial. This also applies more to sharpening, which is almost impossible to remove once it's been applied to an image. If you think you'll want to increase the resolution of an image later on (to make a large print, for example) set **Sharpness** to 0. This will mean that you'll have to sharpen your images later, but before then they'll be far easier to resize without a visible drop in quality.

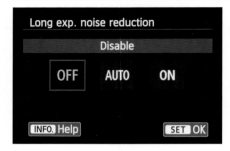

Sensors generate heat, and the longer they're active, the hotter they get. Heat corrupts the image data generated by the sensor, resulting in the appearance of noise in the final image. The longer the exposure you use, the greater the risk that your image will lose detail because of noise.

The solution is a technique called "dark frame subtraction," which relies on the fact that noise patterns in long exposures tend to be consistent over a set period of time. The idea is that you first make a long exposure, and then the camera creates a second exposure of exactly the same length, this time without opening the shutter.

This second exposure should theoretically be completely black, but in reality noise will actually lighten areas of the image slightly. The camera can use this tonal variation to work out where noise is occurring and then subtract it from the original exposure. The EOS 70D's **Long**

exp. noise reduction uses dark frame subtraction in just such a way.

Set **Long exp. noise reduction** to **AUTO** and your EOS 70D will perform noise reduction on exposures of 1 second or more, if it deems it necessary. Setting **Long exp. noise reduction** to **ON** means that the camera will always perform noise reduction when an exposure is 1 second or more.

You may have guessed the drawback to **Long exp. noise reduction** already: when it's activated, your long exposures will take twice as long because the camera is essentially making two exposures. This can make using long exposures a long, drawn-out affair, particularly as you cannot shoot more images until the camera is finished. **Long exp. noise reduction** also increases the risk that the batteries in your EOS 70D will deplete before the exposure is finished.

Set to **OFF**, no noise reduction will be performed when shooting long exposures. This means that your long exposures will be the expected length, although you may be forced to do extensive noise reduction later in postproduction.

› High ISO speed noise reduction

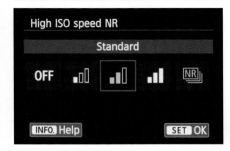

Noise in an image can also become a problem when higher ISO settings are used. **High ISO speed NR** lets you set whether your EOS 70D attempts to tackle high ISO noise.

The greatest amount of noise reduction is applied when this function is set to **High**. Unfortunately **High** doesn't just remove noise: it can also remove some of the fine detail in your images as well. **Standard** and **Low** are a better compromise between noise and loss of detail. Your EOS 70D will not perform any noise reduction at all when **Disable** is set, so if there is noise in your images you'll need to tackle it in postproduction.

Another option (when shooting JPEG only) is **Multi shot noise reduction**. When selected, your EOS 70D will take four shots in quick succession and then merge them to produce the final image. As high ISO noise is relatively random, **Multi shot noise reduction** is an effective way of minimizing noise, but it will slow your camera down and restrict the use of other functions such as flash. As the camera needs to shoot four identical images, it's also worth using a tripod so that there's no camera movement between shots.

› Highlight tone priority

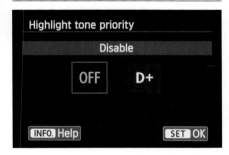

High contrast lighting is often problematic, and usually requires a compromise between retaining detail in the highlights and in the shadows. When **Highlight tone priority** is set to **Enable**, your EOS 70D attempts to rescue highlights so that they aren't overexposed. However, there's always a trade-off with features like this and in this instance it's the risk of increased noise in the shadow areas. If you're a wedding photographer, Highlight tone priority will prove invaluable, as the contrast range at weddings—from the bride's dress to the groom's suit—is often considerable.

Highlight tone priority restricts the ISO range to 200–12,800 (6400 for movies).

When set to **Enable**, **D+** will be displayed in the viewfinder and on the monitor. Auto Lighting Optimizer cannot be used at the same time as Highlight tone priority.

Highlight tone priority can be used when shooting JPEG or Raw, but is better suited to JPEG as there is less leeway for reclaiming highlight detail later on using JPEG. When shooting Raw, the effects of Highlight tone priority can be removed in postproduction, and you can also achieve the same effect by underexposing your images by 1 stop and adjusting the tone curve during postproduction.

› Dust Delete Data

Digital sensors and dust were made for each other. A sensor has an electrical charge that attracts dust, and once dust lands on the sensor (or to be more accurate, the low-pass filter in front of the sensor), it will potentially be visible in every subsequent image. Fortunately, Canon uses a very effective system that literally throws

dust off the sensor out of harm's way. Every time you turn your EOS 70D on or off, the low-pass filter is vibrated to remove dust—it's a proven system that works very well.

However, there are certain types of foreign matter that can be trickier to remove. If a particle is wet, it can bond to the sensor and stay there, no matter how many times the low-pass filter is vibrated. At this point, the sensor will need to be manually cleaned. There's more information about sensor cleaning later in this chapter.

Another way to deal with dust is to leave it on the sensor and fix the problem in postproduction. **Dust Delete Data** lets you shoot a reference image that's analyzed by your EOS 70D to create a map of the location of any dust on the sensor. This information is then appended to every subsequent image. The supplied Digital Photo Professional (DPP) software uses this data to remove dust automatically from your images. However, it's not foolproof and you may find important details in your images are removed at the same time.

Setting Dust Delete Data

1) Attach a lens with a focal length longer than 50mm to your EOS 70D. Set it to manual focus and set the focus at ∞.

2) Point your camera at a clean white surface, such as a sheet of paper, from a distance of approximately 12 inches (30cm). The white surface should fill the viewfinder entirely.

3) Press **MENU**, navigate to 📷, and select **Dust Delete Data**. Select **OK** to continue or **Cancel** to return to the 📷 menu.

4) The EOS 70D will perform a sensor cleaning sequence. When **Fully press the shutter-release button, when ready** is displayed, press the shutter-release button down. Once the Dust Delete Data image has been captured, it will be processed. When **OK** is displayed, press ⑤. If the data is not obtained correctly, follow the instructions on screen and try again.

5) Shoot as normal. Both JPEG and Raw files will now have Dust Delete Data added.

6) Switch on your computer, import any photos shot after obtaining Dust Delete Data, and then launch DPP. Select one of these photos in the main DPP window and click on the **Stamp** button. The photo will redraw itself and any dust will be removed using the Dust Delete Data. Once this

process is finished, click on **Apply Dust Delete Data**.

7) Click **OK** to return to the main DPP window.

> **Notes:**
> If you don't use a clean white surface, any blemishes on the surface may be mistaken for dust.
>
> **Dust Delete Data** will slowly become out of date as you use your camera. Reshoot periodically, particularly if you're working in a dusty environment.

DUST
Dust is seen as small dark disks and is particularly noticeable in areas of light, even tone such as sky.

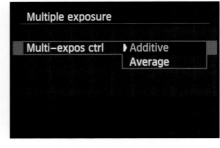

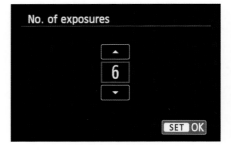

When **Multiple exposure** is set to **Enable**, you can blend between two and nine shots together to form an often-dreamlike composite image. **Multi-expos ctrl** controls the method used to blend the images, with two options available: **Additive** and **Average**.

 Additive adds the exposures together, so the more exposures you add to the merge, the brighter the final merged image will be. Typically, you should allow about 1 stop underexposure for two merged images and then another 0.5 stop underexposure for every multiple image shot after that.

 Average takes the hard work out of calculating the exposure, and applies exposure compensation automatically. The number of exposures that are merged is set by **No. of exposures**.

 As you shoot the sequence of exposures for merging, ▬ will flash on the top LCD. After each shot, you can press ▄ to remove

that image from the sequence, save and exit, or exit without saving.

 If you select **Continuously** on the **Multiple exposure** menu screen, you will continue to shoot multiple images until you switch off your EOS 70D. Select **1 shot only** if you just want to shoot one merged sequence before returning automatically to normal shooting.

› HDR

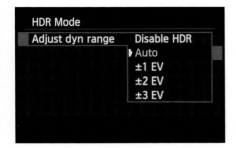

HDR is a technique that increases the dynamic range of a camera by shooting a number of frames at different exposures and then blending the results. Until relatively recently, this was a process that required a certain amount of work in postproduction, but many new cameras, including the EOS 70D, are able to shoot HDR in-camera. To achieve this, the EOS 70D shoots and blends three images together to create a final JPEG file (HDR isn't selectable unless you have Image Quality set to JPEG). Because a sequence of frames is shot, it's a good idea to shoot using a tripod—the EOS 70D can **Auto image align** (when set to **Enable**) if necessary, but this will require more time to process the final HDR image.

Begin shooting your HDR image by setting **Adjust dyn range** to **Auto** (the EOS 70D will determine the exposure range for you) or to **±1 EV**, **±2 EV**, or **±3 EV**. The greater the contrast range, the

higher the ± EV value should be. Set Adjust dyn range to **Disable HDR** to stop HDR shooting (you can also set the EOS 70D always to shoot HDR by setting **Continuous HDR** to **Every shot** or limit the shooting to **1 shot only**).

> **Note:**
> Postproduction HDR is known for a particular visual style. This style is not subtle and can be divisive. The EOS 70D's HDR mode has a more restrained aesthetic that is more grounded in "reality."

› Live View Shooting

› Continuous AF

In order to use the EOS 70D's Live View facility, you must have **Live View Shooting** set to **Enable** (for still-image shooting). When **Disable** is selected, you can't use Live View, and looking through the viewfinder will be the only way to compose an image. There's no real advantage to having Live View set to **Disable** other than that it will stop Live View being accidentally activated.

› AF method

Sets the AF method when using Live View. *See page 41* for details.

When **Continuous AF** is set to **Enable**, your EOS 70D will constantly adjust the focus when switched to Live View. This has the advantage that when you take a shot, the focus will either be correct or will only need a minor—and therefore quick—adjustment. This reduces any potential lag in focusing before the shutter can be fired to take the shot. The drawback is that constantly driving the AF motor in the lens will drain the camera's battery more quickly. If you're shooting still subjects, switch this function to **Disable** to conserve battery power.

> **Note:**
> If you use Quick mode AF, **Continuous AF** will automatically be set to **Disable**.

› Touch Shutter

› Grid display

You're not restricted to just using the shutter-release button to focus and take pictures—you can also do both by tapping the LCD in Live View. If you just want to set the focus by touching the LCD, set **Touch Shutter** to **Disable**. To take the shot, the shutter-release button must then be pressed down. However, if you also wish to fire the shutter by tapping the LCD, set **Touch Shutter** to **Enable**.

One problem with using the touch shutter is that it's possible to knock the camera in doing so, increasing the risk of camera shake. It's not a good idea to use touch shutter when the LCD is folded out fully, since this causes maximum instability. Don't jab at the LCD, either—a gentle press is sufficient.

Grid display overlays three types of grid on the LCD in Live View that can be used as a compositional aid or as a check that the scene is straight relative to the camera.

3x3 divides the screen into nine rectangles using two vertical lines and two horizontal lines. This can be used to compose according to the "Rule of Thirds," which suggests that an image is more pleasing if the subject is placed on a thirds line or at an intersection of two lines. It isn't actually a rule, more a guide—repeated use in your images will make them look formulaic.

6x4 divides the screen into 24 squares, useful when shooting architectural subjects that need to be square to camera.

3x3+diag INFO. uses the 3x3 grid plus two diagonal lines that run from the top to bottom corners. These lines are useful for composition, since diagonals in an image add energy. **Off** turns the grid function off.

› Aspect ratio

The aspect ratio of an image is the ratio of its width to its height. The EOS 70D offers the option of creating images with an aspect ratio of **3:2**, **4:3**, **16:9**, or **1:1** when shooting in Live View. JPEG files are cropped in-camera, but if you shoot Raw, cropping information is appended to the file instead. This is used by Canon's DPP software (during postproduction) to crop the image to your chosen aspect ratio automatically.

The default setting is **3:2**, which

matches the aspect ratio of 35mm film, and this uses the full resolution of the sensor (when shooting in any aspect ratio other than **3:2**, the resolution is reduced). Shooting at **3:2** and cropping in postproduction will achieve the same effect as employing any of the other aspect ratios.

The **16:9** aspect ratio is more "panoramic" and matches the standard aspect ratio used for HD video; **4:3** is the standard shape of an analog television; **1:1** is square—a strangely difficult shape to compose for, but common in medium format film photography. When an Aspect ratio other than **3:2** is selected, black borders are added to the Live View image to show how the image will be cropped after shooting.

Image Quality	Aspect ratio and resolution (pixels)			
	3:2	4:3	16:9	1:1
L/RAW	5472 x 3648	4864 x 3648	5472 x 3072	3648 x 3648
M	3648 x 2432	3248 x 2432	3648 x 2048	2432 x 2432
M RAW	4104 x 2736	3648 x 2736	4104 x 2310	2736 x 2736
S1 / S RAW	2736 x 1824	2432 x 1824	2736 x 1536	1824 x 1824
S2	1920 x 1280	1696 x 1280	1920 x 1080	1280 x 1280
S3	720 x 480	640 x 480	720 x 405	480 x 480

› Expo. simulation

CROPPED

When using 4:3 (top), 16:9 (middle), and 1:1 (bottom) aspect ratios, the shaded area of the image is cropped away compared to the standard 3:2 shape.

One truly wonderful thing about Live View is that it allows you to see a reasonable representation of your final image before exposure (although any effects on movement due to shutter speed won't be seen). When **Expo. simulation** is set to **Enable**, the brightness of the Live View display will reflect the exposure settings you use. If you deliberately underexpose, the display will darken; overexpose and it will lighten.

If you'd prefer the Live View display to remain at a constant brightness (so that exposure is not simulated), you can choose **Disable** or you can choose **During** so that you only see a simulation of the exposure when you hold the depth of field button down.

› Silent LV shoot.

› Metering timer

Silent shooting is beneficial when you're in a situation where you don't want to draw attention to yourself. Live View is quieter than standard shooting because the mirror is permanently raised, but it isn't totally silent since the EOS 70D relies on a mechanical shutter that has to be recocked every time it's fired. There are two types of silent shooting when using Live View:

Mode 1 allows you to shoot continuously at a quieter level than normal (slightly quieter than when **Disable** is selected).

Mode 2 does not recock the shutter until you release the shutter-release button. This means that you can't shoot continuously, but the minimum amount of noise is made when a shot is taken. It is then up to you whether you leave the scene—holding down the shutter-release button—to find somewhere that the shutter recocking noise won't disturb anyone.

This function sets the length of time that AE lock is held after it has been selected. The options are **4**, **16**, and **30 seconds**, and **1**, **10**, and **30 minutes**. Metering timer is set to 16 seconds when the mode dial is set to a Basic Zone mode.

» MOVIE SHOOTING 1 📹

› AF method

AF options for movie shooting based on Live View AF. *See page 41* for details.

› Movie Servo AF

Setting this option to **Enable** will allow continuous focusing during movie recording. However, unless you are using an external microphone or one of Canon's new STM lenses, it is very likely that you'll record the noise of the lens's AF motor on your movie soundtrack. Older, non-STM lenses can be particularly noisy when focusing.

The other drawback with using AF during movie recording with a non-STM lens is that focusing won't be particularly quick. It can take a second or more for focus to lock successfully. If you do need to refocus (and there's a reasonable distance from the first focus point to the second),

it's often better to pause recording, refocus, and possibly even recompose your shot. Then, in postproduction, edit the two clips together to make it a seamless sequence.

Set this option to **Disable** to stop Servo AF permanently during movie recording. You can also start and stop Servo AF during movie recording by pressing ⚡ or by tapping ꜱᴇʀᴠᴏ on the LCD.

› Silent LV shoot.

See opposite.

› Metering timer

See opposite.

Tip

Use the touchscreen to move the AF point to the precise point you want to focus on when recording a movie. This is particularly useful when using telephoto lenses with a large aperture and when depth of field is restricted.

FUNCTIONS » LIVE VIEW 2 / MOVIE SHOOTING 1

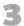
› Movie rec. size

The resolution of your movies, compression method, and the frame rate are all set using **Movie rec. size.** The various options are shown below. The frame rate of a movie will depend on whether **Video System** (on the 🔧 menu) is set to **PAL** or **NTSC**.

› Grid display

See page 119.

Resolution (pixels)	
`1920` (1920 x 1080)	Full HD recording with an aspect ratio of 16:9.
`1280` (1280 x 720)	HD recording with an aspect ratio of 16:9.
`640` (640 x 480)	Standard definition recording with an aspect ratio of 4:3. Suitable for analog TV and Internet use.
Frame rate	
`30`/`60`	For use in NTSC TV standard areas (North America/Japan).
`25`/`50`	For use in PAL TV standard areas (Europe/Australia).
`24`	For conversion to motion picture / film standard. Arguably, 24fps footage appears more natural, although there may be issues converting footage shot at 24fps to 25fps or 30fps for standard HDTV broadcasting.
Compression	
`IPB`	Compresses multiple frames at a time. This increases the efficiency of the compression, allowing more movie footage to be fitted onto a memory card.
`ALL-I`	Compresses each frame individually. Less footage can be fitted onto a memory card, but the footage is more suitable for editing in postproduction.

› Digital zoom

Digital zoom allows you to zoom into a scene between 3x and 10x as you record a movie, effectively extending the reach of any lens you fit to a camera. However, **Digital zoom** is achieved by cropping the movie and resizing the cropped area back to selected movie resolution. The resizing is achieved by "interpolation," which is a method of filling in gaps in data by inserting values that logically bridge that gap. The more you zoom digitally, the more the image data is interpolated, which means there will be fewer "true" pixels in the image and a noticeable drop in quality. The higher the ISO, the more ugly interpolation will look, so if you plan to use **Digital zoom** keep the ISO as low as is practical.

There are a few other drawbacks to **Digital zoom**. Servo AF is disabled, so you can't refocus during movie recording (unless you focus manually). If you want to use AF to establish focus, this must done before you begin recording by pressing halfway down

on the shutter-release button (focusing will also be slower than normal). The maximum ISO is also limited to ISO 6400 (largely because of the potential loss of quality caused by interpolation) and you won't be able to record still-images during recording.

However, if you're aware of the limitations of **Digital zoom** and can work round them, you'll find it a useful feature. It will help to get close-up footage that wouldn't be possible unless you were able to invest heavily in extremely long focal length lenses. Just don't expect miracles.

Using Digital zoom
1) Set **Digital zoom** to **Approx. 3–10x zoom**.

2) Press lightly down on the shutter-release button to return to movie shooting.

3) Press ▲ to zoom in. As you zoom in, a bar at the right side of the screen will rise toward [♦]. When it reaches [♦], you've set digital zoom to maximum (10x).

4) Press ▼ to zoom out. As you zoom out, the bar will drop toward [♦♦♦]. When it reaches [♦], you've set digital zoom to minimum (3x).

5) Set **Digital zoom** to **Disable** to return to standard movie shooting mode.

› Sound recording

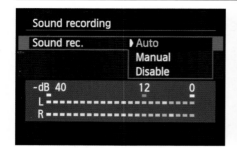

Sound recording gives you control over the recorded volume of your movie's soundtrack (either through the built-in microphone or via an external microphone when fitted). When **Sound rec.** is set to **Auto**, the soundtrack volume is adjusted automatically as it is recorded.

Manual allows you to set the volume level between 1 and 64. If you choose **Manual**, select **Rec. level** and use ◀ / ▶ or tap the arrows on the LCD to set the volume. You should aim to have your peak (or loudest) sound level reach the -12dB level. Any higher and the recorded sound may be distorted.

When **Sound rec.** is set to **Disable**, no sound will be recorded.

If you set **Wind filter** to **Enable**, your EOS 70D will try to eliminate wind noise from your movie's soundtrack during recording. This achieves the same effect digitally as a foam windshield on an

external microphone. However, it's not perfect and mustn't be used indoors or in calm conditions, in order to avoid degrading the quality of the recorded sound. If you're not shooting in wind, set this option to **Disable**.

Attenuator tries to reduce the effects of loud noises that may occur during movie recording. As with **Wind filter**, switch **Attenuator** to **Disable** if you're confident that there won't be problems with sound during recording.

> ## Time Code

A Time Code is a sequence of numbers generated by a timing system. When you're shooting movies on your EOS 70D, you can add a time code to the movie clip, which can then be used as reference when you're editing, logging, or organizing the clip or synchronizing sound. The time code generated by the EOS 70D is recorded as hours, minutes, seconds, and frames.

Time Code options

Count up	**Rec run** Time code counts up as you record a movie. **Free run** Time code counts up even when movie is not being recorded.
Start time setting	**Manual input setting** Enables you to set the hours, minutes, seconds, and frames. **Reset** Time set by **Manual input setting** and **Set to camera time** is reset to 00:00:00:00. **Set to camera time** Sets hours, minutes, and seconds to the EOS 70D's internal clock.
Movie rec count	**Rec time** Shows the elapsed time from the beginning of movie recording. **Time code** Shows the time code during movie recording.
Movie play count	**Rec time** Shows the recording and playback time from the beginning of playback. **Time code** Shows the time code during playback.

› Video snapshot

A video snapshot is a video clip that can be a **2 sec. movie**, **4 sec. movie**, or **8 sec. movie** (the choice of clip length being made when **Video snapshot** is set to **Enable** and **Create a new album** is selected on the **Album settings** menu).

Video snapshots are saved in albums. By shooting a number of snapshots and then viewing the resulting album, you effectively produce a movie that consists of a number of separate scenes—just like a real movie.

An album is distinguished from a standard movie by **SET ◻** in the top left corner of the LCD. You can alter the order or delete snapshots using the Edit panel outlined in chapter 2.

› Protect images

This mode allows you to set or remove protection on images to avoid accidental erasure. *See page 54* for details.

› Rotate

Sometimes, your camera might get confused about the orientation it was held in when you took a shot so you will need to rotate it. Once you've selected **Rotate**, press ◀ / ▶ to find the errant image. Press (SET) when the image is displayed and it will be rotated 90° clockwise; press (SET) a second time to rotate it a further 180°; press (SET) a third time to restore the image to its original orientation. To rotate additional images, press ◀ / ▶ and repeat the process.

› Erase images

Select and erase unprotected single images, or all images in a folder or on a memory card. *See page 53* for more information.

› Print order

Sets the print order for your images to control how they are printed when the camera is connected to a PictBridge printer or when the memory card is taken to a lab for printing. *See chapter 8* for information.

› Photobook

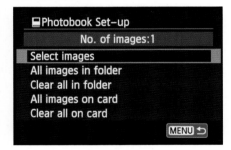

One of the big changes brought about by digital photography is the ability to create professional-looking photobooks using your own images. These can be ordered online from companies such as Blurb and Lulu in any quantity from a single copy to as many as you can afford to have printed.

Photobook allows you to select up to 998 images. If you use EOS Utility, you can then transfer the selection to your computer, where they'll be saved into a dedicated folder. The procedure for choosing images is similar to choosing images for protection. You can: **Select images; All images in folder; Clear all images in folder; All images on card; Clear all images on card**. The procedure for selecting and deselecting images is similar to selecting individual images for protection—*see page 54.*

The key to creating a satisfying photobook is in the images you choose and the impact of a book will be lessened by the inclusion of images that don't make the grade. You need to be ruthless when selecting: don't be tempted to add images purely for the purpose of filling space.

Tip

An effective method of assessing whether the composition of an image has worked is to view it upside down. If the image still looks good when it's the wrong way up, then the composition has worked. If it doesn't, the reason why not is often easier to establish.

There's much fun to be had playing around with images in postproduction, but why wait? Your EOS 70D can apply a variety of effects to your images in-camera: **Grainy B/W; Soft focus; Fish-eye effect; Art bold effect; Water painting effect; Toy camera effect; Miniature effect**.

The effects can be applied after shooting and the results saved as a new file, so that your original always remains safe. If you're shooting Raw, you can apply these effects, but the results will be saved as a JPEG (not a new Raw file).

Effect name	Results	Options
Grainy B/W	Creates a high contrast, grainy, black-and-white image.	Low; Standard; High
Soft focus	Adds a soft focus glow to an image for a more romantic feel.	Low; Standard; High
Fish-eye effect	Distorts the image so that it looks as if it were shot with a fish-eye lens.	Low; Standard; Strong
Art bold effect	Increases the saturation of colors in the image.	Light; Standard; High
Water painting effect	Alters the image so that it looks less like a photo and more like an artist's sketch.	Low; Standard; Deep
Toy camera effect	Adds a vignette around the image and alters the color palette.	Color tone: Cool tone; Standard; Warm tone
Miniature effect	Makes the image look like a miniature model by adjusting the apparent focus.	Move the bar up and down, or left and right to set the focus point

› RAW image processing

You've shot an image as Raw and then you discover that you need a JPEG version immediately. However, you don't have access to a computer to do the conversion. What to do? Fortunately, your EOS 70D has a built-in image processor to convert Raw files to JPEGs. The tool isn't as well specified as decent Raw conversion software, but it's useful if you really need a JPEG in a hurry.

Converting RAW files

1) Select **RAW image processing.**

2) Find the Raw file you wish to convert (JPEGs will not be displayed) and press (SET).

3) Use ✲ to highlight an adjustment tool, then turn ◌ to make the adjustment. To view a more detailed screen, press (SET) or tap the relevant icon. Use ✲ and ◌ to make adjustments, then press (SET) or tap ⤺ to return to the main image processing screen.

4) Highlight ◢L **Image quality** and press (SET) to adjust the quality of the JPEG image.

5) Select ◻ at the bottom of the LCD. Select **OK** to save the JPEG or **Cancel** to continue altering your image.

Symbol	Image adjustment
☀±0	Adjusts image brightness by ±1 stop in ⅓-stop increments
AWB	Alters white balance using presets or Kelvin value
⌨S	Sets Picture Style
⊞OFF	Applies Auto Lighting Optimizer
NR▪	High ISO speed noise reduction
◢L	JPEG image quality
sRGB	Sets color space
◻OFF	Applies peripheral illumination correction
⊞OFF	Corrects lens distortion
⁄⁄OFF	Chromatic aberration correction

› Resize

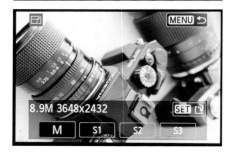

› Rating

Resize allows you to shrink your JPEG images, saving the smaller image as a new file. Unfortunately you cannot increase an image's size (though this can be done later in postproduction if necessary). The main restriction to **Resize** is that the smaller the original image, the fewer options you have to make it smaller still.

Rating enables you to tag your images with one to five stars (★) or no stars (**Off**—the default for every image you shoot). The rating information is embedded in the image's metadata and can be used to filter them when using **Image jump w/**, **Slide show**, or when viewing them in Canon Digital Picture Professional on your computer.

Using the **Rating** function is a good way of quickly sorting images and an obvious use is to rank your images

Original Size	Sizes available for resizing			
	M	**S1**	**S2**	**S3**
L	Yes	Yes	Yes	Yes
M	–	Yes	Yes	Yes
S1	–	–	Yes	Yes
S2	–	–	–	Yes
S3	–	–	–	–

depending on how successful you think
they are. However, **Rating** can also be used
more subtly. You could use it sort images
into categories: 1 ★ for portraits, 2 ★ for
landscapes, and so on.

Changing the rating
1) Select **Rating**.

2) Press ◀ / ▶ to skip through the images
on the memory card. To view three images
on screen at once, press ▦ / ◯⁻; to view
a single image on screen, press ◯⁺.

3) When you reach an image that you
want to rate, press ▲ / ▼ to decrease or
increase the rating, or tap the relevant
arrow at the bottom of the LCD.

4) When you're finished, press **MENU** to
return to the main ▶ menu screen.

› Slide show

Slide show turns your EOS 70D into a
digital "slide projector" that you can use to
display a slideshow of your images on the
LCD or, for more impact, on a TV (*see
chapter 8*).

Using Slide show
1) Highlight **Slide show** and press ⚙.

2) On the main **Slide show** screen, select
⊟ **All images**. Press ▲ / ▼ to change
this to ▦ **Date**, ▬ **Folder**, '▯ **Movies**,
◻ **Stills**, or ★ **Rating** as required.
When ▦ **Date**, ▬ **Folder**, or ★ **Rating**
are selected, you can view and alter further
options by pressing **INFO.**. There are no
options for ⊟ **All images**, '▯ **Movies**,
or ◻ **Stills**. The images that are displayed
during the slide show will be dependent

on the choices that you make at this stage. Press (SET) when you're finished.

3) Select **Set up** and highlight **Display time** to choose how long each image will remain on screen. Set **Repeat** to either **Enable** or **Disable** depending on whether you want your slideshow to repeat. **Transition effect** allows you to set how one image replaces another during the slide show. Finally, **Background** music lets you choose what music to play during the slide show. The music must be copied to the memory card of your EOS 70D using the EOS Utility software provided with the camera. Press **MENU** once you've set all the required options.

4) Select **Start** to start the slide show.

5) The slide show will pause and restart when you press (SET) or if you tap the LCD (and then press the play icon on the LCD to restart). Press **MENU** to stop the slide show and return to the main slide show screen.

> **Note:**
> The images in the slide show will be displayed according to how you have playback set up. Press **INFO.** to change the display mode during the slide show if necessary.

› Image jump w/🔄

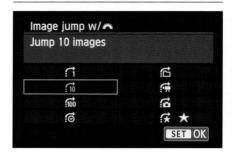

This option allows you to set how your EOS 70D skips through images when turning 🔄 in single-image playback. When you've set how you'd like the images to jump, press 🔄 to enter playback and then turn 🔄. How **Image jump w/🔄** is set becomes more important the greater the number of images saved on the memory card. The rating option is particularly useful, since it can be used to classify and group types of images together (such as landscape or portrait).

Symbol	Description
🔂1	Display one image at a time
🔂10	Jump 10 images at a time
🔂100	Jump 100 images at a time
🔂⊙	Display images by date
🔂	Display images by folder
🎬	Display movies only
📷	Display still images only
★	Display by rating

› Highlight alert

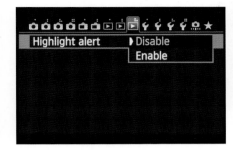

When **Highlight alert** is set to **Enable**, any areas of an image where the highlights have blown will blink. This is a useful—if crude—way of determining where an image is overexposed. The disadvantage to having Highlight alert active is that it can prove distracting, since part of the image will be obscured by the highlighting and you will not be able to see the full image as it was shot. **Disable** this option if this proves to be the case.

› AF point disp.

When you view an image in playback with **AF point disp.** set to **Enable**, the AF points that were used to achieve focus are shown overlaid on the image. As with Highlight alert, it can be a useful way of checking that all is right with your image—in this instance, that the AF point is where you

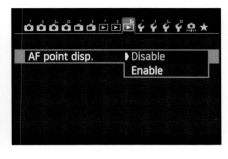

intended it to be. However, as with Highlight alert it may prove distracting, as part of the image will be obscured. In which case, switch this option to **Disable**.

› Playback grid

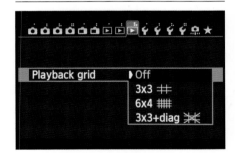

You can display the same grid patterns in playback over your images as you can when using Live View: **Off** (no grid), **3x3** ⊞, **6x4** ⊞, and **3x3+diag INFO.** As with the Live View grid, this is useful for checking your compositions, this time after shooting.

› Histogram display

The EOS 70D can display either a **Brightness** or **RGB** histogram when showing detailed shooting information in Playback mode—and then both together with the loss of some useful shooting information. Choose which histogram you'd prefer to see with detailed shooting information.

› Movie play count

This option shows either the recording time of a movie or the time code in movie playback (*see page 127* for more information on time codes).

› Ctrl over HDMI

When your EOS 70D is connected to a CEC HDMI-compatible television, setting **Ctrl over HDMI** to **Enable** allows you to use the TV's remote control to control certain aspects of the camera's Playback functions. If your television is not compatible, set this option to **Disable**.

» SET UP 1 ♈

› Select folder

When you shoot a still image or movie, it is stored in a folder on the memory card. When you format a memory card, a new default folder is automatically created. However, you can create new folders and use those instead.

There are a variety of reasons for doing this. You may want to create a new folder for a particular shooting session, for example, and this will keep those images separate from all the others on the memory card. When it comes to copying your images to a computer, you would only need to find and copy the photographs in that folder, rather than sorting through the entire memory card.

To create a new folder, choose **Select Folder**, followed by **Create Folder**. Select **OK** to confirm. Folders created on the EOS 70D use a three-number system starting with 100 and continuing up to 999. The numbers are followed by the word CANON. The new folder number will be one more than the highest folder number already on the memory card.

To select a folder, select **Select Folder** and then select the folder name that you want to use. Until you choose or create a new folder, the EOS 70D will save all subsequent images and movies shot into this folder.

› File numbering

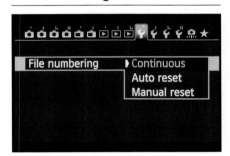

Every time a file is written to the memory card, it is assigned a file name. The last four characters before the file type suffix are numbers—a count of the number of images you've created starting from 0001.

If you select **Continuous**, the count continues up to 9999 and then reverts to 0001, even if you use multiple folders and memory cards.

Selecting **Auto reset** forces your EOS

70D to reset the count to 0001 every time an empty memory card is used.

Finally, if you select **Manual reset**, a new folder is created on the memory card and the count is reset to 0001.

> **Note:**
> The first four characters of still images are IMG_. Movie files use MVI_.
>
> If you create a folder on the memory card, when it is connected to your computer it must use the same naming convention. The five-letter word can only use alphanumeric characters (a–z, A–Z, or 0–9) or an underscore "_." No other characters (including "space") are allowed.

› Format

Allows you to format your SD memory card. *See page 30.*

› Eye-Fi settings

Used for Eye-Fi memory card control and only visible when an Eye-Fi card is installed. *See chapter 8* for more information.

› Auto rotate

This option allows you to choose whether vertical (portrait format) images are rotated or not. When rotated, they will appear in the correct orientation on the LCD of your EOS 70D, but the image will be relatively small and will not fill the LCD entirely. If the images aren't rotated, they will fill the LCD entirely, but you will need to turn your camera 90° to view the image in the correct orientation.

Selecting **On** rotates the images so that they remain vertical on the LCD and on your computer (once they've been copied there from your memory card); **On** does not rotate the images when viewing them on the camera, but does rotate them so that they are in the correct orientation when copied to your computer; **Off** does not rotate the images on either your camera or computer, so you will need to use image-editing software to rotate the images.

» SET UP 2

› Auto power off

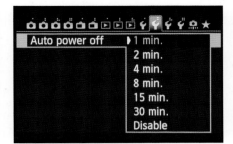

› LCD brightness

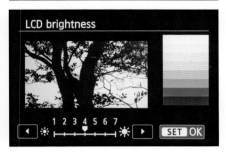

If you don't touch the controls of your EOS 70D, it will eventually go to "sleep" to conserve power. There are six options for the length of time this takes: **1**, **2**, **4**, **8**, **15**, or **30** minutes, or you can **Disable** this function entirely. When the camera is asleep, lightly pressing on the shutter-release button, **MENU**, **INFO.**, ▶, or ◻ will wake it. When set to **Disable**, the camera will not power down, although the LCD screen will still switch off after 30 minutes of inactivity (or if you press **INFO.**).

Allowing your EOS 70D to enter sleep mode is reasonably battery-efficient, and it actually uses less power than continually switching the camera on and off, since sensor cleaning—which is a drain on the battery—isn't activated.

The EOS 70D's LCD can be difficult to see in bright light, but it's possible to adjust the brightness of the screen to compensate. To adjust the brightness, select **LCD brightness** and then press ◀ to darken the LCD or ▶ to brighten it. Ideally you should be able to distinguish all eight of the gray bars at the right of the screen. Press ⑤ET when you've adjusted the brightness to the level you desire.

No matter how dark or bright the LCD, don't use the image displayed as a way of assessing exposure. A far more objective method is using the Live View or playback histogram (*see page 47*).

› LCD off/on btn

The shooting functions display is a useful way to quickly see how your EOS 70D is configured. When **LCD off/on btn** is set to **Shutter btn.**, the LCD is turned off when you press lightly down on the shutter-release button, which turns off the shooting functions display. Set LCD off/on btn to **Remains on** if you'd prefer that the shooting functions display remains on screen even when you're shooting. To turn off the shooting functions display screen, press **INFO.**

› Date/Time/Zone

Lets you set the correct date, time, and time zone. For more details, *see chapter 2.*

› Language

The EOS 70D can display the menu and shooting options in the following languages: English; German; French; Dutch; Danish; Portuguese; Finnish; Italian; Ukrainian; Norwegian; Swedish; Spanish; Greek; Russian; Polish; Czech; Hungarian; Romanian; Turkish; Arabic; Thai; Simplified Chinese; Chinese (traditional); Korean; Japanese. Although it can be fun to set the language to one other than your own, be careful that you can find this option again to restore the menu system to a more familiar language.

› GPS device settings

Settings available when GPS unit GP-E2 is fitted. *See page 217* for more details about the GP-E2.

» SET UP 3 ♀

› Video system

There are two main television standards in use around the world and if you want to connect your EOS 70D to a TV, you should select the standard relevant for your location: the NTSC standard is used in North America and Japan; the PAL standard is mainly used in Europe, Russia and Australia. The video system will also affect the available frame rates when shooting movies.

› Feature guide

You can **Enable** your EOS 70D to display notes on the LCD that show simple explanations of the various shooting functions as you choose them. Once you feel confident about using your camera, selecting **Disable** will turn these notes off. This will marginally speed up the operation of your camera and make the menu screens feel less cluttered.

› Touch control

There are many reasons to **Disable** the LCD's touch control. One of those reasons is to prevent the accidental setting of functions without realizing it, but you may simply not like the touchscreen feature (using the touchscreen invariably adds smears to the LCD from your fingers and you may simply find it easier to use the buttons and dials on the camera body). Select **Enable** if you want to switch the touchscreen functionality back on again.

» SET UP 4

› INFO. button display options

Determines what information is displayed on the LCD when you press **INFO.** in Shooting mode. Choose between: **Displays camera settings**, **Electronic level**, and **Displays shooting functions.**

› Wi-Fi & Wi-Fi function

See chapter 8 for more details.

› Sensor cleaning

By default, **Auto cleaning** is set to **Enable**, so every time you switch your EOS 70D on or off the sensor will be cleaned. This process takes a second or two. To save time you could set **Auto cleaning** to disable, but this means that the sensor will not be automatically cleaned. This increases the likelihood that you'll lose any time you save cloning out specks of dust from your images in postproduction. If you start to notice specks of dust in your images as you shoot, you can force the camera to **Clean now**.

One type of dirt the camera can't remove automatically is specks and marks caused by moisture or lubricants (the latter a very rare occurrence and more likely to happen in the first few weeks of ownership). These need to be cleaned off using a commercial sensor cleaning system. **Clean manually** raises the mirror and exposes the sensor to allow you to do this. Manual cleaning should only be

attempted with a freshly charged battery and only if you're confident that you know what you're doing. Get it wrong and you could scratch the surface of the low pass filter resulting in an expensive repair bill.

› Battery info.

Up to six LP–E6 batteries can be registered to your EOS 70D so that you can keep an eye on their recharge performance history over time. Every LP–E6 has a unique serial number that can be written onto a label and fixed to the battery. A standard LP–E6 battery is rated for approximately 500–600 charge cycles. A charge cycle is when 100% of the battery's power is used and then recharged. This does not mean that the battery needs to be discharged completely before recharging, though—if you were to use 25% of the charge in the battery, recharge it, and repeat the process four times, you would have

completed one charge cycle. Recharging before reaching the point of complete depletion will actually prolong the life of your battery, but if you find your battery does not hold power, it is coming to the end of its useful life. When the **Recharge performance** bar shows only one (red) bar, the battery should be replaced. **Battery info.** also displays the **Shutter count** (the number of times the shutter has been fired to make an exposure) since the last time the battery was recharged, and the **Remaining cap.** (the amount of charge left) of the battery as a percentage.

Registering a battery
1) Select **Battery info.** and then press **INFO.**.

2) Select **Register**. Select **OK** to continue or **Cancel** to return to the start of this step.

3) Press **MENU** to return to the main **Battery info.** screen.

> ### Notes:
> To delete registered battery information, select **Delete** at step 2 instead of Register. Turn ⬡ to highlight the battery you wish to delete and press ⑆ to continue.

3

› Certification logo display

This slightly eccentric option allows you to view the third-party imaging technology that Canon licensed for use in the EOS 70D. It's eccentric because it doesn't show all of the third-party imaging technology that Canon licensed. If you're curious to see that, the relevant logos can be found in the manual that came with your camera. **Certification logo display** is an option you may look at only once, if at all.

› Custom shooting mode (**C** mode)

There's nothing worse than being in the wrong mode when that once-in-a-lifetime photographic opportunity arises. To avoid this, you can save a particular camera configuration so that it can be called up instantly by turning the mode dial to **C**.

Setting a Custom shooting mode
1) Configure your camera as required— the shooting mode (and exposure setting if relevant), drive mode, exposure compensation, ISO speed, and so on. Many of the menu options can be configured and saved too.

2) Select **Custom shooting mode** (**C mode**) on the ♥ menu.

3) Select **Register settings** and then **OK** to save your custom settings. Select **Cancel** to return to the main **Custom shooting mode (C mode)** screen without saving the settings.

Notes:
Select **Clear settings** at step 3 to delete your custom settings permanently.

When **Auto update set.** is set to **Enable**, any changes you make to the camera settings in **C** mode will be automatically applied to your custom settings.

› Clear all camera settings

Choosing this option allows you to reset the camera to its original factory settings. Think carefully before you do this, as you cannot undo your decision!

Clearing settings
1) Select **Clear all camera settings**.

2) Select **OK** to reset your camera or **Cancel** to return to the **Clear settings** sub-menu without clearing the settings.

› Copyright information

As a general rule, every image you shoot belongs to you: it's your property and no one else's (see the note on page 146 for exceptions). This means that if someone uses one of your images without permission, you have the legal right to request payment (although actually obtaining payment is another matter and unfortunately it is often not worth the time

and effort required to pursue minor infractions).

The first step in establishing your legal right of ownership is to add your copyright details to the metadata of your images. Your EOS 70D can be set to automatically add your copyright details to every image you shoot.

A very current issue for photographers is the concept of the "orphan" image. These are digital images that apparently belong to no one because information about ownership has been lost. This can lead to the images being used without attribution and, more importantly, without recompense to the photographer. To avoid this happening to you, it's highly recommended that adding relevant **Copyright information** is one of the first things you do when setting up your EOS 70D.

Setting copyright information

1) Select **Copyright information**.

2) Select either **Enter author's name** or **Enter copyright details.**

3) On the text entry page, press ⓠ to jump between the text entry box and the rows of alphanumeric characters below. Press ✳ or turn 🔘 to highlight the required character and then press (SET) to add it to the text entry box above. Alternatively, press the relevant letters on the keyboard on the LCD (which is the far quicker method of entering the copyright text). If you accidentally enter the wrong character, press 🗑 to delete it. Select or tap **Aa≠1@** on the LCD to toggle the keyboard between lower case letters, numbers/symbols 1, numbers/symbols 2, and upper case letters.

4) Press **MENU** and select **OK** when you've completed the text entry to save the details and return to the main **Copyright**

Information menu, or press **INFO.** and select **OK** to return to the main **Copyright Information** screen without saving.

Other Copyright information settings

Selecting **Display copyright info**. displays the currently set copyright information. If no copyright information is set, this option is grayed out and cannot be selected.

Selecting **Delete copyright information** removes the copyright information set on the camera (but not from the metadata of any images already saved to the memory card). Again, if no copyright information is set, the option is grayed out and cannot be selected.

> **Notes:**
> It's likely that you'll set the same information in **Enter author's name** and **Enter copyright details**. However, you can assign copyright in an image to anyone you wish. In this instance, you would set another person's name or even a company (if you were shooting images as an employee) as the copyright owner.
>
> Some social media web sites strip out the copyright information metadata from images when they're uploaded to the site. Adding a subtle copyright watermark to your images when sharing them is therefore a safer bet if you're worried about others using them without permission.

› Firmware ver.

Your EOS 70D is an astonishingly complex device, with built-in software operating behind the scenes to make sure that everything runs smoothly. This software is known as firmware. However, no camera is flawless and bugs in firmware inevitably come to light. At the time of writing, there are no known issues with the EOS 70D, but that doesn't mean that there aren't any waiting to be discovered. Although there is a lot of white noise and misinformation, online forums can be a good way to find out about problems with cameras.

Canon will sometimes release new firmware to cure bugs that have been discovered, but firmware is also occasionally released that can radically improve a camera. Canon breathed new life into its EOS 7D model in 2012 by overhauling that camera's firmware and adding new features.

Canon will announce on its web site when an update to the firmware is available, as well as by email to registered users. This information is also generally relayed via photography news sites such as www.dpreview.com. Full instructions on how to update your camera will be included with the firmware update, but if you're not confident about updating the firmware yourself, you can also have it updated for you at a Canon Service Center—for a fee.

Canon will also occasionally release specific updates for lenses as well. When the lens is attached, you can update the lens' firmware using this function.

Custom functions are there to help you mold the operation of your EOS 70D to your personal way of working. There are 23 custom functions, which are divided into three groups based on the function type: **C.Fn I: Exposure**; **C.Fn II: Autofocus**; **C. Fn III: Operation/Others**. Custom functions can only be set when the mode dial is set to one of the Creative Zone modes.

Select **Clear all Custom Func. (C.Fn)** if you want to clear the custom functions you've set and return your EOS 70D to its default settings. This is something that can't be undone, so don't proceed unless you're absolutely sure.

Setting Custom Functions

1) Highlight the 📷 tab.

2) Select one of the three groups on the 📷 menu screen.

2) Press ◀ / ▶ to skip between the various custom functions screens in the selected group. Press (SET) when you reach the custom function that you want to alter. At the bottom of the LCD, the current custom functions settings are displayed below their respective numbers.

3) Press ▲ / ▼ to highlight the desired option and then press (SET) once more to select that option.

4) Repeat steps 2 and 3 if there are other functions you wish to alter. Otherwise press **MENU** to return to the main 📷 screen.

› **C.Fn I-1 Exposure level increments**

This custom function allows you to set either **1/3-stop** or **1/2-stop** increments for exposure operations such as shutter speed, exposure compensation, and so on.

When set to 1/2-stop, the exposure controls will be coarser and it will be less easy to get the exact exposure, but selection will be speeded up a fraction, as there is a smaller range of options to select.

› C.Fn I-2 ISO speed setting increments

The same applies to the **ISO speed setting increments**, though the difference between **1/3 stop** and **1 stop** is greater. You'll have finer control over exposure when you can choose ISO values in 1/3-stop increments, so that this is marginally preferable.

› C.Fn I-3 Exposure Bracketing auto cancel

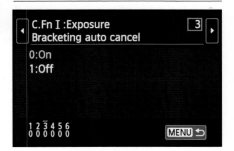

If you shoot a lot of images for postproduction HDR, setting this option to **Off** will make sense. When **Bracketing auto cancel** is disabled, bracketing (both exposure and WB) will not be canceled when you switch your EOS 70D off (it will be temporarily canceled if you switch to movie shooting or when a Speedlite is set to fire).

Set to **On**, bracketing will be canceled when your EOS 70D is switched off, when you switch to movie shooting, and when an attached Speedlite is switched on.

› C.Fn I-4 Bracketing sequence

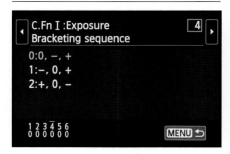

This option sets the order in which exposure and white balance bracketed images are shot. By default, the correctly exposed image is shot first, followed by the negatively corrected image, and then the positively corrected image (**0 - +**). However, you can choose to shoot the negatively corrected image first, and then the "correct" image, followed by the positively corrected image (**- 0 +**), or positive, correct, and negative (**+ 0 -**). There is no real advantage to any setting, although it's possibly more comforting to know that the correct image has been exposed first.

› C.Fn I-5 Number of bracketed shots

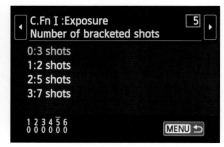

The default number of bracketed exposure and white balance shots is **3 shots**, but you can also select **2 shots**, **5 shots**, or **7 shots**. Typically you would increase the number of bracketed shots for creating HDR images in postproduction so that you had a greater sequence of exposures. When the bracketing order is 0 - + (see left), the sequence shot will be in the order shown in the table below. When 2 shots is selected, you can choose either + or - when setting AEB.

	1st shot	2nd shot	3rd shot	4th shot	5th shot	6th shot	7th shot
3 shots	0	-1	+1				
2 shots	0	±1					
5 shots	0	-2	-1	+1	+2		
7 shots	0	-3	-2	-1	+1	+2	+3

› C.Fn I-6 Safety shift

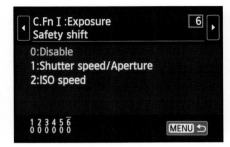

Sometimes it's useful to have a safety net when exposing images. **Safety shift** provides just that. When this function is set to **Shutter speed/Aperture,** Safety shift will automatically alter the manually selected exposure setting in **Tv** and **Av** modes if the scene brightens or darkens to the point that the correct exposure can't be set. When set to **ISO**, the manually selected **ISO** setting in **P**, **Tv**, and **Av** modes will be altered automatically to achieve the same result. If you set this function to **Disable**, under- or overexposure may result if the brightness of the scene can't be adjusted for automatically.

› C.Fn II-1 Tracking sensitivity

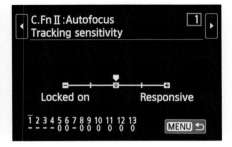

Sets how sensitive AI Servo is when tracking a subject and another potential subject enters the AF area, or when the subject moves away from the cluster of AF points. Set to a minus value (**Locked on**), Tracking sensitivity will try to track the subject as long as possible; set to a positive value (**Responsive**), the focus will tend to track other objects in the scene more quickly (biasing AF to the closest element of the scene).

› C.Fn II-2 Accel./decel. tracking

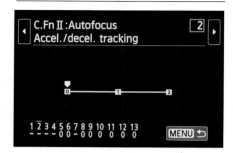

Sets how sensitive the AF system is to sudden acceleration or deceleration in the speed of your subject. Set **Accel./decel. tracking** to **0** if you're shooting mainly static subjects (or subjects that have a constant speed). Increase **Accel./decel. tracking** to **1** or **2** if you're shooting subjects that tend to increase or decrease speed more dramatically (with the downside of an increased tendency for the AF system to be oversensitive).

› C.Fn II-3 AI Servo 1st image priority

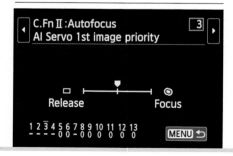

This setting lets you to prioritize between shutter release and focus for the 1st image shot when using AI Servo. **Equal priority** is not biased to either, but when set to **Release priority** the exposure will be made immediately after the shutter-release button has been pressed, regardless of whether focus has been achieved or not. **Focus priority** makes the camera wait until focus is locked on the subject before the shot is taken.

› C.Fn II-4 AI Servo 2nd image priority

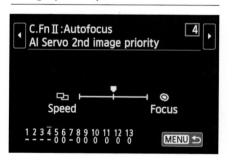

This setting allows you to prioritize between shooting speed and focus for the 2nd image shot when using AI Servo. **Equal priority** is not biased to either; **Shooting speed priority** will maintain shooting speed at the expense of focus accuracy; **Focus priority** makes you wait until focus has been locked on the subject before the shot can be taken.

› C.Fn II-5 AF-assist beam firing

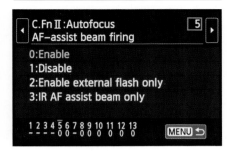

When light levels are low and **AF-assist beam firing** is set to **Enable**, the inbuilt flash or attached Speedlite will pulse light to help the autofocus system. **Disable** turns this function off; **Enable external flash only** will only use an attached Speedlite; **IR AF assist beam only** will use the infrared beam available on certain Speedlites to assist the autofocus.

› C.Fn II-6 Lens drive when AF impossible

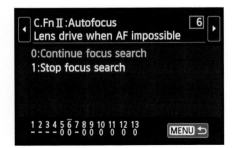

It can be frustrating when a lens tries to focus and fails, and then keeps on trying and trying, and trying. This is precisely what the lens will do in this situation when this option is set to **Continue focus search**. Set to **Stop focus search**, the lens will stop trying if focus cannot be locked. At this point, it is good policy to switch the lens to MF and try to get as close to focus as you can. Switch AF back on to refine the focus.

› C.Fn II-7 Select AF area selec. mode

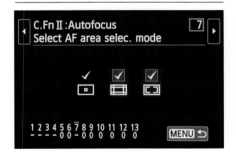

This option allows you too choose which of the AF area selection modes are available when you press the AF area selection button. If you only ever use two of the AF area selection modes, this option arguably makes it faster to switch between them (by switching the third off). However, in doing so you may come unstuck should the third be immediately useful in a particular shooting situation.

› C.Fn II-8 AF area selection method

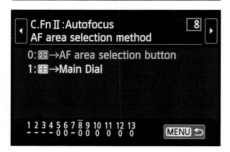

You can change how you switch between the AF area selection modes by altering this custom function. The default is ▣ **AF area selection button**. With this set, pressing either ▣ or ▦ allows you to switch between the AF area selection modes by repeatedly pressing ▦. When set to ▣ **Main Dial**, you turn 🔄 to set the AF area selection modes after pressing either ▣ or ▦.

› C.Fn II-9 Orientation linked AF point

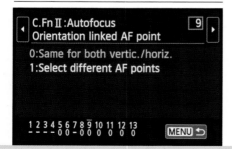

When set to **Same for both vertic./horiz**, the same AF point(s) or AF zone are used whether your EOS 70D is held vertically or horizontally. Set to **Select different AF points**, the AF point positioning can be set separately for three camera orientations: horizontal, vertical with the camera grip to the bottom, and vertical with the camera grip to the top. Whenever you switch the camera's orientation, it will switch to the AF point/AF zone settings for that orientation.

› C.Fn II-10 Manual AF pt. selec. pattern

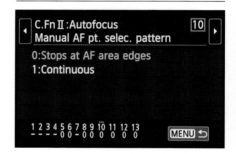

You can choose whether the Manual AF point selection **Stops at AF area edges** when it reaches the edge of the AF frame area or is **Continuous**, so that when the AF point reaches the edge of the AF frame area it jumps to the opposite side. This is another option that will be set purely as a personal preference. **Stops at AF area edges** is arguably more precise, since you won't find your AF point unexpectedly on

the opposite side of the AF frame area. However, it will make it slower to move back and forth across the AF frame area, since you can't take a useful shortcut.

› C.Fn II-11 AF point display during focus

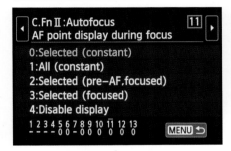

With the viewfinder grid switched on and all those AF points, the viewfinder can become cluttered and distracting. This function allows you to take charge of the AF points and decide when they are displayed during focus. **Selected (constant)** always displays the selected AF point(s) or zones before and after focusing, while **All (constant)** displays all of the AF points, regardless of whether they are selected or not.

The AF points are displayed when you select them, before you begin to focus, and when focus is locked when **Selected (pre-AF, focused)** is chosen. The AF points are only displayed when you select them, and when the camera locks focus if

you choose **Selected (focused)**.

Finally, **Disable display** will only show the AF points when you choose them.

› C.Fn II-12 VF display illumination

Allows you to determine whether the AF points and grid glow red when focus is achieved (**Enable**), or not (**Disable**). Set to **Auto**, the AF points and grid only glow when focus is achieved in low-light conditions.

› C.Fn II-13 AF Microadjustment

Modern camera lenses are high-precision instruments, but that doesn't mean they are infallible. For most shooting situations, critical focusing accuracy is relatively unimportant, but there are times when focusing has to be exactly right. It is then that flaws in AF become apparent.

There are two potential problems. The first, known as backfocus, occurs when the AF system focuses slightly behind the intended focus point. The second, known as front focus, occurs when the AF system focuses slightly forward of the intended focus point.

AF Microadjustment allows you to correct these AF problems for up to 40 lenses, so that each time you fit a corrected lens, back- or front-focus problems are automatically compensated for.

The difficulty with adjusting the AF is knowing how much adjustment to make. Fortunately there are tools available that will help enormously. The first is free and can be

viewed at photo.net/learn/focustest. The second tool, called LensAlign, is a commercial solution created by Michael Tapes Design (michaeltapesdesign.com).

› C.Fn III-1 Dial direction during Tv/Av

This function allows you to set the direction that exposure is altered in **Tv/Av/M** modes when the control dials are turned. When set to **Normal**, turning to the right shortens the shutter speed/reduces the size of the aperture, and turning it to the left lengthens the shutter speed/increases the size of the aperture (**Tv** and **Av** modes).

Switching to **Reverse direction** swaps this around. This is largely a matter of preference, but you may find it difficult to adapt to other cameras if you change from the default.

When using **M**, the direction you need to turn and is reversed when setting exposure.

› C.Fn III-2 Multi function lock

The LOCK▶ switch (when moved upward) can be used to lock the ⟨dial⟩, ⟨dial⟩, and ⟨controller⟩ controls. This can be used to prevent the accidental setting of the wrong function. You can set LOCK▶ to lock all three, or choose none, one, or two controls. Highlight the control you want to set as lockable—or protected from being locked—and press (SET). When a particular control is locked, a ✓ will be shown to the left of the control's description. It's particularly useful for preventing the accidental setting of exposure compensation by turning ⟨dial⟩.

› C.Fn III-3 Warning ❗ in viewfinder

It's easy to forget when a particular function is set. This can prove disastrous if you don't pay attention when shooting. Fortunately, you can set your EOS 70D to warn you when certain functions are set (the warning taking the form of ❗ displayed in the viewfinder).

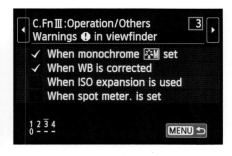

Functions you can be warned about are: **When monochrome ⟨icon⟩ set**, **When WB is corrected**, **When ISO expansion is used**, and **When spot meter. is set**.

To activate or deactivate any of these warnings, highlight the required warning and press (SET). When a particular warning is activated, a ✓ will appear at the left of the warning, disappearing when it is deactivated.

› C.Fn III-4 Custom Controls

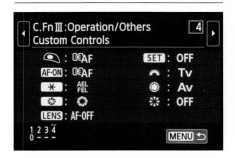

Custom Controls allows you to alter the default function of a select number of buttons. This is largely a matter of preference.

My Menu allows you to compile a list of six of your most commonly used menu settings so they can be found and altered more conveniently.

Adding options to My Menu
1) Press **MENU** and navigate to the ★ tab.

2) Select **My Menu settings** and then **Register to My Menu**.

3) Press ▲ / ▼ to move up and down the function list.

4) Press (SET) when an option you want to add to My Menu is highlighted. Select **OK** to continue or **Cancel** to return to the **Register to My Menu** screen without adding the function. When a function has been added to My Menu, it will be grayed out and can no longer be selected.

5) Continue to add functions as required

and then press **MENU** to return to the My Menu settings menu.

Sorting options registered to My Menu
1) Select **My Menu settings** and then **Sort**.

2) Highlight the item that you want to move and press (SET). Press ▲ / ▼ to move the item up and down the list. Press (SET) when you're done.

3) Repeat step 3 to move other items up or down the list.

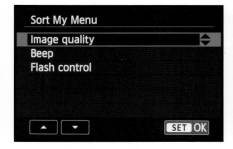

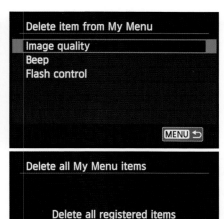

4) Press **MENU** to return to the main My Menu screen.

Deleting options registered to My Menu
1) Select **My Menu settings**.

2) To delete individual options from the list, select **Delete item/items**. Highlight the option you want to delete, press (SET), and then select **OK** to delete the option, or **Cancel** to return to the option list.

3) To delete every option on the list, select **Delete item/items**. Select **OK** to clear the My Menu list or **Cancel** to return to the My Menu screen.

Note:
Select **Enable** on **Display from My Menu** so that My Menu is always the first menu shown when you press **MENU**.

4 LENSES

One of the attractions of buying a Canon EOS camera is the fact that it is part of a mature and well-supported system. In terms of lenses, you are spoilt for choice, even if you just stick to the Canon brand.

Go to any online retailer and look at the list of lenses available for Canon DSLRs and you will see just how much choice you have: Canon produces nearly 70 different types of lens, and when you factor in lenses by third-party manufacturers such as Sigma, Tamron, and Tokina you'll quickly realize that there is a lens available to satisfy almost every photographic requirement you could possibly think of.

Some of the lenses border on the esoteric (Canon produces four tilt-and-shift lenses that are very specialized, for example), but there are plenty of other lenses that are suited to everyday use. If the EOS 70D is your first DSLR, then you may have purchased it with the EF-S 18–135mm f/3.5–5.6 IS STM kit lens. This lens very definitely falls into the "everyday" category, with a respectable focal length range that is suitable for landscape, portraiture, and even nature photography at a push.

This chapter is an introduction to the full range of Canon's EF and EF-S lenses, which are all compatible with your EOS 70D. It will cover some of the concepts you'll need to understand in order to make an informed decision about other types of lenses you may want to add to your camera bag.

KIT LENS ⌄
Canon EOS 70D and EF-S 18–135mm
f/3.5–5.6 IS STM lens.

SPECIALIST »
This image was shot with a tilt-and-shift lens, which allowed me to keep the verticals straight.

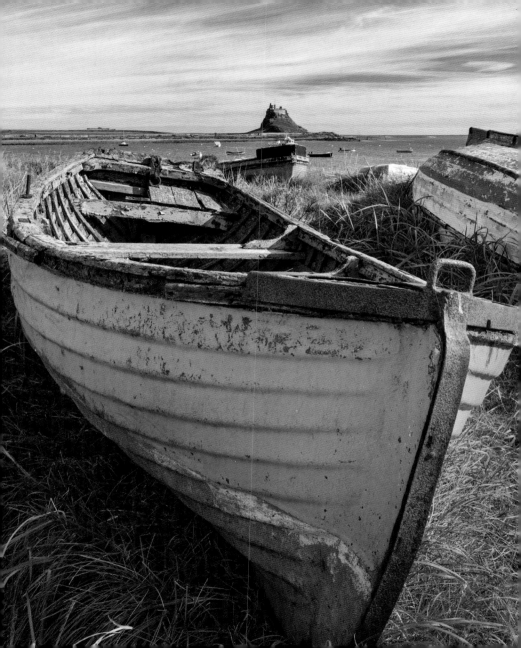

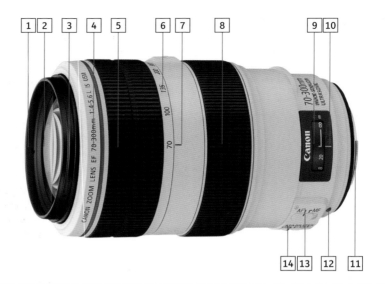

1 Filter thread	**8** Focus ring
2 Lens front element	**9** Focus distance window[2]
3 Lens hood mount	**10** Focus distance index
4 Lens information (model/focal length/ maximum aperture/features)	**11** Lens mount
5 Zoom ring[1]	**12** Lens mount index
6 Focal length range	**13** AF/MF switch
7 Focal length index mark	**14** Image stabilization switch

1 Slightly frustratingly, Canon differentiates its zoom lenses by the positioning of the focus and zoom rings. More expensive zoom lenses (typically L-series) have the zoom ring at the front of the lens, with the focus ring to the rear. Less expensive zooms reverse this. This makes it less intuitive to swap between different types of lens. **2** Not every Canon lens features a distance scale: EF-S lenses typically don't have a focus distance indicator.

» LENS RANGES

The Canon lens range is split into two groups: EF lenses that are compatible with all Canon EOS cameras (both film and digital), and the EF-S range that are only suitable for digital cameras with APS-C sized sensors (such as the EOS 70D). Third-party lens manufacturers such as Sigma use their own naming convention to designate whether a lens is suitable for all EOS cameras or just APS-C cameras (in Sigma's case, DC is used instead of EF-S). The EF range is further subdivided into L-series lenses and non-L lenses.

The S in EF-S stands for "short back focus," which refers to the fact that the rear element of the lens projects farther inside the camera than an EF lens. It's this characteristic that makes them incompatible with full-frame cameras— the rear element would catch on the reflex mirror if you were able to fit an EF-S lens to a full-frame camera. Because of this, if you think you may purchase a full-frame camera at some point, it's a good idea to keep your EF-S lens collection to a minimum.

EF lenses make up the bulk of the Canon lens range, with a lineage stretching back to the introduction of the first EOS camera in 1987. There are many deleted EF lenses that are still compatible with your EOS 70D and these can expand your choice of lens if you're prepared to buy used.

L-series lenses are at the top of Canon's lens range and this is reflected by their price. Many L-series lenses use expensive technology such as fluorite glass lens elements and diffraction optics. Currently there are no EF-S L-series lenses available.

NEW «
Announced in August 2013, the EF-S 55–250mm lens is Canon's latest EF-S lens.

> **Note:**
> To confuse things further, Canon introduced the EF-M lens mount in 2012. This mount is currently only used on Canon's EOS-M compact system camera—lenses for this camera are incompatible with the EOS 70D.

Canon employs a number of technologies to improve the handling, focusing speed, and optical performance of its lenses. The following pages list and explain these technologies, as well as some of the problems that are overcome by them.

Autofocus stop feature (AF-S)

If a lens has an AF-S button, you can press it down to temporarily stop autofocus. Autofocus does not resume again until the button is released.

Circular Aperture (CA)

The aperture in a lens is composed of a number of blades. The more blades used, the more circular the aperture (and the more complex the mechanism). Circular apertures help to make the out-of-focus areas in an image look more aesthetically pleasing. This is often referred to as the "bokeh" of a lens.

Dust and water resistance (DW-R)

Some of Canon's lenses are fitted with thin rubber seals around the periphery of the lens mount. This creates a dust and watertight seal when the lens is attached to a camera. DW-R is typically found on L-series lenses.

Diffractive Optics (DO)

DO lenses are smaller and lighter than conventional lenses of equivalent focal length, yet they still boast a high optical quality. This is achieved through the use of special—and expensive—glass elements. To date there are only two DO lenses produced by Canon: a 70–300mm zoom and a 400mm prime. These lenses can be distinguished by a green band around the lens barrel.

Fluorine coating

Fluorine is used to provide a micro-thin, antistatic coating on the external glass elements of some Canon lenses. The coating is water repellent and makes cleaning the glass easier.

Fluorite glass

Fluorite glass is unsurpassed as a way to control chromatic aberration. In an ideal world, it would be used to produce all lens elements, but unfortunately it takes four times as long to grind a fluorite glass lens element than one made of standard glass, so they are considerably more expensive. For this reason, fluorite glass is currently only found on L-series lenses, and then not on every one.

Full-time manual focusing (FT-M)

FT-M allows you to override the autofocus at any point without switching AF off permanently. Canon achieves this in one of two ways: with electronic manual

focusing or mechanical manual focusing. The electronic system detects that the manual focus ring is being moved and uses the focusing motor to move the lens elements. The mechanical system relies entirely on the manual focus ring being moved to adjust the focus.

Image Stabilization (IS)

A growing number of Canon lenses are equipped with Image Stabilization (IS). An IS lens can detect the slight movements that occur naturally when handholding a camera and the optical system in the lens is then adjusted to compensate for this movement. The most up-to-date iteration of Canon's IS system, Hybrid IS, can compensate for shutter speeds that are 5 stops slower than would normally cause camera shake. It can also compensate for angular velocity and shift. IS should be turned off when the camera is mounted on a tripod.

Internal focusing and rear focusing

A lens with internal focusing can focus without the need to extend its physical length. Rear focusing is similar, but in this instance only the lens elements toward the rear of the camera are moved. A benefit with both systems is that the front lens element does not rotate during focusing. This is particularly useful when using filters

that need to be set in a certain orientation, such as graduated filters and polarizers.

Stepper motor (STM)

STM is a type of AF motor that is designed to make AF smoother, although it is slower than USM. STM is more useful if you regularly shoot movies than if you principally shoot sports/action still-images.

Tripod collar

When a long, heavy lens is mounted to a camera, the center of gravity is shifted forward, away from the camera. When the camera is then attached to a tripod, this places a strain on the camera's lens mount and makes the entire system less stable. Attaching the entire assembly to the tripod using a collar around the lens makes the camera-lens combination better balanced.

Ultra−low dispersion glass (UD)

UD glass is used to reduce chromatic aberration. It is inferior to Super UD and Fluorite lens elements for this purpose, but far superior to standard glass.

Ultrasonic Motor (USM)

An autofocus motor built into the lens that allows for fast, quiet, and accurate focusing. Canon uses two types of USM—ring and micro. The ring-type USM allows full-time manual focusing in autofocus mode.

» LENS PROPERTIES

› Focal length

Parallel rays of light converge to a point when they enter a lens that is focused at infinity (∞); this point is known as the focal point, or focal plane. The focal length of a lens is the distance in millimeters from the optical center of the lens to the focal point/focal plane. The sensor in the EOS 70D is placed at the focal plane and is shown by the ⊖ symbol at the left of the viewfinder housing on top of the camera.

The focal length of a lens never alters. It is the same whether it is mounted on an EOS 70D or on a full-frame camera such as Canon's EOS 5D MK III: focal length is, after all, just a measurement of distance. However, what does change between cameras with different size sensors is the field of view of a lens. This is referred to as the crop factor. A lens can have a fixed focal length—referred to as a "prime"—or have a variable focal length, also known as a "zoom."

> **Note:**
> In photography the focal point is also referred to as the focal plane.

› Crop factor

The size and shape of 35mm film images is still generally seen as the "standard" for digital sensors, and this standard is known as "full-frame." However, it is expensive to make sensors that correspond to that size (hence the high price of cameras such as Canon's EOS 5D series), so most DSLR cameras, including the EOS 70D, use sensors that match the APS-C film size, which is a smaller format than 35mm. This means that a crop factor must be taken into account when working out the difference in the field of view of a lens between the two sensor sizes.

The EOS 70D has a crop factor of 1.6x, which means that a lens with a field of view of 35° on a full-frame camera will

CROP FACTOR ⌄
This image was shot with a full-frame camera using a focal length of 70mm. The inner rectangle shows the angle of view if the same lens were to be used on an EOS 70D.

have a field of view of 22° on the EOS 70D. In practice, this means that a lens will appear to have a longer focal length because less of the scene is captured—wide-angle lenses will not appear as wide, but telephoto lenses will be usefully longer. However, it's important to remember that the focal length has not changed, just the angle of view. All other aspects of the lens—such as the available depth of field at each aperture—are the same, no matter what sensor size is used.

› Field of view

The field of view of a lens is a measurement—in degrees (°)—of the extent of a scene that is projected by the lens onto the film or sensor. The field of view can refer to either the horizontal, vertical, or diagonal coverage, but if just one figure is given it's generally safe to assume that it's referring to the diagonal coverage. There are two factors that affect the field of view of a lens. The first is the focal length of the lens; the second is the size of the sensor used in the camera.

Short focal length lenses are commonly referred to as wide-angle lenses. These lenses reduce the size of the image projected onto the sensor, so more of the scene is captured. Or, to put it another way, the field of view is wider (hence the

name). The most extreme example of a wide-angle lens is a fish-eye lens, which often has an angular coverage of 180°. The longer the focal length of a lens, the more the image projected onto the sensor is magnified, reducing the angle of view. This is why telephoto lenses appear to bring distant objects closer to you.

FIELD OF VIEW ⦚
This image was shot with an APS-C camera using a 300mm lens. To achieve the same shot on a full-frame camera, I would have needed to use a 480mm lens.

» LENS TYPES

› Primes versus zooms

A prime lens is one with a fixed focal length, such as 35mm, 50mm, or 100mm. This has the immediate drawback that you can't simply turn a zoom ring to change the look of your composition—you have to move physically forward or backward and change your camera-to-subject distance. Oddly enough this is one of the appealing things about using a prime lens. Because of the effort involved, photography can become more rewarding, and with practice it also becomes easier to "see" compositions that suit a particular prime lens. Street photographers who use prime lenses exclusively work almost instinctively for this reason.

Another drawback of using primes is that in order to cover a decent focal length range, you end up with many different lenses (instead of a single zoom lens).

However, prime lenses do have some advantages over zooms. By their very nature, zooms are mechanically and optically more complicated than prime lenses. Although modern zooms are generally excellent, they still can't match a good prime for ultimate image quality. Prime lenses generally have faster maximum apertures than zooms, as well. The fastest zooms in the Canon range tend to be no faster than f/2.8, while numerous prime

lenses have a maximum aperture of f/1.8 or wider. A prime with a large maximum aperture is particularly advantageous if you regularly shoot in low-light conditions, or if you like to use minimal depth of field for aesthetic reasons.

PRIME
Canon's 35mm lens—one of the company's recently released primes.

› Standard lenses

A standard lens is one with a focal length that approximately matches the diagonal measurement of the digital sensor in the camera to which it is mounted. The diagonal width of a full-frame sensor is 43mm and for this reason 50mm is usually seen as a standard lens on a full-frame camera (although Canon's new 40mm pancake lens is arguably closer to the ideal). On an APS-C camera, such as the EOS 70D, the diagonal measurement of the sensor is 26.7mm, meaning that a 28mm focal length is closer to the definition of a standard lens.

The name standard lens comes from the fact that images created with one have a pleasing, natural perspective. Unfortunately, this is often seen as a negative trait, since images shot with a standard lens don't have the immediate impact of those shot with a wide-angle (or even a telephoto) lens. However, when an unfussy, "documentary" style of shooting is required, a standard lens is hard to beat.

The 28mm focal length is marked on the barrel of the 18–135mm kit lens that is often supplied with the EOS 70D, but Canon also produces three 28mm prime lenses. The least expensive is the f/2.8 variant, which is followed in both specification and price by a faster (and weightier) f/1.8 lens. The newest lens of the three is a 28mm f/2.8 lens that features USM focusing and 4-stop image stabilization. The big difference is in the build quality and the maximum aperture: unless you really need an IS lens (and can justify the extra expense) the "regular" f/2.8 lens is more than adequate.

Note:
Using a 50mm lens on your EOS 70D is the equivalent of using an 80mm lens on a full-frame camera. This makes it an excellent portrait lens.

STANDARD ⌄
Canon's latest 28mm lens—a "standard" lens on the EOS 70D.

The term telephoto has now become synonymous with any lens with a focal length longer than "standard." Technically, a telephoto is a very specific type of lens, but for simplicity's sake we'll use the more general meaning here.

A telephoto lens magnifies the image on the sensor, appearing to bring distant objects closer (narrowing the field of view, so less of the scene is captured). This makes longer telephoto lenses popular with wildlife photographers who need to keep a reasonable distance from their subject. The longest telephoto lens Canon currently produces is an 800mm prime lens. It's eye-wateringly expensive, but necessary for certain types of photographer.

There is a much greater range of shorter and more affordable telephotos for the rest of us. Notably, telephoto lenses in the region of 85mm focal length work particularly well as portrait lenses, since they have a more pleasing perspective for facial features than a wide-angle lens.

One limitation with a telephoto lens is that depth of field is often limited: the longer the focal length, the bigger the problem. However, this is not necessarily a drawback, since it means that telephoto lenses are ideal for a technique known as "differential focusing," where only a very specific part of the image appears sharply focused.

Telephoto lenses are also often large and cumbersome, making them difficult to handhold. As the image is magnified, any movement will be exaggerated, increasing the risk of camera shake. Some Canon lenses are equipped with Image Stabilization, but you will often pay a premium over a similar non-stabilized lens.

SKITTISH «
Telephoto lenses are ideal when your subject is nervous and is likely to move or even flee if you get too close.

› Wide-angle lenses

A wide-angle lens is generally thought of as any lens with an angle of view that is wider than a standard lens. Before digital photography, most photographers would have 35mm and 28mm lenses to cover their wide-angle needs, but the crop factor of the EOS 70D means that the equivalents are 22mm and 17.5mm focal lengths respectively. Happily, the standard kit lens (just about) covers both of these focal lengths, but if you want to go wider, Canon produces a number of useful alternatives. The widest EF-S lens is a 10–22mm f/3.5–4.5 USM, which has an equivalent field of view to a 16–35mm lens (making it the APS-C equivalent of the 16–35mm L-series lens). If you wish to go wider still (into the realms of fish-eye lenses), then Canon also produces an EF 8–15mm f/4L USM.

The wider the focal length of a lens, the less natural the perspective of an image will look. Spatial relationships between elements in a scene are stretched, and distant objects will appear far smaller in the image than they would if you were looking at the scene in question. Landscape photographers frequently use wide-angle lenses for this very reason, as their optical properties help to create a sense of space in an image. However, wide-angle lenses are not flattering portrait lenses: the increase in apparent distance between elements in an image will apply equally to a person's facial features as to a landscape.

ARCHITECTURAL »
Wide-angle lenses are invaluable when shooting architecture, particularly if there's little room to maneuver in terms of stepping back from your subject.

» OTHER LENS OPTIONS

› Teleconverters

A teleconverter is a secondary lens that fits between the camera body and the main lens to increase the focal length of the main lens by a given factor. Canon currently makes two EOS teleconverters: a 1.4x model that increases the focal length by a factor of 1.4, and a 2x model that doubles focal length. Note that Canon uses "Extender" as a synonym of teleconverter.

Teleconverters are a relatively inexpensive way of increasing the usefulness of your lens collection, but they have several drawbacks. For a start, only a certain number of Canon lenses can be used with a teleconverter, and some lenses will even be damaged if used with a teleconverter (see the lens chart at the end of this chapter for details). In addition, image quality is reduced in comparison to a non-extended lens of the same focal length, and a teleconverter also restricts the amount of light passing through the lens, effectively making the lens slower. In low light, this can reduce the effectiveness of the AF system, as well as making the viewfinder darker. A 1.4x teleconverter loses 1 stop of light, a 2x teleconverter loses 2 stops.

EXTENDER EF 1.4X III ☆ **EXTENDER EF 2X III** ☆

TELECONVERTER	SPECIFICATIONS	DIMENSIONS (MM)	WEIGHT (G)
Extender EF 1.4x III	7 elements in 3 groups	72 (w) x 27 (h)	225
Extender EF 2x III	9 elements in 5 groups	72 (w) x 53 (h)	325

› Tilt-and-shift

Canon produces four "tilt-and-shift" lenses: 17mm f/4L, 24mm f/3.5L II, 45mm f/2.8, and 90mm f/2.8. All of these lenses are manual focus only and have the prefix TS-E.

A tilt-and-shift lens can perform two very useful tricks compared to a conventional lens. The first trick is that the front element of the lens can be angled relative to the camera ("tilt"); the second is the ability to move the front lens element up or down, left or right ("shift").

Tilting the front element of a lens allows you to control the plane of focus in an image. This technique can be used to either throw large areas of an image out of focus or to increase sharpness throughout an image without resorting to the use of small apertures. This latter trait is useful for avoiding diffraction when you want to achieve front-to-back sharpness. See the end of this chapter for details.

Shifting the front element of a lens is useful when you want to avoid "converging verticals." This is an optical effect caused when a camera is tilted backward (or forward) to fit a vertical subject into a composition. This results in the vertical lines of a subject no longer appearing parallel to each other. Shifting a lens allows you to keep the camera parallel to the subject and adjust your composition to include the required elements of your subject.

CANON 24MM TS-E II **»**
Canon's recently revised 24mm TS-E lens is optically a big improvement over the first version.

3 » TILT/SHIFT

The camera should be kept parallel to the subject when using a TS-E lens to shoot architectural subjects. The 70D's built-in electronic level is invaluable to help you achieve this aim. Setting up a camera to shoot architecture this way does take time and effort. Arrive in plenty of time to set up for your shot so that you don't rush the process.

Settings
> Aperture priority **AV** mode
> ISO 800
> 3 sec. at f/11
> Evaluative metering
> 17mm TS-E lens

» FOCUS

Longer focal length lenses have inherently less depth of field at a given aperture than a wide-angle lens. This means that focusing has to be more precise, particularly when shooting with the aperture wide open. For this shot, I used Live View and zoomed into the focus point to check that focus was exactly where I wanted it.

Settings
> Aperture priority **Av** mode
> ISO 400
> 1/2000 sec. at f/3.2
> Evaluative metering
> 100mm lens

4 › Third-party lenses

You don't have to stick to the Canon brand when you decide to expand your lens collection; buying a third-party lens has a lot to recommend it. For a start, third-party lenses are often cheaper than an equivalent Canon lens. While this could potentially mean a drop in quality, it's not always the case. Third-party lenses once had a bad reputation and were seen as a second-rate option, but modern third-party lenses are often just as good (in terms of build quality and optics) as the Canon equivalents.

There are three main manufacturers of lenses for the EOS system: Sigma, Tamron, and Tokina. Sigma and Tamron have an extensive lens range that includes both prime and zoom lenses, while the Tokina range is smaller and composed primarily of zoom lenses (the exception being a 100mm macro lens). A more niche range of lenses is produced by Zeiss: these are manual focus prime lenses offering superb optical quality.

There are a few downsides when using a third-party lens, though. For a start, Canon doesn't support third-party lens profiles, so in-camera lens aberration correction will not work. However, using postproduction software such as Adobe Lightroom can solve this problem relatively easily (at least when shooting Raw).

Another potential problem is the long-term compatibility of a third-party lens with Canon cameras. Canon doesn't license its AF technology to others, so if it were to one day subtly change the way its AF technology worked this could mean that third-party lenses become incompatible. It's a small risk, but one that's worth thinking about.

SIGMA 18–35MM F/1.8 DC HSM ⌄
The world's first constant f/1.8 zoom lens designed specifically for APS-C cameras.
© Sigma

» DIFFRACTION

Since the aperture controls depth of field you'd think that to achieve maximum sharpness you'd want to use the smallest available aperture. In theory this is correct, since the smallest aperture will create maximum depth of field, but you may be disappointed by the results.

A lens is optically at its best 2 or 3 stops down from the maximum aperture (the exact aperture varies from lens to lens). Use a smaller aperture and image quality will drop noticeably. This is due to an effect known as "diffraction." When light enters a lens it is scattered randomly ("diffracted") as it strikes the edges of the aperture blade. This causes the resulting image to appear softer and the smaller the aperture, the worse the problem becomes. Therefore using a lens's smallest aperture is only advisable if it's absolutely necessary.

Unfortunately, using the mid-range of apertures means dealing with a reduced depth of field. Thankfully, there's a technique that can be used to optimise the depth of field for a particular aperture. The technique requires the lens to be focused to a point known as the "hyperfocal distance." By setting the lens to the hyperfocal distance, the image will be sharp from half that distance to infinity. Focusing this way and using the largest aperture that will comfortably cover the required depth of field means that you reduce the risk of diffraction.

On the following page are hyperfocal distance tables that cover the focal length range of the 18–135mm kit lens commonly sold with the EOS 70D. However, the tables can also be used for any lens with a focal length that falls between 18mm and 135mm.

**HYPERFOCAL «
DISTANCE**
The technique of focusing to the hyperfocal distance is particularly useful for scenes that need front-to-back sharpness.

To use the tables, first set the lens to the required focal length. Once you've set the focal length, focus at the hyperfocal distance (HD)—since some lenses don't have distance scales you may need to guess. Set the required aperture. It pays to be conservative so, if in doubt, set the aperture slightly smaller than that specified in the table. Now, depth of field will stretch from the Near point to Infinity. Note: all distances are in meters.

18mm: Hyperfocal distance

f/2.8		f/4		f/5.6		f/8		f/11		f/16	
Near	HD	Near	HD	Near	HD	Near	HD	Near	HD	Near	HD
3.05	6.09	2.13	4.26	1.52	3.05	1.07	2.13	0.78	1.55	0.53	1.07

24mm: Hyperfocal distance

f/2.8		f/4		f/5.6		f/8		f/11		f/16	
Near	HD	Near	HD	Near	HD	Near	HD	Near	HD	Near	HD
5.41	10.83	3.79	7.58	2.71	5.41	1.89	3.79	1.38	2.76	0.95	1.89

35mm: Hyperfocal distance

f/2.8		f/4		f/5.6		f/8		f/11		f/16	
Near	HD	Near	HD	Near	HD	Near	HD	Near	HD	Near	HD
11.5	23	8.06	16.1	5.76	11.5	4	8	2.9	5.9	4	2

50mm: Hyperfocal distance

f/2.8		f/4		f/5.6		f/8		f/11		f/16	
Near	HD	Near	HD	Near	HD	Near	HD	Near	HD	Near	HD
23.5	47	16.4	32.8	11.7	23.5	8.2	16.4	6	12	4.1	8.2

85mm: Hyperfocal distance

f/2.8		f/4		f/5.6		f/8		f/11		f/16	
Near	HD	Near	HD	Near	HD	Near	HD	Near	HD	Near	HD
68	135	48	95	34	68	24	48	17	35	12	24

135mm: Hyperfocal distance

f/2.8		f/4		f/5.6		f/8		f/11		f/16	
Near	HD	Near	HD	Near	HD	Near	HD	Near	HD	Near	HD
171	340	120	240	85	171	60	120	43	87	30	60

» DIFFRACTION

Longer focal length lenses allow you to keep your distance from your subject. I physically couldn't get close to these backlit ferns. However, a 100mm prime lens allowed me to bridge the gap. By using a large aperture, I was also able to throw the background out of focus so that it was less distracting.

Settings
> Aperture Priority **Av** mode
> ISO 100
> 1/100 at f/5.6
> Evaluative metering
> 100mm lens

» CANON LENSES

Lens	Field of view	35mm equivalent	Min. focus distance
EF 8–15mm f/4 L USM	118–83°	12.8–24mm	0.15m
EF-S 10–22mm f/3.5–4.5 USM	96–53°	16–35mm	0.24m
EF 14mm f/2.8 L II USM	81°	22mm	0.2m
EF 15mm f/2.8 Fish-eye	–	–	0.2m
EF-S 15–85mm f/3.5–5.6 IS USM	83–18°	22–136mm	0.35
EF 16–35mm f/2.8 L II USM	69–35°	25–56mm	0.28m
TS-E 17mm f/4 L	76°	27mm	0.25m
EF 17–40mm f/4 L USM	76–37°	27–64mm	0.28m
EF-S 17–55 f/2.8 IS USM	76–27°	27–88mm	0.35m
EF-S 17–85mm f/4–5.6 IS USM	76–18°	27–136mm	0.35m
EF-S 18–55mm f/3.5–5.6 III	73–27°	28–88mm	0.25m
EF-S 18–55mm f/3.5–5.6 IS STM	73–27°	28–88mm	0.25m
EF-S 18–55mm f/3.5–5.6 IS II	73–27°	28–88mm	0.25m
EF-S 18–135mm f/3.5–5.6 IS	73–11°	28–216mm	0.45m
EF-S 18–135mmm f/3.5–5.6 STM	73–11°	28–216mm	0.39
EF-S 18–200mm f/3.5–5.6 IS	73–7°	28–320mm	0.45m
EF 20mm f/2.8 USM	67°	32mm	0.25m
EF 24mm f/1.4 L II USM	58°	38mm	0.25m
EF 24mm f/2.8	58°	38mm	0.25
EF 24mm f/2.8 IS USM	58°	38mm	0.2
EF 24–70mm f/2.8 L USM	58–21°	38–112mm	0.38m
EF 24–70mm f/2.8 L II USM	58–21°	38–112mm	0.38m
EF 24–70mm f/4 L USM	58–21°	38–112mm	0.2m*
TS-E 24mm f/3.5 L	58°	38mm	0.3m
TS-E 24mm f/3.5 L II	58°	38mm	0.3m
EF 24–85mm f/3.5–4.5 USM	58–18°	38–136mm	0.5m
EF 24–105mm f/4 L IS USM	58–14°	38–168mm	0.45m
EF 28mm f/1.8 USM	51°	45mm	0.25m
EF 28mm f/2.8	51°	45mm	0.30m
EF 28mm f/2.8 IS USM	51°	45mm	0.23m
EF 28–80mm f/3.5–5.6 II	51–19°	45–128mm	0.38m
EF 28–90mm f/4–5.6 II USM	51–17°	45–144mm	0.38m

In macro mode at 70mm

Minimum aperture	Reproduction ratio	Filter size	Dimensions (mm)	Weight (grams)
f/22	1:25	67mm	79 x 83	540
f/22–f/29	1:5.8	77mm	83.5 x 89.8	385
f/22	1:6	rear	80 x 94	645
f/22	1:4.5	rear	73 x 62.2	330
f/22–f/36	1:5	72mm	81.6 x 88	575
f/22	1:4.5	82mm	88.5 x 111.6	635
f/22	1:5.8	n/a	88.9 x 106.9	820
f/22	1:4.2	77mm	83.5 x 96.8	500
f/22	1:5.8	77mm	83.5 x 110.6	645
f/22–f/32	1:5	67mm	78.5 x 92	475
f/22–f/36	1:3	58mm	68.5 x 70	195
f/22–f/38	1:3	58mm	69 x 75.2	205
f/22–f/36	1:3	58mm	68.5 x 70	200
f/22–f/36	1:5	67mm	75.4 x 101	455
f/22–f/38	1:4	67mm	77 x 96	480
f/22–f/36	1:4	72mm	78.6 x 162.5	595
f/22	1:5.8	72mm	77.5 x 70.6	405
f/22	1:6.3	77mm	93.5 x 86.9	650
f/22	1:6.3	58mm	67.5 x 58.5	270
f/22	1:6.3	58mm	68.4 x 55.7	280
f/22	1:3.4	77mm	83.22 x 123.5	950
f/22	1:3.4	82mm	88.5 x 113	805
f/22	1:3.4	77mm	83 x 93	600
f/22	1:7	72mm	78 x 86.7	570
f/22	1:2.9	82mm	78 x 86.7	570
f/22–f/32	1:6	77mm	73 x 69.5	380
f/22	1:4.3	77mm	83.5 x 107	670
f/22	1:5.6	58mm	73.6 x 55.6	310
f/22	1:7.7	52mm	67.4 x 42.5	185
f/22	1:7.7	58mm	68.4 x 51.5	280
f/28–f/39	1:3.8	67mm	67 x 71	220
f/22–f/32	1:3	58mm	67 x 71	190

» CANON LENSES

Lens	Field of view	35mm equivalent	Min. focus distance
EF 28–90mm f/4–5.6 III	51–17°	45–144mm	0.38m
EF 28--105mm f/3.5–4.5 II USM	51–14°	45–168mm	0.5m
EF 28–105mm f/4.0–5.6 USM	51–14°	45–168mm	0.48m
EF 28–135mm f/3.5–5.6 IS USM	51–11°	45–216mm	0.5m
EF 28–200mm f/3.5–5.6 USM	51–7°	45–320mm	0.45m
EF 28–300mm f/3.5–5.6 L IS USM	51–6°	45–480mm	0.7m
EF 35mm f/1.4 L USM	42°	56mm	0.3m
EF 35mm f/2	42°	56mm	0.25m
EF 40mm f/2.8 STM	37°	64mm	0.3m
TS-E 45mm f/2.8	33°	72mm	0.4m
EF 50mm f/1.2 L USM	30°	80mm	0.45m
EF 50mm f/1.4 USM	30°	80mm	0.45m
EF 50mm f/1.8 II	30°	80mm	0.45m
EF 50mm f/2.5 Compact Macro	30°	80mm	0.23m
EF 55–200mm f/4.5–5.6 II USM	27–7°	88–320mm	1.2m
EF-S 55–250mm f/4–5.6 IS	27–6°	88–400mm	1m
EF-S 60mm f/2.8 Macro USM	25°	96mm	0.2m
MP-E 65mm f/2.8 1–5x Macro	23°	104mm	0.24m
EF 70–200mm f/2.8 L IS II USM*	21–7°	112–320mm	1.2m
EF 70–200mm f/2.8 L USM*	21–7°	112–320mm	1.5m
EF 70–200mm f/4 L IS USM*	21–7°	112–320mm	1.2m
EF 70–200mm f/4 L USM*	21–7°	112–320mm	1.2m
EF 70–300mm f/4.5–5.6 DO IS USM	21–6°	112–480mm	1.4m
EF 70–300mm f/4–5.6 IS USM	21–6°	112–480mm	1.5m
EF 70–300mm f/4–5.6 L IS USM	21–6°	112–480mm	1.2m
EF 75–300mm f/4–5.6 III	20–6°	120–480mm	1.5m
EF 75–300mm f/4–5.6 III USM	20–6°	120–480mm	1.5m
EF 80–200mm f/4.5–5.6 II	19–7°	128–320mm	1.5m
EF 85mm f/1.2 L II USM	18°	136mm	0.95m

Indicates that a lens is compatible with Canon's Extenders

Minimum aperture	Reproduction ratio	Filter size	Dimensions (mm)	Weight (grams)
f/22–f/32	1:3	58mm	67 x 71	190
f/22–f/27	1:5.3	58mm	72 x 75	375
f/22–f/32	1:5.3	58mm	67 x 68	210
f/36	1:5.3	72mm	78.4 x 96.8	540
f/22–f/36	1:3.5	72mm	78.4 x 89.6	500
f/40	1:3.3	77mm	92 x 184	1670
f/22	1:5.6	72mm	79 x 86	580
f/22	1:4.3	52mm	67.4 x 42.5	210
f/22	1:5	52mm	68 x 27	130
f/22	1:6.3	72mm	81 x 90.1	645
f/16	1:6.7	72mm	85.8 x 65.5	580
f/22	1:6.7	58mm	73.8 x 50.5	290
f/22	1:6.7	52mm	68.2 x 41	130
f/32	1:2	52mm	67.6 x 63	280
f/22–f/27	1:4.8	77mm	92 x 184	1670
f/22–f/32	1:3	58mm	71 x 109	391
f/32	1:1	52mm	73 x 69.8	335
f/16	5:1	58mm	81 x 98	730
f/32	1:4.8	77mm	89 x 199	1490
f/32	1:4.8	77mm	76 x 193.6	1310
f/32	1:4.8	67mm	76 x 172	760
f/32	1:3.8	67mm	76 x 172	705
f/32–f/38	1:5.3	58mm	82.4 x 99	720
f/32–f/45	1:3.8	58mm	76.5 x 142.8	630
f/32	1:5	67mm	89 x 143	1050
f/32–f/45	1:4	58mm	71 x 122	480
f/32–f/45	1:4	58mm	71 x 122	480
f/22–f/27	1:4.8	52mm	69 x 78.5	250
f/16	1:9.1	72mm	91.5 x 84	1025

» CANON LENSES

Lens	Field of view	35mm equivalent	Min. focus distance
EF 85mm f/1.8 USM	18°	136mm	0.95m
TS-E 90mm f/2.8	17°	144mm	0.5m
EF 100mm f/2 USM	15°	160mm	0.9m
EF 100mm f/2.8 Macro USM	15°	160mm	0.31m
EF 100mm f/2.8 L Macro IS USM	15°	160mm	0.3m
EF 100-300mm f/4.5-5.6 USM	16-6°	160-480mm	1.5m
EF 100-400mm f/4.5-5.6 L IS USM*	16-3°5'	160-640mm	1.8m
EF 135mm f/2.8 soft focus	11°	216mm	1.3m
EF 135mm f/2 L USM*	11°	216mm	0.9m
EF 180mm f/3.5 L Macro USM*	8°	288mm	0.48m
EF 200mm f/2 L IS USM*	7°	320mm	1.9m
EF 200mm f/2.8 L II USM*	7°	320mm	1.5m
EF 200-400mm f/4 L IS*	7-3°5'	320-640mm	1.5m
EF 300mm f/2.8 L IS II USM*	6°	480mm	2m
EF 300mm f/4 L IS USM*	6°	480mm	1.5m
EF 400mm f/2.8L IS II USM*	3°5'	640mm	2.7m
EF 400mm f/4 DO IS USM*	3°5'	640mm	3.5m
EF 400mm f/5.6 L USM*	3°5'	640mm	3.5m
EF 500mm f/4 L IS USM*	3°4'	800mm	3.7m
EF 500mm f/4 L IS II USM*	3°4'	800mm	4.5m
EF 600mm f/4 L IS USM*	2°34'	960mm	4.5m
EF 600mm f/4 L IS II USM*	2°34'	960mm	4.5m
EF 800mm f/5.6 L IS USM*	1°55'	1280mm	6m

Indicates that a lens is compatible with Canon's Extenders

+ Indicates drop-in filter size

Minimum aperture	Reproduction ratio	Filter size	Dimensions (mm)	Weight (grams)
f/16	1:9.1	72mm	91.5 x 84	1025
f/32	1:3.4	58mm	73.6 x 88	565
f/22	1:7.1	58mm	75 x 73.5	460
f/32	1:1	58mm	79 x 119	600
f/32	1:1	67mm	77.7 x 123	625
f/32–f/38	1:5	58mm	73 x 121.5	540
f/32–f/38	1:5	77mm	92 x 189	1380
f/32	1:8.3	52mm	69.2 x 98.4	390
f/32	1:5.3	72mm	82.5 x 112	750
f/32	1:1	72mm	82.5 x 186.6	1090
f/32	1:8	52mm+	128 x 208	2520
f/32	1:6.3	72mm	83.2 x 136.2	765
f/40	1:4	58mm	73 x 121.5	540
f/32	1:5.5	52mm+	128 x 248	2400
f/32	1:4.2	77mm	90 x 221	1190
f/32	1:5.8	52mm+	163 x 343	3850
f/32	1:8.3	52mm+	128 x 232.7	1940
f/32	1:8.3	77mm	90 x 256.5	1250
f/32	1:8.3	52mm+	146 x 383	3190
f/32	1:6.5	52mm+	168 x 449	3920
f/32	1:8.3	52mm+	168 x 456	5360
f/32	1:8.3	52mm+	168 x 448	3920
f/32	1:7.1	52mm+	163 x 461	4500

5 FLASH

The EOS 70D has a useful built-in popup flash. It is also compatible with Canon's Speedlite flash range and many other third-party alternatives.

You have two choices when the ambient light levels are low: you can either increase the exposure (by using a longer shutter speed, a larger aperture, and/or increasing the ISO), or you can add your own light to the scene. The most common way to add light is to use flash, but achieving pleasing results is seen as something of a dark art. Fortunately, using flash is simpler than you might think, and once a few concepts have been grasped, illumination (often literally) soon follows.

There are two limitations with the EOS 70D's built-in flash and disappointment is more likely to arise if you're not aware of these. The first limitation is power. The built-in flash is not a particularly powerful light source, so its effective range is relatively small. The second limitation is that the built-in flash is a frontal light. Frontal lighting isn't particularly appealing, since it appears to flatten subjects, making them look less three-dimensional.

> **Note:**
> Canon uses the word Speedlite as a synonym for an external flash, and that's the convention we'll use in this chapter.

This chapter is an introduction to the world of flash with your EOS 70D, and a guide to how you can take a few simple steps to improve your flash photography.

BUILT-IN FLASH ⌃
Frontal lighting isn't particularly flattering to your subject, and can have the feel of a police "mugshot."

THEATRICAL »
Off-camera flash can be used to direct light more carefully when illuminating a subject.

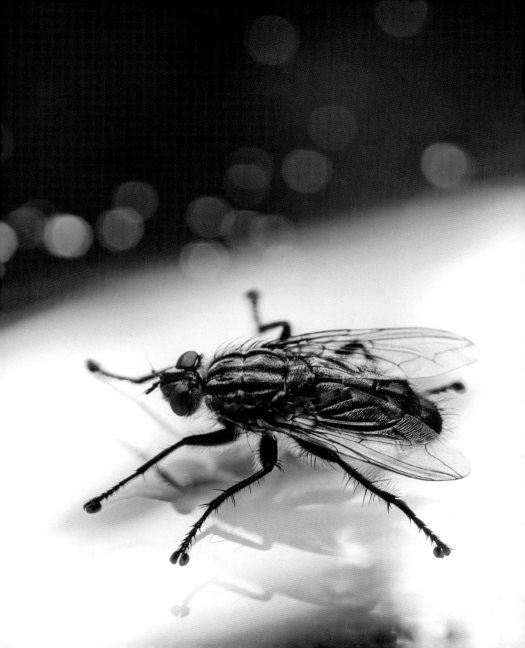

The basic components of a flash are a power source, a capacitor, and an airtight chamber filled with xenon gas. The process starts with the power source charging up the capacitor (the length of time it takes to do so is known as the "recycling time"). When the flash is fired, the capacitor is discharged, pulsing an electrical charge into the xenon gas. This charge causes the molecules of gas to release energy in the form of light.

If the flash is fired at full power, the capacitor's entire charge is used and the flash will need to recharge fully before it can be fired again. If the flash is fired at ½ power, then only ½ of the capacitor's charge is used and so the flash can be fired twice before needing to recharge. At ¼ power, the flash will be able to fire four times before needing to be recharged, and so on.

Although the power output to which the flash is set controls the amount of light released, the brightness of the flash is constant. What changes is the length of time that the flash emits light for. Think of it as an "energy tap." At full power, the "tap" is turned on until the capacitor is exhausted, resulting in a relatively long flash of light (approximately 1/800 second.). At ½ power, the energy "tap" is turned off in ½ that time (approximately 1/1600 sec.), which results in a halving of the light emitted. At ¼ power, the flash duration is halved again and the amount of light emitted reduced still further. Every halving of power results in less light emitted due to the duration of the flash getting shorter.

BUILT-IN ⌄

The EOS 70D's built-in flash works on exactly the same principles as a top-of-the-range Canon Speedlite.

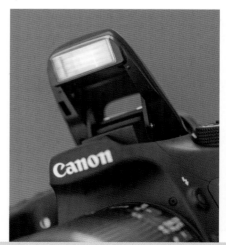

> **Note:**
> Using a lower power setting makes it easier to freeze movement with flash. The downside is that you need to be closer to your subject to effectively illuminate it.

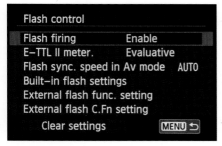

ADJUSTMENTS ⌃
The EOS 70D's Flash control menu.

There are two ways to control the light from the flash (or Speedlite if fitted). You can either let the EOS 70D determine the correct exposure automatically, or you can set the flash to manual and adjust the flash exposure to suit.

Canon uses a proprietary exposure system known as E-TTL II to automatically determine the correct exposure of flash. Generally, E-TTL II is an accurate system, but it is not foolproof. It can also lead to inconsistent results, with the flash exposure changing between shots depending on the reflectivity of your subjects.

Setting the flash exposure manually is slightly more complicated, but it does mean that the results are more predictable and therefore consistent. When flash is set to manual, there are two main ways to control its effective distance (the maximum distance that flash can

effectively illuminate a subject). The first method is to use flash exposure compensation, which can be set using the EOS 70D's Flash control menu or directly on a Speedlite if one is fitted (some Speedlites also let you change the power of the flash).

The second exposure control is the aperture set on the camera. The smaller the aperture used, the shorter the effective distance of the flash. If a subject is farther than the effective flash distance for the selected aperture, it will be underexposed, so you would need to use a larger aperture. Alternatively, if your subject is overexposed, this can be remedied by using a smaller aperture setting.

> **Notes:**
> The shutter speed has no influence on the flash exposure. However, the shutter speed you use will affect the exposure of any area of a scene not lit by light from the flash. This is useful for slow sync exposures, as described later in this chapter.
>
> Increasing the ISO also increases the effective distance of flash.

» GUIDE NUMBER

The power of a flash is referred to by its "guide number" or "GN," which tells you the effective range of the flash in either meters or feet. If you increase the ISO on your camera, the GN increases also, so to avoid confusion, camera and flash manufacturers generally use ISO 100 as the standard reference when quoting a GN.

If you know the GN of a flash, you can use it to determine either the required aperture value for a subject at a given distance, or the effective range of the flash at a specified aperture.

The formula to calculate both is:

Aperture=GN/distance
Distance=GN/aperture

The built-in flash on the EOS 70D has a GN of 12m/39.4ft at ISO 100. You can use the grid below to quickly work out the effective range of the built-in flash for a typical range of apertures and distances. There are also many apps available for smartphones that help make flash exposure calculations easier.

	Aperture					
ISO	**f/2.8**	**f/4**	**f/5.6**	**f/8**	**f/11**	**f/16**
100	14ft 4.2m	9.8ft 3m	7ft 2.1m	4.9ft 1.5m	3.6ft 1m	2.5ft 0.75m
200	20ft 6m	14ft 4.2m	9.8ft 3m	7ft 2.1m	4.9ft 1.5m	3.6ft 1m
400	28ft 8.6m	20ft 6m	14ft 4.2m	9.8ft 3m	7ft 2.1m	4.9ft 1.5m
800	40ft 12m	28ft 8.6m	20ft 6m	14ft 4.2m	9.8ft 3m	7ft 2.1m
1600	56ft 17m	40ft 12m	28ft 8.6m	20ft 6m	14ft 4.2m	9.8ft 3m
3200	80ft 24m	56ft 17m	40ft 12m	28ft 8.6m	20ft 6m	14ft 4.2m
6400	112ft 34m	80ft 24m	56ft 17m	40ft 12m	28ft 8.6m	20ft 6m
12,800	159ft 48m	112ft 34m	80ft 24m	56ft 17m	40ft 12m	28ft 8.6m

» THE BUILT-IN FLASH

The EOS 70D's GN of 12m/39.4ft makes it a relatively weak light, particularly if you compare it to the power of even the most modest of Canon's Speedlites. If you expect it to effectively illuminate a large room, think again. However, any flash is better than none when you need a little extra illumination, and the built-in flash is certainly useful as a fill-in light when shooting subjects close to the camera that are backlit.

When the mode dial is set to a Basic Zone mode, the built-in flash will either rise and fire automatically as required, or it is not available (see the grid below). To have complete control over the built-in flash (including the option of adjusting its power and setting red-eye reduction), you'll need to set your EOS 70D to one of the Creative Zone modes.

Raising and using the flash
1) Press the ⚡ button just above the lens-release button.

2) Press halfway down on the shutter-release button to focus as normal. If the flash is ready for use, ⚡ will be displayed at the bottom left corner of the viewfinder.

3) The flash needs to charge after use, so there may be a short delay before the next photo can be shot. During this time, ⚡ BUSY will be displayed in the viewfinder and BUSY ⚡ will be shown on the LCD.

4) Press down fully on the shutter-release button to take the photo.

Mode	M	Av	Tv	P	Ⓐ⁺	🄵	CA	🟡	🏔	🌷	🏃	🖼	🌃	🎆
Flash fires automatically	N	N	N	N	Y	-	Y	Y	-	Y	-	Y	N	-
Flash needs to be raised manually	Y	Y	Y	Y	N	-	N	N	-	N	-	N	Y	-
Flash can be disabled	-	-	-	-	N	-	Y	N	-	N	-	N	Y	-
Flash is disabled	N	N	N	N	N	Y	N	N	Y	N	Y	-	-	Y

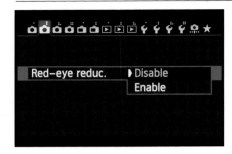

Red-eye occurs when direct on-camera flash (such as the EOS 70D's built-in flash) is used and your (human or animal) subject is looking directly at the camera. In this situation, the light from the flash bounces off the back of your subject's eyes toward the camera, picking up the color of the blood vessels inside the eyes as it does so. The problem is made worse by the fact that flash is most often used in low-light conditions when pupils in eyes are at their widest.

You can help prevent this by activating a red-eye reduction lamp before the final exposure is made. This causes the pupils of your subject's eyes to contract, and so reduces the risk of red-eye.

Enabling red-eye reduction
1) Select **Red-eye reduc.** on the 📷 menu.

2) Select **Enable** and then press the shutter-release button down lightly to return to shooting mode.

3) Press the shutter-release button down halfway to focus your camera. The orange red-eye reduction lamp should now light. Looking through the viewfinder, the usual exposure scale will be replaced by a bar. Keeping your finger on the shutter-release button, press down to take the shot when the bar disappears.

> **Notes:**
> The farther the flash is from the camera lens, the less risk of red-eye. This is impossible with the built-in flash, but is effective if you use an external flash away from the camera.
>
> Red-eye reduction is not available in 🌃, 🏞, 🏃, and 🍴 modes.
>
> Red-eye reduction is set to **Disable** by default.
>
> The red-eye reduction lamp isn't very subtle. If you want to maintain an element of surprise or avoid disturbing your subject switch red-eye reduction to **Disable**.

You can lock the flash exposure in a similar way to using AE lock. To determine the correct exposure before locking, the EOS 70D must first fire a preflash, so FE lock is not subtle. If you don't want your subject to know that you're taking a shot, don't use FE lock. FE lock can be applied to both the built-in flash and an attached Speedlite, and it is particularly useful when your subject is off-center and when the background may make normal flash exposure unreliable.

Notes:
If ⚡ blinks in the viewfinder, your subject distance exceeds the effective flash distance. Either move closer to your subject, use a wider aperture setting, or increase the ISO.

You cannot use FE lock when you are using Live View.

Setting FE lock
1) Raise the built-in flash, or attach and switch on your Speedlite.

2) Press the shutter-release button down halfway to focus. Check that ⚡ is displayed in the viewfinder.

3) Aim the camera at your subject, so that the subject is in the center of the viewfinder.

4) Press ✱. The flash will fire and the exposure details will be recorded. The word FEL will be briefly displayed in the viewfinder and ⚡* will replace ⚡. Each time you press ✱, the flash will fire and new exposure details will be recorded.

5) Recompose your shot and press the shutter-release button down fully to make the final exposure.

6) FE lock will still be fixed: press ▦ to cancel it and resume normal shooting.

» FLASH CONTROL MENU

The **Flash control** menu (on ![camera icon]) allows you to set the shooting parameters of the built-in flash and compatible Speedlites (when fitted and switched on).

› Flash firing

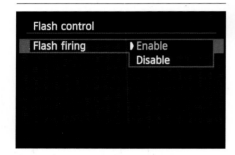

Set to **Enable**, the flash or Speedlite will fire when a shot is taken. Set to **Disable**, neither will fire, but the AF assist beam on the Speedlite will still activate (if it has one). The AF assist beam is most useful when there is not enough ambient light for effective autofocusing.

› E-TTL II Metering

E-TTL II stands for "evaluative through-the-lens" metering. Flashes were once fitted with sensors that determined the correct exposure, but E-TTL II hands this responsibility to the camera. This makes flash exposures more accurate, particularly

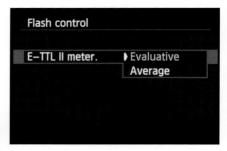

if the flash is used off-camera and/or when filters are used.

The system works by firing two bursts of light from the flash. The first burst of flash is used by the camera to determine the optimum exposure, and the second burst is used to make the exposure, with the power of the flash modified so that the subject is correctly exposed. This happens so quickly that you and your subject won't even be aware that there were two bursts of flash. If used with a compatible lens, the E-TTL II system also uses the focus distance as a factor in determining accurate exposure. See the grid opposite for a list of E-TTL II compatible lenses.

The EOS 70D offers two methods of E-TTL II metering. The default is **Evaluative** and is the recommended method, but if you're using a lens that doesn't supply focus distance information, **Average** may be preferable. Experimentation will determine which is most suitable for your purposes.

Fully E-TTL II compatible lenses that supply distance information

(lenses in gray have been discontinued)

EF-S 10–22mm f/3.5–4.5 USM	EF-S 18–55mm f/3.5–5.6 IS
EF 70–200mm f/2.8L IS USM	EF 100mm f/2 USM
EF 14mm f/2.8L USM	EF 20mm f/2.8 USM
EF 70–200mm f/2.8L USM	EF 100mm f/2.8 Macro USM
EF 16–35mm f/2.8 L USM	EF 20–35mm f/3.5–4.5 USM
EF 70–200mm f/4 L USM	EF 100mm f/2.8 Macro L USM
EF 16–35mm f/2.8 L II USM	EF 24mm f/1.4 L USM
EF 70–210mm f/3.5–4.5 USM	EF 100–300mm f/4.5–5.6 USM
EF 17–35mm f/2.8 L USM	EF 24–70mm f/2.8 L USM
EF 70–300mm f/4.5–5.6 DO IS USM	EF 100–400mm f/4.5–5.6 L IS USM
EF 17–40mm f/4 L USM	EF 24–70mm f/2.8 L II USM
EF 70–300 f/4–5.6 IS USM	EF 135mm f/2 L USM
EF-S 17–55mm f/2.8 IS USM	EF 24–85mm f/3.5–4.5 USM
EF 85mm f/1.2 II L	EF 180mm f/3.5 L Macro USM
EF-S 18–55mm f/3.5–5.6 USM	EF 24–105mm f/4 L IS USM
EF 85mm f/1.8 USM	EF 200mm f/2 L IS USM
EF-S 18–55mm f/3.5–5.6	EF 28mm f/1.8 USM
EF 90–300mm f/4.5–5.6 USM	EF 200mm f/2.8 L USM
EF-S 18–55mm f/3.5–5.6 II	EF 28–70mm f/2.8 L USM
EF 90–300mm f/4.5–5.6	EF 200mm f/2.8 L II USM

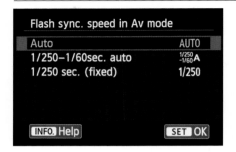

The fastest shutter speed you can use with flash is 1/250 sec. However, you don't have to stick to this shutter speed every time you use flash. If you're shooting in low light, you may find that 1/250 sec. is too fast to record details in the areas not illuminated by flash.

Slow sync is the technique of using shutter speeds longer than the X-sync speed to expose the parts of a scene lit only by ambient light. It is most effective when ambient light is low, but still usable, and where you can use flash to illuminate your subject. The lower the ambient light level, the longer the shutter speed and so the greater the risk of camera shake—as the ambient light level drops, there's more need to use a tripod. **Flash sync. speed in Av mode** lets you change how the camera sets the shutter speed in **Av mode** when using flash.

Setting Flash sync. speed in Av mode
1) Select Flash control on the ◘ menu followed by **Flash sync. speed in Av mode.**

2) Select the option you require (see below). Press down lightly on the shutter-release button to return to shooting mode and set the mode dial to **Av**.

Option	Result
Auto	The EOS 70D will use a shutter speed of between 30 sec. and 1/200 sec. to achieve correct exposure for non-flash-lit areas. Hi-speed sync with a compatible Speedlite is still possible.
1: 1/250–1/60 sec. auto	To minimize the risk of camera shake, the EOS 70D will use only a shutter speed between 1/60 sec. and 1/250 sec. Areas that are not illuminated by flash may be underexposed.
2: 1/250sec. (fixed)	Only the sync speed of 1/250 sec. is available. Areas that are not lit by flash may be underexposed, but the risk of camera shake is minimized.

» BUILT-IN FLASH SETTINGS

Select **Built-in flash** on the **Flash control** menu and you'll be taken to another screen of options that allow you to further refine the use of the built-in flash.

› Flash mode

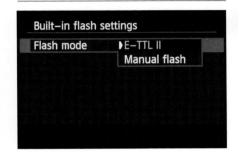

You can either set your Speedlite to use **E-TTL II** metering (the default) or switch to **Manual flash** exposure. Once set to **Manual flash**, you must determine the flash exposure yourself, taking into account the guide number of the flash, its power output, and the ISO and aperture you've set on your EOS 70D.

› Shutter sync

The shutter in your EOS 70D is composed of two light-tight metal curtains, one in front of the other. When the shutter-release button is pressed down, the first curtain begins to rise, exposing the sensor to light. After a set

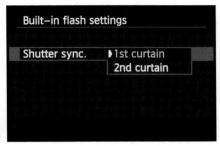

period of time, the second curtain follows, stopping the sensor's exposure to light as it does so. The period of time between the first and second curtains rising is the length of the selected shutter speed.

When you use first curtain sync, the flash is fired when the first curtain starts to rise. The movement of your subject across the frame during the exposure will be frozen by the light from the flash at the start of the exposure. If the shutter speed is sufficiently long, the rest of the exposure will be lit by available light and any subsequent movement will be recorded as a blur that appears in front of the (flash-lit) subject.

If you set the camera to use second curtain sync, the flash is fired when the second curtain starts to rise. The movement of your subject is frozen by the flash at the end of the exposure, resulting in the movement being recorded as a blur behind the subject. Of the two settings, second curtain sync usually looks more natural.

› Flash exposure compensation

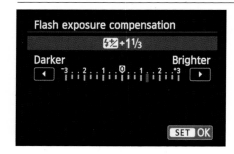

By default, your EOS 70D uses E-TTL II metering to correctly calculate the exposure for the built-in flash and any fitted Speedlite. However, it's not infallible and sometimes your flash exposures can be inaccurate. As with standard exposure, you can apply exposure compensation to your flash images, up to ±2 stops. Flash exposure can be adjusted one of two ways on your EOS 70D:

Notes:
Although you can apply exposure compensation to your flash, you will not be able to increase the effective flash distance for your chosen aperture unless in addition you increase the ISO.

You may also be able to adjust the flash exposure compensation on the Speedlite (depending on the model).

Flash exposure compensation: method 1

1) Press the Q button.

2) Select 🔆 on the Quick Control menu screen.

3) Turn 🎛 to the left to decrease the power of the flash or to the right to increase it. 🔆 will be shown in the viewfinder.

4) Press down lightly on the shutter-release button to return to shooting mode.

Flash exposure compensation: method 2

1) Select **Flash control** on the 📷 menu followed by **Built-in flash settings**.

3) Select 🔺 **exp. comp.** Press ◀ to decrease the power of the flash or ▶ to increase it.

4) Press (SET) to apply the changes and return to the **Built-in flash settings** screen.

› Wireless func.

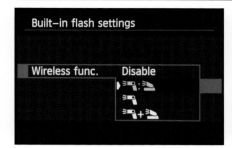

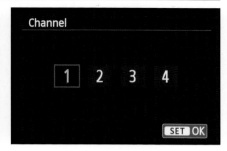

Your EOS 70D's built-in flash can be used to trigger external (and wireless-compatible) Speedlites. This is useful, since it allows you greater freedom in how your subject is lit by the Speedlites.

In this scenario, the built-in flash is referred to as the "master" flash, since it controls when the Speedlites fire. The Speedlites, because they are being controlled, are referred to as "slave units." Although this technique is known as wireless flash (because there is no physical connection), information is passed between flashes using infrared control. The infrared sensor on a wireless-compatible Speedlite is found on the front panel below the flash head, and if the sensor can't "see" the master flash the Speedlite may not be triggered successfully. Using the Speedlite's bounce head is a good way of directing the flash head toward the subject while keeping the sensor aimed toward your EOS 70D.

The use of infrared light also limits the distances over which wireless flash can be used: you need to keep a Speedlite within 10m/33ft and 80° of the camera indoors or 5m/16.5ft and 80° of the camera outdoors.

To start using wireless flash, set **Wireless func.** to an option other than **Disable** (see the table over the page for a description of the other options). To avoid triggering the wrong Speedlites (if another photographer is working in the same area, for instance), you can assign a **Channel** number between 1 and 4. Both your EOS 70D and Speedlite need to be set to the same channel number (which should be different to the channel number of any Speedlite you don't want to fire).

Wireless func.	Options
⁼🔦:🔌	Allows you to use the built-in flash to trigger one external Speedlite. When this option is selected, you can adjust the **Flash expo. comp** (affecting both the built-in flash and Speedlite), as well as 🔦:🔌 (also known as the flash ratio, which is how bright the built-in flash is compared to the Speedlite). Both options are shown on the **Wireless func.** menu screen when ⁼🔦:🔌 is selected.
⁼🔦:	When this option is selected, the built-in flash does not illuminate the subject: it's only used to trigger one or more Speedlites. If you're using multiple Speedlites, these can be split into a **Firing group** for greater control over lighting (see below).
⁼🔦:+🔌	This option allows you to use the built-in flash to trigger one or more Speedlites, and both are used to illuminate your subject. It's more flexible than ⁼🔦:: 🔌, since you can adjust the exposure of the built-in flash and Speedlites by setting **Flash expo. comp** separately for both. As with ⁼🔦:, if you're using multiple Speedlites, these can be split into a Firing group for greater control over lighting.

Firing group	Options
🔦 All	Treats multiple Speedlites as one unit so that the exposure settings are common to all.
🔦 (A:B)	Allows you to split multiple Speedlites into two groups (A and B). The ratio between the two groups can be controlled using **A:B fire ratio**.
🔦 All and 🔌	Lets you set the **Flash expo. comp** of the built-in flash and Speedlite(s) separately.
🔦 (A:B) 🔌	Lets you set the **Flash expo. comp** of the built-in flash and grouped Speedlite(s) separately, as well as the **A:B fire ratio** of the grouped Speedlites.

Other	Options
🔦:🔌	Sets the ratio of the built-in flash to the Speedlite(s). 1:1 means that the power of the flashes is equal, while 8:1 means that the Speedlite's output is ⅛ the power of the built-in flash.

» EXTERNAL FLASH

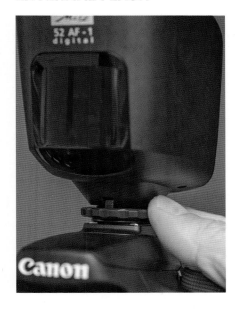

The hotshoe above the built-in flash allows you to attach an external flash. Although the basic hotshoe is a standard design used by most camera manufacturers, the electrical connections differ between brands. For this reason, you should only use flash units designed for Canon cameras with your EOS 70D. Canon currently produces five compatible Speedlites, which it refers to as the EX series. Usefully, the model number divided by ten is the GN of the Speedlite in meters (the Speedlite 320EX has a guide number of 32m, for example).

Although Canon recommends that you don't use third-party flashes, companies such as Sigma and Metz produce flash units that are compatible with the EOS 70D, including some that support functions such as wireless flash. Certain Speedlite functions can be set using the **External Flash Function Settings** found on the **Flash Control** menu screen; some functions may need to be set on the Speedlite itself.

Fitting an external flashgun
1) Make sure that both your EOS 70D and Speedlite are switched off.

2) Slide the Speedlite shoe into the hotshoe of the camera. If your Speedlite has a locking collar, press the locking button and slide the collar around until it clicks into the locked position.

3) Turn the Speedlite on first, followed by the EOS 70D.

4) A $\frac{1}{2}$ symbol will be displayed in the viewfinder of the EOS 70D, or on the LCD if you are in Live View.

5) To remove the Speedlite, switch off the EOS 70D and Speedlite, and reverse the procedure in step 2.

» EXTERNAL FLASH FUNCTION SETTINGS

The **External flash func.** setting screen allows you to set the shooting functions of compatible Speedlites in-camera rather than on the Speedlite itself.

Changing options on the External flash func. setting menu

1) Fit your Speedlite as described on the previous page. Turn both your camera and the Speedlite on.

2) Select **Flash Control** on the ◙ menu and then **External flash func. setting.** Anything you change on this menu will be applied automatically to the Speedlite.

3) Select the function you want to change by using ✳ and then pressing (SET). Select the required option by pressing ◀ / ▶ and then (SET). Press (SET) to continue.

4) If you want to change the custom functions of the Speedlite, these can be altered on the **Flash C.Fn settings** submenu. The available custom functions will vary between Speedlites.

5) Press **MENU** to return to the main ◙ menu, or press lightly down on the shutter-release button to return to Shooting mode.

SPECIFICATIONS ⌄
The external flash functions available depend on the specifications of the Speedlite you use.

› Flash mode

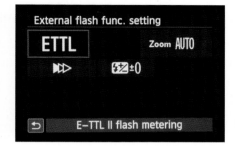

As with the built-in flash setting screen, this option lets you set whether the flash uses E-TTL II metering or whether the exposure is determined manually. Other options may also be available depending on the specifications of your Speedlite.

› Wireless functions

Sets the wireless function—either optical or radio—of your Speedlite.

› Flash zoom

If your flash has a compatible zoom head, setting **Flash zoom** to **Auto** will ensure that the zoom adjusts to match the focal length of the lens to give you even coverage across the image frame. You can, however, choose to adjust the focal length of the zoom head on the flash yourself.

This would usually be done if you used a lens that didn't supply the necessary focal length information for Auto zoom. However, you can also zoom the flash head for creative effect: to focus the light from the Speedlite more on your subject and leave the area around the edge of the frame darker.

› Flash exposure bracketing

Bracketing with a Speedlite is similar in concept to standard exposure bracketing. It is not a feature you will find on every Speedlite, though—in fact, it's restricted to all but the high-end Speedlites such as the 600 EX-RT (it's certainly not available when using the built-in flash). Instead of the exposure for the ambient light altering, the Speedlite output is altered between shots. Bracketing can usually be applied in ⅓-, ½-, or 1-stop increments.

This option lets you set whether your Speedlite is fired using first or second curtain sync. It also lets you set high-speed sync (HSS). The sync speed (or X-sync) on a camera is the fastest shutter speed at which the entire image is illuminated evenly by the light from a Speedlite.

The EOS 70D's 1/250 sec. sync speed limit is usually not a problem, since flash is generally used in low light when a slower

shutter speed would be required anyway. However, flash is also useful as a fill light for backlit subjects in bright conditions. Using flash in this way it's all too easy to require a shutter speed faster than 1/250 sec., particularly if you want to use a wide aperture to minimize depth of field.

To get around this limitation, Canon's current Speedlites (with the exception of the 90EX) have an HSS mode that enables you to use shutter speeds up to 1/8000 sec. in combination with flash. High-speed sync works by pulsing the Speedlite output to "build up" the exposure as the shutter curtains travel across the sensor (effectively turning the flash into a constant light source during the exposure). This reduces the power of the flash (and therefore its effective distance), but as long as you keep your subject relatively close to the camera, high-speed sync is an invaluable technique for creative flash photography.

> **Note:**
> For an explanation of shutter sync, see **Built-in flash settings** earlier in this chapter.

HSS «
High-speed sync makes it easier to balance the exposure of the background with the flash-lit subject.

» CANON SPEEDLITES

› SPEEDLITE 90EX

The 90EX is the most recent Speedlite released by Canon. It's also the smallest, lightest, and the least powerful—the GN is actually lower than the EOS 70D's built-in flash. The 90EX was originally designed for Canon's EOS M camera (and is usually bundled with that camera), but it is also compatible with the EOS 70D. Unusually for such a low-powered, low-specification Speedlite, it can be used as a master flash to trigger other compatible flashes. However, since the EOS 70D's built-in flash can perform this trick as well, the 90EX can be safely discounted.

Guide number (GN)
29ft/9m (at ISO 100)

Tilt/swivel
No

Focal length coverage
Min. 24mm*

AF-assist beam
Yes

Flash metering
E-TTL II/E-TTL

Approximate recycling time
5.5 seconds

Batteries
2 x AAA/LR03

Dimensions (w x h x d)
1.7 x 2 x 2.5in./44 x 52 x 65mm

Weight
1.8oz./50g (without batteries)

*35mm equivalent

The 270EX II is the next model up in Canon's range. It's not a particularly powerful flash, although it is more powerful than the EOS 70D's built-in unit. The 270EX II also features a zoom and bounce head, and rapid, near-silent recharging. The 270EX II can be used wirelessly as a slave flash in conjunction with a suitable master Speedlite or the built-in flash. However, unlike the 90EX, it cannot be used as a master flash to fire other Speedlites.

Guide number (GN)
89ft/27m (at ISO 100)

Tilt/swivel
Tilt only

Focal length coverage
28–50mm*

AF-assist beam
Yes

Flash metering
E-TTL II/E-TTL

Approximate recycling time
3.9 seconds

Batteries
2 x AA/LR6

Dimensions (w x h x d)
2.5 x 2.6 x 3.0in./64 x 65 x 72mm

Weight
5.1oz./155g (without batteries)

Other information
HSS

Included accessories
Soft case, shoe stand, manual

*35mm equivalent

› SPEEDLITE 320EX

The 320EX is a relatively recent addition to the Speedlite range, and is larger and more powerful than the 270EX II. The most distinctive aspect of the 320EX is the built-in LED light in addition to the main flash head. The LED light is there to provide a constant light source when shooting movies. In theory this is a good idea, but in practice the light isn't that powerful so your subject needs to be very close to the camera to be illuminated evenly. Like the 270EX II, the 320EX can be used as a slave flash, but does not have master flash capability.

Guide number (GN)
104ft/32m (at ISO 100)

Tilt/swivel
Yes

Focal length coverage
24–50mm*

AF-assist beam
Yes

Flash metering
E-TTL II/E-TTL

Approximate recycling time
2.3 seconds

Batteries
4 x AA/LR6

Dimensions (w x h x d)
2.75 x 4.5 x 3.09in./70 x 115 x 78.4mm

Weight
9.7oz./275g (without batteries)

Other information
HSS

Included accessories
Soft case, shoe stand, manual

*35mm equivalent

The Speedlite 430EX II is the smaller, less powerful sibling to the top-of-the-range 600EX-RT. It can be used fitted to the EOS 70D, or as a slave flash, triggered by the EOS 70D's built-in flash. The 430EX II features high-speed, first and second curtain flash synchronization, has comprehensive exposure compensation options, and nine custom functions.

Guide number (GN)
141ft/43m (at ISO 100)

Tilt/swivel
Yes

Focal length coverage
14–105mm

AF-assist beam
Yes

Flash metering
E-TTL II/E-TTL

Approximate recycling time
0.1–3.7 seconds

Batteries
4 x AA/LR6

Dimensions (w x h x d)
2.8 x 4.8 x 4.0in./72 x 122 x 101mm

Weight
11.6oz./320g (without batteries)

Other information:
HSS, first and second curtain sync

Included accessories
Soft case, shoe stand, manual

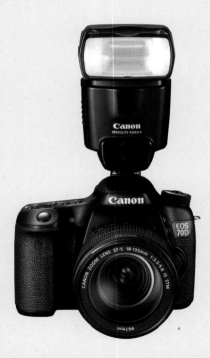

› SPEEDLITE 600EX-RT

Announced in March 2012, the Speedlite 600EX-RT replaced the 580EX II as the largest, heaviest, and highest specified flash in the Canon range. The 600EX-RT has integrated radio-triggering as well as infrared wireless flash control, improved weather sealing, high-speed synchronization, and 18 custom functions. However, its size and weight make it a tricky proposition to use when fitted to the EOS 70D; the combination feels top-heavy, particularly if a small, lightweight lens is used. It is best used as an external flash, triggered by the EOS 70D's built-in flash.

Guide number (GN)
196.9ft/60m (at ISO 100)

Tilt/swivel
Yes

Focal length coverage
14–200mm

AF-assist beam
Yes

Flash metering
E-TTL II/E-TTL/TTL/Manual

Approximate recycling time
0.1–5.5 seconds
(0.1–3.3 seconds using quick flash)

Batteries
4 x AA/LR6

Dimensions (w x h x d)
3.1 x 5.6 x 4.9in./79.7 x 142.9 x 125.4mm

Weight
15oz./425g (without batteries)

Other information:
HSS, first and second curtain sync

Included accessories
Soft case, shoe stand,
color filters (with case and holder)

> Bounce flash

The light from a Speedlite mounted on your camera isn't very flattering. This is partly because the light from a flash is a point light source. A point light source is relatively small in comparison to the subject being lit. This creates high contrast with bright highlights and deep shadows, which have sharply defined edges.

Fortunately, all of the current Speedlites (with the exception of the 90EX) allow you to angle the flash head upward (and sideways on some models) so you can use a technique known as "bounce flash." By bouncing the light off a surface such as a low ceiling or white card, the area that the light appears to emanate from is increased. This has the effect of softening the light and reducing contrast. Softer light makes shadows less hard, and the transition from light to dark is more attenuated.

There are two potential problems to be aware of when using bounce flash. The first is the risk of a color cast caused by the light picking up the color from the surface you bounce it from. If possible, try to use a neutrally colored surface to bounce from, unless you deliberately want to add color to the light.

The second problem is that you are increasing the flash-to-subject distance by bouncing the light, so your image will be underexposed if your flash isn't powerful enough or you use an aperture setting that is too small.

BOUNCED **«**
The image on the left was shot with the Speedlite pointed toward the subject, while the image on the right was shot with the Speedlite pointing upward and the light bounced off a reflector.

› Flash diffusers

Diffusers also help to soften the light from a flash. As with bounce flash, this is achieved by increasing the area from which the light appears to emanate. Diffusers come in a variety of sizes and shapes. The simplest are the size of the flash head—which is where they are fitted—and are usually made of translucent plastic. A similar effect can be achieved by taping tissue paper to the flash head. Because of their size, they are only marginally better than naked flash, but are usually cheap and worth keeping in a camera bag.

Box-type diffusers are slightly more sophisticated. Although they are larger, and can be cumbersome, they are very effective at softening the light from a flash. The largest type requires the use of a stand, which means using your Speedlite off-camera, either connected by a cord or using a wireless transmitter to fire it. The larger the diffuser, the softer the light will be.

Canon doesn't produce diffusers for its Speedlite range, but there are plenty of third-party manufacturers who do, including respected companies such as Sto-Fen and Lumiquest.

BOX DIFFUSER »
Lastolite EZYBOX flash diffuser.

ACCESSORIES

It's perfectly possible to use your EOS 70D straight from the box and never purchase another piece of equipment. In practice, though, most photographers expand their photographic equipment with a variety of different accessories.

Accessories seem to fall into three camps, starting with those that are invaluable. They may not necessarily be cheap—in fact, they may be very costly—but they are justifiable because they add to a camera's capabilities. Tripods fall into this category.

The second type of accessory is useful, although not strictly necessary. Hotshoe spirit levels arguably fall into this category (particularly if you're more inclined to portrait photography rather than landscapes).

The final type of accessory is fun for a few moments, but then is never used again. This type of accessory usually ends up at the back of a drawer, forgotten and unlamented.

The moral is that it pays to be critical when choosing accessories for your camera. This involves being honest with yourself about your way of working and whether your purchase will genuinely enhance your photography or whether it's just a one-day wonder.

SYSTEM ^
The EOS 70D is a "system" camera, so called because it's the hub for a system of accessories that can be used to expand its capabilities.

FILTERS »
ND Graduated filters are often necessary to retain detail in areas of a scene that aren't lit by direct light.

» FILTERS

A filter is a shaped piece of glass, gelatin, or optical resin that is designed to affect the light that passes through it to one degree or another. Filters are sold in two different forms: round and threaded, so the filter can be screwed to the front of a lens, or square/rectangular, to be slotted into a holder attached to the lens.

Round filters are usually less expensive than those designed for a filter holder, but if you have several lenses with different filter thread sizes, you may need to buy the same filter several times over. One solution is to buy filters for the lens with the largest filter thread size and then use adapters to fit them onto the smaller lenses.

The alternative is a filter "system," which combines a filter holder with slot-in filters. Probably the best-known filter system manufacturer is Cokin, who produce four sizes of filter holders: the A-system, which takes 67mm filters; the 84/85mm P-system; the 100mm Z-Pro system; and the 120mm X-Pro system. An alternative to Cokin is Lee Filters, which makes a popular 100mm system that is compatible with Cokin's Z-Pro system. Both systems use inexpensive adapter rings that allow you to use the same filter holder (and therefore the same filters) on various lenses.

LEE FILTER HOLDER »
A Lee filter holder with 100mm polarizing filter attached.

› UV and skylight

UV and skylight filters absorb ultraviolet light. This is typically found at high altitude and on hazy days, and can cause a distinct blue cast in an image. Skylight filters have a slightly pink tint to them, helping to warm up the image, while UV filters are more neutral. Neither filter affects exposure. For this reason, they are often used to protect the front elements of lenses from damage, although "clear" lens protection filters are also available for this purpose.

> **Notes:**
> Don't use **AWB** if you use a colored filter (even one with a faint coloring such as a Skylight filter): **AWB** will try to correct for the color of the filter.
>
> The filter thread size is shown on the front face of all Canon lenses. It can also be found inside the lens cap.

› Neutral density filters

Much is made of the fact that modern DSLR cameras have excellent high ISO performance, which makes it easier to shoot handheld in low-light conditions while avoiding camera shake. However, there are occasions when a lower ISO than the base ISO is beneficial. Even ISO 100 (the lowest setting on the EOS 70D) can be too sensitive at times. If you're working in bright conditions, it can be difficult to achieve longer shutter speeds or larger apertures at ISO 100; this can be especially problematic when shooting movies.

Fortunately, there is a solution: the neutral density (or ND) filter. ND filters are semi-opaque and block some of the light that passes through them, effectively simulating lower light conditions. This is achieved without altering the color of the light, hence the name. ND filters are available in a variety of strengths, from 1-stop (which is equivalent to halving the ISO speed) to very dense 10- or 12-stop filters.

As long as the ND filter isn't too dense, the EOS 70D's exposure and AF systems should be able to cope with it without a problem. If the AF system struggles (and this is inevitable when a 10- or 12-stop filter is used), it is a good idea to focus before fitting the filter and then switch to MF so that the focus doesn't shift when the filter is fitted. If there is plenty of light, Live View AF is sometimes able to cope even when very dense filters are used, although having a lens with a large maximum aperture is helpful.

MOVEMENT ⌄
The longer the shutter speed, the more abstract recorded movement becomes.

Tips

ND filters are often sold using an optical density figure. A 1-stop ND filter has an optical density of 0.3, a 2-stop is 0.6, and so on.

When light reflects from a non-metallic surface, its rays are scattered randomly. This causes glare on the surface and an apparent reduction in its color saturation. Light that's been scattered in this way has been polarized. A polarizing filter cuts out this polarized light from every plane but one, restoring color saturation and reducing glare. The effect can be seen on surfaces as diverse as water, shiny paint, and even wet or glossy leaves on trees. The effect works best when the camera/polarizer combination is used at 35° to the surface.

The most striking effect of a polarizer is the deepening of blue sky. This effect is strongest when the polarizer is pointed toward the sky at 90° to the sun. Move the polarizer away from this angle and the effect diminishes—at 180°, a polarizer has no effect on the sky at all. The height of the sun will also affect how strongly the polarizing filter appears to work.

Polarizers are made of glass mounted in a holder that can be rotated through 360°. This allows the strength of the polarizing effect to be varied by rotating the holder. A polarizer is slightly opaque and this will reduce the amount of light reaching the sensor. The exposure meter in the EOS 70D should automatically compensate when a polarizer is fitted, but if you're shooting in **M** or **B** modes, you'll need to compensate the exposure manually. The amount of compensation required will vary, but 2 stops is a good starting point when the filter is used at "full strength."

Tips

Because a polarizer cuts out light, it can also be used as an ND filter.

Polarizing filters are available as either linear or circular types. This has nothing to do with the shape, but with the way in which they polarize light. For technical reasons, linear polarizers are only really suitable when using a lens set to MF or when using Live View AF.

SKIES »

Polarizing filters can be used to boost the blues in the skies. It's particularly effective in slightly cloudy skies, but can make a completely clear sky appear unnatural.

» SUPPORTING THE CAMERA

› Tripods

The tripod is a slightly underrated piece of photographic equipment, more so than ever before. Modern digital cameras, such as EOS 70D, can be used at high ISOs with only a moderate drop in image quality. If you've got a lens with a wide maximum aperture, it's possible to handhold a camera in low light and still obtain sharp results, but there are techniques for which a tripod is still necessary.

Tripods are most useful when you're using a slow shutter speed: when you're working in low light and using small apertures for depth-of-field reasons, a tripod is essential. Apart from their practical benefits, a tripod also forces a slower pace of photography, so it encourages more thought to be given to how a shot is composed and exposed. Because a more self-disciplined approach is required, editing happens more at the shooting stage.

The EOS 70D is far from being a heavy camera, but it's still important to choose a tripod that will be stable. This means choosing a tripod that can be raised to a reasonable height without the use of the center-column (although you don't want to pick a tripod that's so heavy you're

discouraged from using it). There's a definite compromise between weight and stability. Carbon fiber tripods generally offer the best weight to stability ratio, but they are usually far more expensive than a plastic or aluminium equivalent.

Tripods are sold either as one unit—head included—or as a set of legs to which a separate head must be attached. The latter option is more expensive, since you need to buy two things rather than one, but it does give you more choice in how your tripod operates.

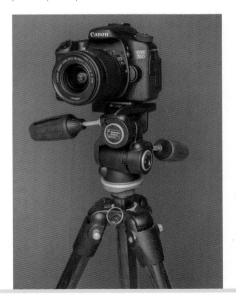

SUPPORT »
Canon EOS 70D on a Manfrotto carbon fiber tripod and 3-way head.

There are three main types of tripod head. Ball heads are light, but strong, although they can be fiddly when small adjustments are required. Three-way tripod heads are simple to use, with the head being adjustable in three different directions. Geared heads are the easiest to make fine adjustments to, but tend to be heavy and expensive. Although tripod manufacturers generally make both legs and heads, there's no reason not to mix and match, using the head from one manufacturer on the legs of another.

Tips

If you're using a tripod and your lens has Image Stabilization, be sure to turn IS to off.

Tripods are most useful when paired with a remote release. If you don't have a remote release, using mirror lock-up combined with the camera's self-timer will help reduce the risk of camera movement during an exposure.

› Other supports

A useful alternative to a tripod is a monopod. As the name suggests, a monopod has just one leg, so it is less stable than a tripod—you wouldn't use one when shutter speeds are measured in full seconds,

for example. However, at moderately slow speeds they still offer far more support to a camera than handholding alone. Some monopods can also be used as walking poles, which is useful if you're a landscape photographer who climbs hills regularly.

A beanbag is another useful item to keep in a kit bag, allowing you to rest your camera on a flat surface such as a wall, damping down vibrations, and preventing scratches to the base of your EOS 70D.

FLEXIBILITY ⌄
For event photography, a tripod is too cumbersome. A monopod, although offering less support, is far quicker and easier to use.

» OTHER ACCESSORIES

Remote switches

A remote switch allows you to fire the shutter-release button without touching the camera. They're not suitable for all types of photography—you wouldn't use one for sports photography, for example—but they are almost essential if you use a tripod. Canon currently sells two types of remote switch that are compatible with the EOS 70D: one that connects via a cable and another that uses infrared.

The RS-60E3 is the cable type and it allows you to fire the shutter, as well as lock it open when using Bulb. The RC-6 uses an infrared beam to fire the shutter (the sensor on the camera is in the grip at the front). The RC-6 is a simple device, with functions limited to firing the shutter immediately or after a 2-second delay. The two drawbacks to the RC-6 are its limited range and the fact that you need to maintain line of sight between the camera and the remote switch.

The EOS 70D can also be controlled remotely using its Wi-Fi function—*see chapter 8* for more details.

GPS receiver GP-E2

The GP-E2 fits to your EOS 70D's hotshoe and records the location information (longitude, latitude, elevation, and direction) of your images to the EXIF metadata. This information can be read by software such as Adobe Lightroom 4, so that your images can be quickly sorted by location and shown on a world map. The GP-E2 will also update the clock automatically in your EOS 70D so that it is accurate.

GPS RECEIVER GP-E2

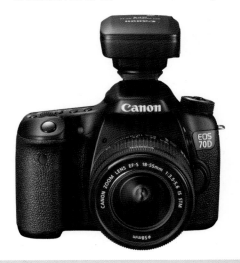

> Battery grip BG-E14

The BG-E14 turns your EOS 70D into an EOS 1-series lookalike. Controls are mirrored on the grip, allowing you to use your camera effectively whether it is held horizontally or vertically. The grip allows you to use two LP-E6 batteries together for extended shooting sessions, or use six AA batteries instead. The latter option is particularly useful if you're away from home, can't recharge the LP-E6 batteries, and have to rely on batteries on sale locally.

BATTERY GRIP BG-E8

> Microphones

If you use your EOS 70D to shoot movies, it's a good policy to invest in a good quality microphone. An external microphone can be positioned away from the camera (out of range of any noises made by the camera) and closer to your subject. If the microphone has a foam cover, this will help to reduce the effect of wind noise, as well as protecting the microphone head itself.

> AC adapter

You can power your EOS 70D using the ACK-E6 AC adapter kit (sold separately). This is particularly useful when using your camera to display images or movies on a TV or when transferring a large number of files to your computer or printer.

To use the adapter, turn the EOS 70D off and then plug the power cord of the ACK-E6 adapter into the DR-E6 coupler. Open the battery cover on the camera and slide the coupler into the camera as a replacement for the standard battery. The coupler should click into place. Close the battery cover, slotting the power cord into the DC Coupler cord hole.

Plug the power cord into the AC adapter and then connect to a convenient wall socket. Turn the camera on and use as normal. Turn the camera off and reverse the process above, to remove the AC adapter.

When light levels are very low—after sunrise or before sunset—the shutter speed is often measured in full seconds or even minutes. There's no way to keep a camera steady without a sturdy support, so even if you never use a tripod at any other time, they're absolutely invaluable in very low light.

Settings
> Aperture Priority **Av** mode
> ISO 100
> 65 sec. at f/16
> Evaluative metering
> 18–55mm lens at 18mm

7 CLOSE-UP

Many general-purpose lenses are described as having a macro facility, but there is a difference between a lens that allows you to focus closely and a true macro lens.

A macro lens is one that is able to project an image onto a sensor that is life size or larger—if you were able to measure the projected image of your subject on the sensor, it would be exactly the same size (or larger) than the subject itself. A life-size image is said to have a reproduction ratio of 1:1, twice life-size 2:1, and so on. The 18–135mm STM kit lens is able to focus down to 39cm, but the projected image only has a reproduction ratio of 1:4. This is good for a general-purpose lens, but it's not strictly macro.

The reproduction ratio is one of two ways that manufacturers show the macro capabilities of a lens. The other is the magnification figure. Unfortunately lens manufacturers generally use one or the other, but rarely both. To convert a reproduction ratio to a magnification figure, divide the number on the left of the reproduction ratio by the number on the right (so 1:4 would give a magnification figure of 0.25x). To convert in the other direction, divide 1 by the magnification to get the figure that should be placed on the right side of the reproduction ratio.

> **Note:**
> Rather confusingly, the EOS 70D has a Close-up mode, but how close you can focus is entirely dependent on the lens fitted to the camera.

THE WORLD «
OF THE SMALL
Experiment with macro photography and you soon become aware of subjects that may have gone unnoticed before.

CLOSE-UP »
A macro lens allows you to focus on details that are hard to see with the naked eye.

You don't necessarily need to buy a macro lens to shoot macro imagery. It's possible to extend the focusing capabilities of any lens with the addition of the equipment described here. This won't give you the image quality of a true macro lens, but these options are a relatively inexpensive entry to the world of macro photography.

> ## Close-up attachment lenses

By far the simplest method of adding a macro capability to a lens is to fit a close-up attachment lens. Close-up attachment lenses screw onto the filter thread on the front of the lens. Think of them as a magnifying glass for a lens and you wouldn't be too wide of the mark. Close-up attachment lenses work by reducing the minimum focusing distance of the lens. They're easy to use because they don't interfere with either the autofocus or exposure system of the camera.

Close-up attachment lenses are available in a variety of strengths, which is shown by the diopter value: the higher the diopter value, the greater the magnification. It's also possible to stack close-up attachment lenses to increase the magnification strength, although image quality will take a noticeable drop. For optimum image quality, it's better to use one close-up attachment lens with a prime lens, rather than a zoom.

Canon currently produces two close-up attachment lenses: a +2 Diopter (Type 500D) to fit 52mm, 55mm, 72mm, and 77mm filter threads and a +4 Diopter (Type 250D) to fit 52mm and 55mm filter threads.

OLD AND NEW »
A reversing ring with a 58mm thread allows me to use an old Minolta 50mm manual focus lens with my EOS cameras.

> Reversing ring

If you turn a lens around (so that the front element faces into the camera), it instantly becomes a macro lens. The problem, of course, is keeping the lens attached to the camera. A reversing ring allows you to do exactly that. One side is shaped to fit the lens mount of your camera; the other side is a thread that allows you to screw a lens to the ring.

When you buy a reversing ring, you need one that fits the filter thread of the lens you want to use. However, they do not usually carry a signal from the lens to the camera, so AF will be disabled. It also means that there's no way to set the aperture of the lens.

The easiest way to overcome this problem is to use a manual lens with an aperture ring. Canon used to produce lenses like this (FD lenses), which pre-date the EOS mount. FD lenses are in plentiful supply secondhand and can be bought very cheaply. Set the mode dial on your EOS 70D to **M** once the lens has been fitted to the camera, then set the shutter speed as normal and adjust the aperture ring until the correct exposure has been obtained.

> Extension tubes

Extension tubes (also known as extension rings) are hollow tubes that are fitted between the camera and a lens. This decreases the minimum focusing distance of the lens and increases the magnification.

RAINDROPS
This image was shot with the setup on the opposite page. Even though the lens was stopped down, there is still very little depth of field.

Since there is no glass in an extension tube there is very little loss of image quality. Extension tubes by third-party manufacturers are often sold in sets of three rings of different lengths. These rings can be detached and used separately or combined to create the maximum magnification.

Unfortunately, cheaper extension tubes generally don't maintain a connection between the lens and the camera. As with reversing rings, this means that AF is disabled, as is aperture control. Canon produce two extension tubes: EF 12II and RF/25II. The first extends the lens by 12mm, the second by 25mm. Both extension tubes retain AF and aperture control of the lens.

Kenko, a third-party manufacturer of photographic products, produce probably the most popular extension tubes, and these also allow the use of AF and aperture control.

› Bellows

Bellows are similar in principle to extension tubes, although they can be extended or compressed along a guide rail, so it's easier to set the desired amount of magnification. Once this is achieved, the bellows are locked into position ready for shooting. The downside of using bellows is that they are heavier and more cumbersome than extension tubes, which is why most bellows systems are used in studios, with the camera mounted on a tripod. Bellows are also far more expensive than extension tubes. Canon don't make bellows for the EOS system, but compatible systems can be bought from companies such as Novoflex.

KENKO EXTENSION TUBE SET　　　**»**
Provides 68mm of extension when the tubes are combined or 12mm, 20mm, and 36mm extension when used individually.

» MACRO TECHNIQUE

Macro photography is deceptively similar to "standard" photography, but it has unique challenges that require a certain amount of patience and a willingness to solve problems.

› Working distance

The working distance of a macro lens is the distance from the lens to the subject needed to achieve the required reproduction ratio: the longer the focal length of a macro lens, the greater the working distance. The working distance of a 50mm macro lens is half that of a 100mm lens and a quarter of a 200mm lens at a 1:1

reproduction ratio, for example.

The longer the working distance, the farther back you can stay from your subject. For some subjects, this is relatively unimportant, but if your subject is likely to be disturbed easily (if it's an insect or animal for instance), a longer working distance is invaluable.

The downside of using a longer focal length macro lens is that they are inevitably heavy and bulky. They are also far more expensive than macro lenses with a shorter focal length. Choosing a macro lens involves thinking about your budget and what you think your primary subjects are likely to be.

PERSPECTIVE »
The farther back you get from your subject—while maintaining a 1:1 magnification—the more natural the perspective will be.

› Depth of field

One of the biggest problems when shooting macro images is the lack of depth of field. It's often impossible to achieve front-to-back sharpness, even when using the minimum aperture. Choosing the most appropriate point of focus is therefore more important than when shooting "standard" images. With insects or small animals, this would most often be the eye; flowers are more difficult, but a good starting point is the tips of the stamens. If your subject is a flat plane, depth of field is less critical, though it's important to have the subject exactly parallel to the camera. If it is at a slight angle, the subject may not be critically sharp across the entire image.

Because depth of field is so small, a subject that moves can be difficult to deal with. It often doesn't take much movement for the subject to drift out of focus. If your subject is blowing in the wind, try to shelter it with your body. Use the EOS 70D's Continuous shooting and AF Servo facilities to expose a number of frames and edit the sequence later, deleting those images that don't have critical sharpness.

A lack of depth of field is not necessarily a bad thing, though. When looking at an image, we don't like to linger over areas that aren't in focus. If only one part of an image is sharp, the eye will be naturally drawn there.

FOCUS　　　　　　　　　　　　　　**«**
Since depth of field can be so restricted when shooting close-up or macro images, precise focusing is very important.

> Illuminating your subject

If your subject is moving, you'll need to use a reasonably fast shutter speed. However, unless you use a high ISO, you'll be forced to use your lens' maximum aperture. This will cut the available depth of field to a minimum, making it more difficult to keep you subject in focus. What to do?

The solution is to illuminate your subject with as bright a light source that is as close to the subject as possible. The placement of the light is critical. The built-in flash on your EOS 70D isn't suitable for macro photography, since the lens will get

in the way and cast a shadow on your subject. A better solution is to use off-camera flash, triggering it with either a cable connection or the EOS 70D's wireless flash facility.

Another approach is to use a ring light. These lights "wrap" around the front of the lens, creating a subtle and soft illumination for macro subjects. Canon sells two dedicated macro flashes: the Macro Twin Lite MT-24EX and Macro Ring Lite MR-14EX.

If you use one light source, there may be problems with contrast, particularly if it's a point light source such as an off-camera flash. Placing a sheet of white card or a commercial reflector on the opposite side of the subject to the light will help to throw light back into the shadows and reduce contrast.

Working outdoors can be challenging. The soft light of an overcast day works well for a lot of subjects, particularly softer organic subjects such as flowers. The light on overcast days will be biased toward blue so either create a custom WB or the ☁ preset.

REFLECTOR　　　　　　　　　　　**«**
This backlit scene required the use of a reflector to lower the contrast by lightening the shadow areas.

7 » MACRO LENSES

› Canon Lenses

Canon currently produces five macro lenses. All of the lenses are fixed focal length, all but one offer a 1:1 (or better) reproduction ratio, and all but one can be used as a conventional lens for non-macro photography.

First in the lineup is the EF-S 60mm f/2.8 Macro USM. This lens can only be used by cropped-sensor cameras such as the EOS 70D and it's unique in that it's Canon's only macro EF-S lens.

The quirkiest of Canon's macro lenses is the MP-E 65mm f/2.8 1–5x Macro. This lens has a 5:1 reproduction ratio, allowing you to capture macro images that are five times life-size. This lens is manual focus only, though it's often easier to mount the lens/camera assembly to a rail system and move the entire setup backward and forward to achieve critical focus.

In 2009, Canon updated its popular EF 100mm macro lens by improving the optical system (achieving L-lens status) and adding a new Image Stabilization system. The new Hybrid IS system is designed to be effective when shooting macro, something that rarely applies to older IS systems. Both the original and updated 100mm lenses are currently available.

The largest, heaviest, and most expensive Canon macro lens is the EF 180mm f/3.5L Macro USM. With the longest working distance of all the Canon macros, this is the perfect lens when working with subjects that benefit from you keeping your distance.

> **Note:**
> Canon also produces the EF 50mm f/2.5 Compact Macro. Arguably it's not a true macro lens, though, as it only has a reproduction ratio of 1:2.

CANON 100MM L IS USM MACRO LENS ❯❯

> Third-Party Lenses

Canon is not the only manufacturer of macro lenses that are compatible with the EOS 70D. There are many third-party alternatives that are less expensive and sometimes optically the equal of Canon's offerings. The table below shows the current range of lenses produced by Sigma, Tamron, and Tokina for the Canon EF-S lens mount.

Sigma

Lens	Minimum focus distance (cm)	Reproduction ratio	Filter thread size (mm)	Dimensions (diameter x length mm)	Weight (g)
50mm f/2.8 EX DG	19	1:1	55	71.4 x 66.5	320
70mm f/2.8 EX DG	25	1:1	62	76 x 95	527
105mm f/2.8 APO EX DG OS HSM	31	1:1	62	78.3 x 126.4	725
150mm f/2.8 EX DG OS HSM	38	1:1	72	79.6 x 150	1150

Tamron

Lens	Minimum focus distance (cm)	Reproduction ratio	Filter thread size (mm)	Dimensions (diameter x length; mm)	Weight (g)
60mm f/2 Di II LD SP AF	23	1:1	55	73 x 80	390
90mm SP f/2.8 SP Di	29	1:1	55	71.5 x 97	405
180mm f/3.5 SP Di	47	1:1	72	84.8 x 165.7	920

Tokina

Lens	Minimum focus distance (cm)	Reproduction ratio	Filter thread size (mm)	Dimensions (diameter x length; mm)	Weight (g)
35mm f/2.8 AT-X PRO DX	14	1:1	52	73.2 x 60.4	340
100mm f/2.8 AT-X	30	1:1	55	73 x 95.1	540

Wind can be problematic when shooting delicate subjects outdoors. A faster shutter speed helps, although you may need to increase the ISO in order to use a small aperture for depth of field. To keep this spider's web as steady as possible, I sheltered it with an unfurled reflector. Even then, I had to shoot several frames and choose the sharpest one later.

Settings
- Aperture Priority
- **Av** mode
- ISO 100
- 1/800 sec. at f/5.6
- Evaluative metering
- 100mm macro lens

OD

Arguably the most difficult macro subject to photograph is insects. If they're fast moving, it can be all but impossible to track them using a camera's AF system. It is generally better to shoot insects early in the morning when it's cooler, since this is when they're at their slowest and are easier to photograph.

Settings
> Aperture Priority
> **Av** mode
> ISO 400
> 1/100 sec. at f/8
> Evaluative metering
> 100mm macro lens

8 CONNECTION

If you want to make the most of your EOS 70D, you'll ultimately need to connect it (or the memory card) to an external digital device such as a computer, printer, or even a television. This will enable you to archive, review, edit, and print your images.

> Color calibration

No matter how much care you take with exposure, Picture Style, and white balance, there's no guarantee that the image will print out accurately later. Once an image has been copied to a computer, the precision with which colors are displayed and printed depends on your color calibration regime.

The first potential source of inaccuracy is the computer's monitor. Colors on a monitor will drift over time, so you should calibrate the monitor at regular intervals. Hardware color calibrators are readily available from most good retail and online electronics stores, and image-editing software will use the monitor profile created by the calibrator to ensure that you're viewing accurate colors on screen.

To make prints from your images, you'll also need an accurate profile for the particular type of paper you want to use with the printer. A profile specifies how the printer needs to modify its output so that a particular paper type receives the correct amount of ink in the right proportions. This ensures that an image's colors are

reproduced correctly when printed. Most paper manufacturers supply generic profiles for their papers for popular printers, but a specially created profile for your personal printer and paper combination will be more accurate. Creating a printer profile also requires a hardware calibrator (different to a monitor calibrator). However, if you only use a few different types of paper, there are companies who will create bespoke profiles for a nominal fee.

CALIBRATION ⌃
I regularly calibrate my computer's monitor.

CONNECTION »
By connecting your camera to a PC or printer, you can share your images socially.

8 » CANON SOFTWARE

Your EOS 70D is bundled with Digital Photo Professional, ImageBrowser EX, EOS Utility, PhotoStitch, and Picture Style Editor software. It's not obligatory to use this software—there are commercial alternatives such as Adobe Lightroom—but the various packages are an inexpensive way to begin organizing and adjusting images from your EOS 70D.

There is not enough space in this book to give an in-depth guide to all of this software, but Canon supplies comprehensive PDF manuals on the disk that comes with the EOS 70D. To install the software, follow these instructions.

If using Windows:

1) Log on as normal (or as Administrator if required to do so to install software).

2) Insert the Canon CD-ROM disk into the CD-ROM drive.

3) The Canon software installation screen should appear automatically. Click on **Easy Installation** to install all the software automatically. Click on **Custom Installation** to select which of the programs you want to install. Follow the instructions on screen to continue.

4) When the installation is complete, click on either **Finish** or **Restart** as required.

5) Remove the CD-ROM.

Warnings!

The software is only compatible with Windows 7, Vista, and XP (SP3), plus Intel Mac OS X 10.6–10.7.

Uninstall any previous versions of ZoomBrowser or ImageBrowser from your PC before installing the new software.

If using Mac OS X:

1) Log on as normal (or as Administrator if required to do so to install software).

2) Insert the Canon CD-ROM disk into the CD-ROM drive.

3) Double-click on the CD-ROM icon on your Mac's desktop.

4) Double-click on **Setup**. The Canon software installation screen should now appear. Follow the instructions on screen to select your geographical region and country. On the Selecting an Installation Type screen, click on **Easy Installation** to install all the software on the disk automatically. Click on **Custom Installation** to select which of the programs you want to install and then follow the on-screen instructions to continue.

5) When the installation is complete, click on **Finish**.

6) Remove the CD-ROM.

INSTALLATION **»**
Installing Canon's software on Mac OS X.

7) The installed software can now be found in the Applications folder on your Mac's hard drive.

> *Notes:*
> The latest iMacs don't have optical drives. This means you will need to download and install the software from your local Canon web site or purchase an external optical drive.
>
> You can register for CANON iMAGE GATEWAY during installation. This is a free service that allows you to post your images and videos online for other members to view. As well as this facility, there are technique articles to read and benefits such as free shipping when products are bought through the Canon online store.

Digital Photo Professional

Digital Photo Professional (or DPP) is most useful for editing and converting your EOS 70D's Raw files, before saving them as either JPEGs or TIFFs, or transferring the files directly to Adobe Photoshop. If you've set Dust Delete Data (*see chapter 3*), you would use DPP to automatically clone out dust spots.

PhotoStitch

Panoramic photography is increasingly popular. Although you can shoot in a 16:9 aspect ratio using your EOS 70D, this is at the cost of image resolution. Another way to create panoramic images—and gain resolution—is to shoot a series of images (typically by moving the camera from left to right) and then join them together in postproduction. PhotoStitch takes the pain out of this process by stitching your image sequence together automatically.

ImageBrowser EX

ImageBrowser EX is used to sort your images on your computer. The simple interface allows you to quickly copy, duplicate, move, rename, or delete your images and movie files. You can also rate them using a star system or join the online Canon Image Gateway to post your images for others to view.

EOS Utility

This utility enables you to import your images from your EOS 70D onto your computer, or organize the images on the memory card. It can also be used to capture images directly onto your computer when your camera is attached.

Picture Style Editor

Using this program, you can edit and save your own Picture Styles, which can then be copied to your EOS 70D for use when shooting JPEGs.

» CONNECTING TO A COMPUTER

1) Attach the USB cable to the A/V OUT DIGITAL connector underneath the lower right terminal cover on your EOS 70D.

2) Insert the other end of the USB cable into a USB (2.0 or higher) port on your computer.

3) Turn on your EOS 70D.

4) On Windows computers, click on **Download Images From EOS Camera using Canon EOS Utility**. **Canon EOS Utility** should now launch automatically. Check **Always do this for this device** if you want to make this a default action when you connect your EOS

70D. On Mac OS X, Canon EOS Utility should run automatically when the camera is attached.

5) Follow the instructions on screen in Canon EOS Utility.

6) Quit Canon EOS Utility when you're finished, turn off your EOS 70D, and unplug it from your computer.

Warning!

Before connecting your EOS 70D to your computer, install the Canon software and make sure that the camera is switched off, and that the battery is fully charged.

EOS UTILITY «
Running EOS Utility on Mac OS X.

» TETHERED SHOOTING

When your EOS 70D is connected to your computer via the USB cord, you can use a technique known as "tethered shooting." Tethered shooting allows you to view a Live View image on your computer monitor, make adjustments, and then shoot. The resulting image is then transferred directly to your computer for saving.

The drawback is that you're limited to shooting within the USB cord's "range." This makes the technique more difficult away from the studio, but not impossible with a suitable laptop. Tethered shooting requires the installation of EOS Utility on your computer.

Enabling tethered shooting

1) Connect your EOS 70D to your PC as described on the previous page.

2) Launch EOS Utility (if it doesn't launch automatically) and click on **Camera Setting/Remote Shooting**.

3) Click **Preferences** and select **Destination Folder** from the pop-up menu (Mac) or tab (Windows) at the top of the dialog box. Select the folder that you want your images to be saved to. Alter the other settings as desired.

4) Select **Linked Software** from the pop-up menu (Mac) or tab (Windows) at the top of the dialog box. Select the software that you want to use to edit the captured images.

5) Click **OK** to continue.

6) Click the **Live View shoot...** button to see the camera's output on your computer monitor.

7) Alter settings such as **White Balance** and **Focus** as required. These can be found at the right and below the Live View window.

8) Click on the EOS Utility shutter-release button to capture the image.

9) When you're done, disconnect your EOS 70D from your computer as described on the previous page.

TETHERED SHOOTING ⏷
Shooting with the EOS 70D tethered to a Mac computer.

» EYE-FI

Eye-Fi is a proprietary SD memory card with a built-in Wi-Fi transmitter. This allows you to transfer files between your EOS 70D and a Wi-Fi enabled computer or hosting service. To set up the Eye-Fi card, check the manual that came with your card before use. For more information about Eye-Fi go to www.eye.fi.

Enabling Eye-Fi

1) Select **Eye-Fi Settings** on the 🔧 menu.

2) Set **Eye-Fi trans.** to **Enable**. When **Eye-Fi trans.** is set to **Disable**, the Eye-Fi card won't automatically transmit your files and 📶 will be shown.

3) Shoot a picture. The Eye-Fi symbol turns from a gray 📶 to one of the other icons shown below. When an image has been transferred, 📷 will be displayed on the shooting information screen.

Checking an Eye-Fi Connection

1) Select **Eye-Fi Settings** on the 🔧 menu.

2) Select **Connection info.** The connection information screen will be displayed, showing you the connection status.

3) Press **MENU** to return to the main Eye-Fi Settings menu.

> **Notes:**
> File transfer speeds are dependant on the speed of your wireless connection.
>
> The EOS 70D's battery may be depleted more quickly than usual when transferring images using an Eye-Fi card.
>
> Eye-Fi settings only appear on the 🔧 menu when an Eye-Fi card is installed.
>
> Ensure that the write-protect tab on the Eye-Fi card is set to unlocked.
>
> **Auto power off** is disabled during file transfer.

Displayed symbol	Status
📶 [GRAY]	Not connected
📶 [BLINKING]	Connecting
📶 [SOLID WHITE]	Connection to access point established
📶 (↑)	Transferring

Using a USB cable to connect to a computer has its limitations, and even Eye-Fi isn't ideal, since it's an additional cost. Fortunately, the EOS 70D [W] has built-in Wi-Fi capabilities that will allow you to transfer files wirelessly, so if you intend to transfer files wirelessly on a regular basis you may want to opt for this iteration of the camera (if you have an EOS 70D [N],

you will need an Eye-Fi card to add Wi-Fi capability to your camera).

Images can be transferred to a wide variety of wireless-enabled devices, such as a smartphone or tablet. If your device has a suitable app, you can also control your EOS 70D remotely.

Enabling Wi-Fi

1) Select **Wi-Fi** from the menu and then select **Enable**. If you take your EOS 70D into an area where a Wi-Fi-enabled device wouldn't be welcome, set Wi-Fi to **Disable.**

2) Select **Wi-Fi function** on the menu.

3) The first time you view **Wi-Fi function**, you'll be prompted to enter a nickname.

Symbol	Function
((ţ))OFF	Wi-Fi is set to Disable (rear LCD)
((ţ))OFF	Wi-Fi is set to Enable, but no Wi-Fi signal has been acquired (rear LCD)
((ţ)) / Y.₁	Connection has been made/Signal strength (rear LCD)
((ţ)) ❶ (blinking)/ Y	Transmission error (rear LCD)/No signal
((ţ)) (blinking)/ Y	Camera is waiting for a connection (rear LCD)
Wi-Fi OFF	Camera not connected (top LCD)
((ţ))/Wi-Fi ON	Connection has been made/transmitting (top LCD)
((ţ)) (blinking)/Wi-Fi ON	Waiting for reconnection (top LCD)
((ţ))/Wi-Fi ON (both blinking)	Connection error (top LCD)

The text entry system works in the same way as entering your copyright details (*see page 146*). If you want to change the nickname at a later date, press **INFO.** to view the **General sett./Edit nickname** screen when you select **Wi-Fi function**.

> **Note:**
> Movies cannot be shot when Wi-Fi is enabled.

› Wi-Fi options

There are six connection options when using Wi-Fi: **Transfer imgs between cameras**; **Connect to Smartphone**; **Remote control/EOS Utility**; **Print from Wi-Fi printer**; **Upload to Web service**; and **View images on DLNA devices**.

The procedure for connecting—such as whether a password needs to be entered—will depend on how your device or wireless network is configured. Possibly the most useful function if you're interested in controlling your EOS 70D remotely is the Connect to Smartphone option.

To make the most of this option, you'll need to download the free EOS Remote app produced by Canon. This app is available for Apple iOS and Android devices. Once the app is installed and a

connection made, you can view a Live View feed from your EOS 70D on your device, set shooting functions, and make exposures.

After you've made an exposure, you can use your device to browse images on the EOS 70D's memory card and copy them to your device (the images will be shrunk automatically to suit the size of your device's screen). The limitation with EOS Remote is that you can't copy movie files to your device, although this is unsurprising since movie files are generally far larger than still-images and require far longer to transmit, even with a fast connection.

> **Tip**
>
> *There are two basic ways of connecting wireless devices. An "Ad-hoc" connection (referred to as "Camera access point mode" on the EOS 70D) is a direct connection between two Wi-Fi-enabled devices. An "Infrastructure" connection requires a wireless access point (such as a wireless router), which acts as a bridge to connect the two devices. When connecting to a smartphone, connect using Camera access point mode.*

» CONNECTING TO A TV

The EOS 70D can be connected to either an analog or HD television. Unfortunately, neither an RCA video cord for use with an analog TV, nor a Type C mini-pin HDMI cord for connection to an HDTV set is supplied with the camera. However, Canon supplies the former (AVC-DC400ST) through its usual outlets; the latter can be found readily in good consumer electronics stores.

Connecting your EOS 70D to an analog TV

1) Ensure that both your EOS 70D and TV are switched off.

2) Open the EOS 70D's lower right terminal cover and insert the AV cord plug into the AV OUT/DIGITAL port.

3) Insert the three RCA plugs into the relevant connections on your TV. The connectors are color-coded: yellow for video, and white and red for the left and right audio inputs respectively. Match the correct color plug to the correct connection. If the connectors on your TV are not color-coded, check the TV's instruction manual before proceeding.

4) Turn on your TV and switch to the correct channel for external devices.

5) Turn on your EOS 70D and then press the 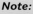 button. The image from the EOS 70D should now be displayed on the TV rather than the LCD.

6) When you have finished, turn off the EOS 70D and TV before disconnecting.

> **Note:**
> Set **Video System** on ✂ to the correct setting for your region.

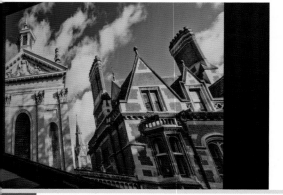

SLIDESHOW «
Watching a slideshow of your images on a TV can be a good excuse for a family get-together.

Connecting your EOS 70D to an HDTV TV

1) Ensure that both your EOS 70D and TV are switched off.

2) Open the EOS 70D's rear terminal cover and connect the HDMI cord plug to the HDMI OUT port.

3) Plug the other end of the HDMI cord into a free slot on your TV.

4) Turn on your TV and switch to the correct channel for external devices.

5) Turn on your EOS 70D. Press ▶ on your camera to view your images on the HDTV.

6) When you are finished, turn off the EOS 70D and TV before disconnecting.

> **Note:**
> Set **Ctrl** over **HDMI** on 🖵 to **Enable** if you want to use your HDTV's remote to control your camera.

› HDMI TV remote control

If your TV is compatible with the HDMI CEC standard, you can use the TV's remote to control the playback function on your EOS 70D.

1) Follow steps 1 to 5 left to connect your EOS 70D to an HDTV.

2) Use the remote's ◀ / ▶ buttons to select the desired option displayed on the TV. If you select Return and then press Enter, you will be able to use the remote's ◀ / ▶ buttons to skip through images on your EOS 70D.

Menu options	
↰	Return
▦	9-image index
▶🖵	Play movie
🔄	Slide show
INFO.	Show image shooting information
↻	Rotate

» USING A PRINTER: PICTBRIDGE

The EOS 70D can be connected directly to a 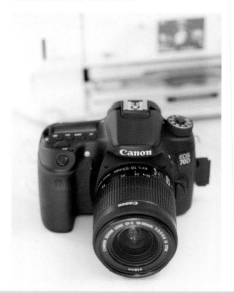 PictBridge compatible printer, allowing you to print out images without copying them to a computer. The EOS 70D is supplied with a suitable USB cable, but some printers also have an SD memory card slot so you don't even need to have your camera handy. Both JPEG and Raw files can be printed when the camera is directly connected to a printer, but only JPEG when using a printer's memory card slot.

Connecting to a printer

1) Check that the camera battery is fully charged before beginning to print.

2) Ensure that both the camera and printer are switched off. Insert the memory card of images you want to print into the EOS 70D if it is not already installed.

3) Open the EOS 70D's rear terminal cover and connect the supplied USB cord to the AV OUT/DIGITAL port.

4) Connect the cable to the printer, following the instructions in the manual supplied with the printer.

5) Turn on the printer, followed by the camera. Press play on the EOS 70D. The PictBridge icon will be displayed at the top left corner of the LCD to show that a

connection has been successfully made.

6) Navigate to the image you want to print and then press (SET).

7) The print options screen will now appear (see grid opposite). Set the required options and then select **Print**; printing should begin.

8) Repeat steps 6 and 7 to print additional images.

9) Turn off the EOS 70D and printer, and disconnect the USB cord.

Option	Description
Printing Effect	
On	Print will be made using the printer's standard setup. Automatic correction will be made using the image's shooting metadata (EXIF).
Off	No automatic correction applied.
Vivid	Greens and blues are more saturated.
NR	Image noise reduction is applied before printing.
B/W B/W	Black-and-white image is printed with pure blacks.
B/W Cool tone	Black-and-white image is printed with bluish blacks.
B/W Warm tone	Black-and-white image is printed with yellowish blacks.
Natural	Prints an image with natural colors.
Natural M	Finer control over colors than Natural.
Default	Printer dependent. See your printer manual for details.
Date & file number imprinting	Choose between overlaying the date, file number, or both on the print.
Copies	Specify the number of prints to made.
Cropping	Allows you to trim and rotate your image before printing.

Paper Settings	Description
Paper size	Select the size of the paper loaded in the printer.
Paper type	Select the paper type.
Page layout	Select how the image will look on the printed page.

Page Layout	Description
Bordered	The print will be made with white borders.
Borderless	The print will go to the edge of the page if your printer supports this facility.
Bordered 🖪	Shooting information will be imprinted on the border of prints that are 3.5 x 5 in./9 x 13cm or larger.
xx-up	Print 2, 4, 8, 9, 16, or 20 images on a single sheet.
20-up 🖪 35-up 🖿	20 or 35 images will be printed as thumbnails on A4 or Letter size paper. 20-up 🖪 will have the shooting information added.
Default	Your printer's default settings will be used.

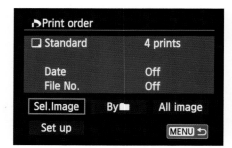
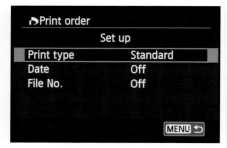

Another way to prepare your (JPEG only) images for printing is to use DPOF (or Digital Print Order Format). DPOF adds instructions to your EOS 70D's memory card that will be followed by a compatible printer or by a photo printing service. These instructions include which images to print, how many of each image, and whether the shooting date or the file name should be overlaid. Once DPOF instructions have been added to the memory card, you either plug the card into a compatible printer or take it to your chosen photo printing service.

Setting DPOF
1) Select **Print Order** on the ▶ menu, followed by **Set up.**

3) Set the **Print type** (select **Standard** for a normal print, **Index** for a sheet of thumbnails, or **Both**).

4) Set **Date** to **On** if you want the date to be imprinted on your prints, or select **Off** if you don't want the date added.

5) Set **File no.** to **On** for the image file number to be imprinted on your prints, or **Off** if you don't want this.

6) Press **MENU** to return to the **Print Order** menu screen.

Marking all images in a folder for printing
1) On the **Print Order** screen, select **By** ▪.

2) Select **Mark all in folder**. Select the required folder followed by **OK**. A print order for one copy of each compatible image in the folder will be set.

3) Select **Clear all in folder** to clear the print order. Select the folder followed by **OK.**

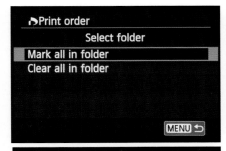

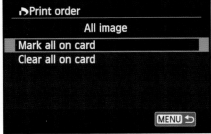

memory card. To view three images, press
/ Q. To view a single image, press ⊕.

3) If you selected **Standard** in the **Setting DPOF** menu, press ▲ / ▼ to set the number of prints to be made from the displayed/highlighted image.

4) If you selected **Index**, press (SET) to add the displayed/highlighted image to the DPOF instructions to be printed in Index form. A ✓ indicates that the image has been selected. Press (SET) to deselect it again if required.

5) Repeat from step 2, then press **MENU** to return to the **Print Order** menu screen.

Direct printing
If your EOS 70D is connected to a PictBridge printer, highlight **Print** on the Print Order menu and press (SET). Follow the instructions and the printer will print according to the DPOF instructions set.

Marking all images for printing
1) On **Print Order** screen, select **All image**.

2) Select **Mark all on card** then **OK**. A print order for one copy of each compatible image on the card will be set.

3) To clear the print order, select **Clear all on card** followed by **OK.**

Print ordering individual images
1) On **Print Order** screen select **Sel. Image.**

2) Turn ⊙ to skip between the images on the

» GLOSSARY

Aberration An imperfection in a photograph, usually caused by the optics of a lens.

AEL (automatic exposure lock) A camera control that locks in the exposure value, allowing a scene to be recomposed.

Angle of view The area of a scene that a lens takes in, measured in degrees.

Aperture The opening in a camera lens through which light passes to expose the sensor. The relative size of the aperture is denoted by f-stops.

Autofocus (AF) A reliable through-the-lens focusing system allowing accurate focus without the photographer manually turning the lens.

Bracketing Taking a series of identical pictures, changing only the exposure, usually in ⅓-, ½-, or 1-stop increments.

Buffer The in-camera memory of a digital camera.

Center-weighted metering A metering pattern that determines the exposure by placing importance on the lightmeter reading at the center of the frame.

Chromatic aberration The inability of a lens to bring spectrum colors into focus at a single point.

CMOS (Complementary Metal Oxide Semiconductor) A type of imaging sensor, consisting of a grid of light-sensitive cells. The more cells, the greater the number of pixels and the higher the resolution of the final image.

Codec A piece of software that is able to interpret and decode a digital file such as Raw.

Color temperature The color of a light source expressed in degrees Kelvin (K).

Compression The process by which digital files are reduced in size. Compression can retain all the information in the file, or "lose" data usually in the form of fine detail for greater levels of file-size reduction.

Contrast The range between the highlight and shadow areas of a photo, or a marked difference in illumination between colors or adjacent areas.

Depth of field This is controlled primarily by the aperture: the smaller the aperture, the greater the depth of field.

Diopter Unit expressing the power of a lens.

dpi (dots per inch) Measure of the resolution of a printer or scanner. The more dots per inch, the higher the resolution.

DPOF Digital Print Order Format.

Dynamic range The ability of the camera's sensor to capture a full range of shadows and highlights.

Evaluative metering A metering system where light reflected from several subject areas is calculated based on algorithms.

Exposure The amount of light allowed to hit the digital sensor, controlled by

aperture, shutter speed, and ISO. Also, the act of taking a photograph, as in "making an exposure."

Exposure compensation A control that allows intentional over- or underexposure.

Fill-in flash Flash combined with daylight in an exposure. Used with naturally backlit or harshly side-lit or top-lit subjects to prevent silhouettes, or to add extra light to the shadow areas of a well-lit scene.

Filter A piece of colored or coated glass, or plastic, placed in front of the lens.

Focal length The distance, usually in millimeters, from the optical center point of a lens to its focal point.

fps (frames per second) A measure of the time needed for a digital camera to process one photograph and be ready to shoot the next.

f-stop Number assigned to a particular lens aperture. Wide apertures are denoted by small numbers (such as f/1.8 and f/2.8), while small apertures are denoted by large numbers (such as f/16 and f/22).

HDR (High Dynamic Range) A technique that increases the dynamic range of a photograph by merging several shots taken with different exposure settings.

Histogram A graph representing the distribution of tones in a photograph.

Hotshoe An accessory shoe with electrical contacts that allows synchronization between a camera and a flash.

Hotspot A light area with a loss of detail in the highlights. This is a common problem in flash photography.

Incident-light reading Meter reading based on the amount of light falling onto the subject.

Interpolation A method of increasing the file size of a digital photograph by adding pixels, thereby increasing its resolution.

ISO The sensitivity of the digital sensor measured in terms equivalent to the ISO rating of a film.

JPEG (Joint Photographic Experts Group) JPEG compression can reduce file sizes to about 5% of their original size, but uses a lossy compression system that degrades image quality.

LCD (Liquid crystal display) The flat screen on a digital camera that allows the user to preview digital photographs.

Macro A term used to describe close focusing and the close-focusing ability of a lens.

Megapixel One million pixels is equal to one megapixel.

Memory card A removable storage device for digital cameras.

Noise Interference visible in a digital image caused by stray electrical signals during exposure.

PictBridge The industry standard for sending information directly from a camera to a printer, without the need for a computer.

Pixel Short for "picture element"—the smallest bit of information in a digital photograph.

Predictive autofocus An AF system that can continuously track a moving subject.

Raw The file format in which the raw data from the sensor is stored without permanent alteration being made.

Red-eye reduction A system that causes the pupils of a subject's eyes to shrink, by shining a light prior to taking the main flash picture.

Remote switch A device used to trigger the shutter of the camera from a distance, to help minimize camera shake. Also known as a "cable release" or "remote release."

Resolution The number of pixels used to capture or display a photo.

RGB (red, green, blue) Computers and other digital devices understand color information as combinations of red, green, and blue.

Rule of thirds A rule of composition that places the key elements of a picture at points along imagined lines that divide the frame into thirds, both vertically and horizontally.

Shutter The mechanism that controls the amount of light reaching the sensor, by opening and closing.

Soft proofing Using software to mimic on screen how an image will look once output to another imaging device. Typically this will be a printer.

Spot metering A metering pattern that places importance on the intensity of light reflected by a very small portion of the scene, either at the center of the frame or linked to a focus point.

Teleconverter A supplementary lens that is fitted between the camera body and lens, increasing its effective focal length.

Telephoto A lens with a large focal length and a narrow angle of view.

TIFF (Tagged Image File Format) A universal file format supported by virtually all relevant software applications. TIFFs are uncompressed digital files.

TTL (through the lens) metering A metering system built into the camera that measures light passing through the lens at the time of shooting.

USB (universal serial bus) A data transfer standard, used by the Canon EOS 70D (and most other cameras) when connecting to a computer.

Viewfinder An optical system used for composing and sometimes for focusing the subject.

White balance A function that allows the correct color balance to be recorded for any given lighting situation.

Wide-angle lens A lens with a short focal length and, consequently, a wide angle of view.

» USEFUL WEB SITES

CANON

Canon Worldwide
www.canon.com

Canon US
www.usa.canon.com

Canon UK
www.canon.co.uk

Canon Europe
www.canon-europe.com

Canon Middle East
www.canon-me.com

Canon Oceania
www.canon.com.au

GENERAL

David Taylor
Landscape and travel photography
www.davidtaylorphotography.co.uk

Digital Photography Review
Camera and lens review site
www.dpreview.com

Photonet
Photography Discussion Forum
www.photo.net

EQUIPMENT

Adobe
Image-editing software (Photoshop,
Photoshop Elements, and Lightroom)
www.adobe.com

Apple
Hardware and software manufacturer
www.apple.com/uk

PHOTOGRAPHY PUBLICATIONS

**Photography books &
Expanded Camera Guides**
www.ammonitepress.com

Black & White Photography magazine
Outdoor Photography magazine
www.thegmcgroup.com

THE EXPANDED GUIDE

FRONT OF CAMERA

BACK OF CAMERA

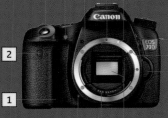

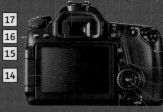

1	DC coupler cord hold
2	Remote control sensor
3	Shutter-release button
4	Red-eye reduction / Self-timer lamp
5	Lens mount
6	EF lens mount index
7	EF-S lens mount index
8	Left strap mount
9	Lens lock pin
10	Lens-release button
11	Reflex mirror
12	Lens electrical contactsx
13	Depth of field preview button
14	LCD monitor
15	LCD monitor hinge
16	MENU button
17	**INFO.** button
18	Eyecup

19	Viewfinder eyepiece
20	Diopter adjustment
21	Live View / Movie shooting switch
22	Start / Stop button
23	Q Quick control button
24	AF Start button
25	✱ AE/FE Lock / Image index / Reduce button
26	AF-Point selection / Magnify button
27	Access lamp
28	▶ Playback button
29	Multi controller
30	Multi function lock switch
31	Quick control dial
32	(SET) Setting button
33	Delete button

TOP OF CAMERA

| 34 | 35 | 36 | 37 | 38 | 39 | 40 | 41 | 42 |

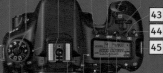

43
44
45

51 50 49 48 47 46

BOTTOM OF CAMERA

| 58 | 59 | 60 | 61 |

LEFT SIDE

53
52
54
55
56
57

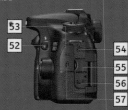

RIGHT SIDE

62

34	Mode dial
35	Mode dial lock button
36	Mode dial index mark
37	Hot shoe
38	Built-in flash
39	AF mode button
40	Drive mode button
41	AF area selection button
42	Main dial
43	Metering selection button
44	Top LCD illumination button
45	Right strap mount
46	ISO speed setting button
47	Top LCD
48	Focal plane mark

49	Right stereo microphone
50	Left stereo microphone
51	On/Off switch
52	Flash release button
53	External microphone terminal
54	Speaker
55	HDMI out terminal
56	Audio/Video out /USB terminal
57	Remote release terminal
58	Information panel
59	Tripod socket
60	Battery cover
61	Battery cover lock release
62	Memory card cover